Hugh Morton's North Carolina

Hugh Morton's

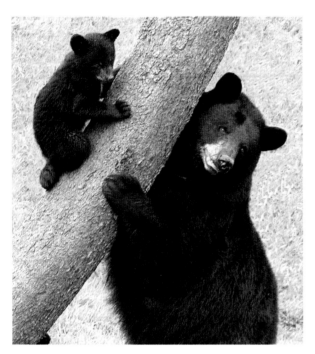

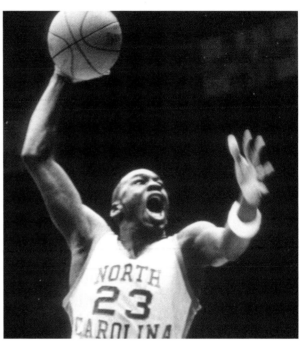

North Carolina

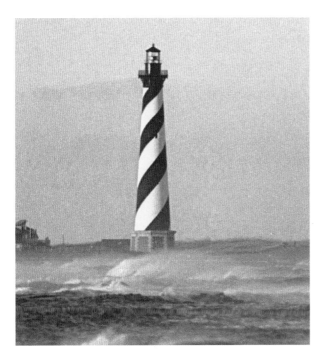

FOREWORD BY WILLIAM FRIDAY

The University of North Carolina Press *Chapel Hill & London*

Designed by Richard Hendel
and Eric M. Brooks
Set in Charter and TheSans types
by Eric M. Brooks
Manufactured in the United Kingdom
by Butler & Tanner

The paper in this book meets the
guidelines for permanence and durability
of the Committee on Production
Guidelines for Book Longevity of the
Council on Library Resources.

Library of Congress
Cataloging-in-Publication Data
Morton, Hugh M.
Hugh Morton's North Carolina /
foreword by William Friday.
 p. cm.
Includes index.
ISBN 0-8078-2832-7 (cloth: alk. paper)
1. North Carolina—Pictorial works.
I. Title.
F255 .M68 2003
917.56'0022'2—dc21 2003006430

07 06 05 04 03 6 5 4 3 2

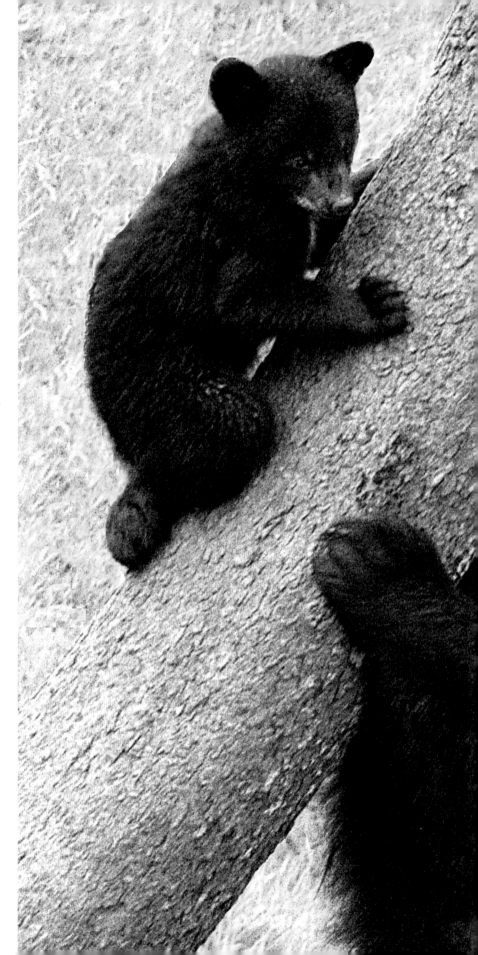

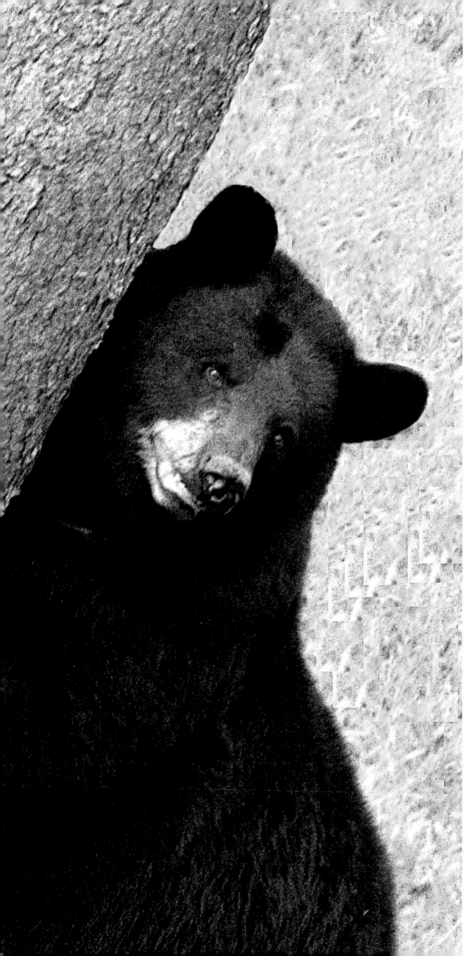

Contents

Foreword

North Carolina is a land of personalities and unique individuals who have made and continue to make a great difference in our lives. Hugh Morton is one of those creative forces. For seven decades Hugh and his trusted cameras have roamed our state, creating the photographic essay now spread over these pages for the reader to enjoy. He has watched North Carolina as it weathered the Great Depression and the years of World War II and has been a part of its progress in this new age of science and technology, banking and cultural growth. And he has been a forceful leader in developing tourism into the major industry it is in the state today. For me, this splendid book is a collection of faces and events that vividly bring to mind the exciting times through which we have lived.

Hugh's love of photography began when he was a boy at summer camp. Later, as a staffer for the *Daily Tar Heel* at the University of North Carolina, his subjects ranged far and wide, including his famous photo of university president Dr. Frank Graham pitching horseshoes. He experienced, and he filmed, the violence of World War II as a combat cameraman of distinction, and he captured life behind the lines, traveling with Bob Hope and his show and covering General MacArthur in the South Pacific.

When Hugh came home from the war, he determined, like so many of his generation, that he would spend the rest of his productive years making a difference in the growth and development of the state he loved. He has succeeded in his personal mission, not only as the unofficial state photographer, whose images have graced our billboards and advertisements for our state's natural beauties, but also as a public servant engaged in many ways in the making of the new and different North Carolina that we live in today.

By helping to bring home the battleship *North Carolina*, the most decorated battleship of World War II, Hugh taught the significance of that war to 700,000 schoolchildren, who contributed their dimes to the enormous venture. His photographs of Jesse Helms and Jim Hunt saving the Cape Hatteras Lighthouse, of Congressman Robert Doughton and Sena-

tor Sam Ervin, of Skipper Bowles and his ice cream cone, of that invaluable UNC servant Billy Carmichael, of Sam Ragan and his piled-high desk, and of Andy Griffith and "What It Was Was Football" in Kenan Stadium—all are collector's items. So, too, are the photographs of dozens more Tar Heels who have moved across the public scene.

Hugh covered statewide political happenings and every governor since J. Melville Broughton. His scenes of gubernatorial informality are rare indeed. He photographed presidents who came to visit and national newscasters and journalists—David Brinkley, Walter Cronkite, Charles Kuralt, Charlie Rose, and others—who were here to report the political goings on. Indeed, Hugh once thought of getting into politics himself. Though he stood aside for others, he would have made a fine leader.

Most North Carolinians know that Hugh Morton owns Grandfather Mountain. Being the strong environmentalist and conservationist that he is, Hugh has led major efforts to clean the air, purify the water, protect animals, and preserve the magnificent wildflower and forest legacy so rich and so important to each of us. The fact that the mountain is now a designated global preserve testifies to the quality of his efforts. The Meadows at Grandfather, now famous for the Highland Games, Singing on the Mountain, the ministry of Billy Graham, and the artistry of Arthur Smith and many other mountain musicians, manifests Hugh's consuming desire to preserve the glorious riches of nature and share them with all citizens. Looking at his photographs, it is clear that all of nature's beauties, from the mountains to the sea, have had his personal attention.

Over the years, Hugh has served on many state boards and commissions that have advanced tourism, conservation, and environmental protection. He has also made Grandfather Mountain a major tourist attraction because he has practiced the conservation and preservation he has preached. His animal habitat, whose most popular resident for many years was the beloved Mildred the Bear, merits visiting to see other bears, cougars, bald eagles, deer, and playful otters. The museum of flowers has no equal in its display of the reproductions of the plants of the region.

It was during those early years at camp that Hugh got his first newspaper assignment in sports photography. That began a lifelong career, in which he has covered practically every major sports personality in North Carolina for the last half century. As you visit this part of the book, note how many players, coaches, and events you recognize. They are all here: Choo-Choo, Michael, Catfish, Dean, Mike, and dozens more. Enjoy, enjoy!

The range and scope of competition—scholastic, collegiate, and professional—has become a major part of our culture and economy. Today,

the largest sporting events in the South are stock car races. A single event can attract more than 150,000 fans and produce an economic impact of several hundred million dollars, and Hugh has been there to watch and record it all.

Hugh's wife, Julia, a longtime and hard-working public servant in her own right, has been his constant companion and source of strength in all his endeavors. Their lovely mountain home facing Grandfather Lake is a serene place for nurturing two dynamic people whose lives are expressions of uncommon devotion and unselfish service to North Carolina.

Hugh Morton's North Carolina is a fascinating, important, and thoroughly entertaining book. Every resident of our state will enjoy the splendid, authentic photographic record of the last fifty years found here and nowhere else. Hugh's personal commentary enriches each picture and invites the reader to reflect on and remember a journey shared. All of us are deeply indebted to this noble native son for his lifetime of exemplary service to the Tar Heel State.

William Friday

Preface

My parents gave me my first somewhat primitive camera when I was thirteen and a camper at Camp Yonahnoka in the mountains near Linville. Little did I know then, when I took the camp's photography course in 1934, that photography would become the principal means for expressing my thoughts and fostering my interests for the rest of my life. I had no inkling then of the interesting people and events I would eventually cover, or the host of loyal friends that photography would help me make.

The counselor for photography did not return to camp in summer 1935, and I was notified during the winter that at age fourteen, as a junior counselor, I would be in charge of photography. That sudden responsibility required that I quickly learn everything I could to prepare for teaching young campers to expose, develop, and print their own pictures. My being made the instructor really forced me to learn more about photography, and also it was exciting to see younger campers learning from my instruction. No question, that pushed me deep into photography.

The summertime job as photography counselor at Yonahnoka continued for five more years. In 1940, at nearby Linville, a fourteen-year-old kid from Tarboro named Harvie Ward embarrassed a lot of adults by winning the prestigious Linville Men's Golf Tournament. Burke Davis, sports editor of the *Charlotte News*, contacted the Linville Club for a photograph of Harvie Ward, and I was called to come up from camp to carry out what was my first photo assignment for a daily newspaper. Davis liked my Harvie Ward pictures, and this led to many photo assignments for the *Charlotte News* during my college years at the University of North Carolina in Chapel Hill.

My first published picture for a UNC student publication was of Dr. Frank Porter Graham pitching horseshoes, used on the cover of *Carolina Magazine*. That brought me the opportunity to be on the photo staffs of the *Daily Tar Heel*, *Yackety Yack*, and *The Buccaneer* and its successor, *Tar & Feathers*. Orville Campbell, Ed Rankin, Bill Snider, Louis Harris, and Walter Klein were among the friends I made while working on student publications, and those associations have continued long after college. In

addition to working for student publications, I was kept very busy shooting pictures of the university for Colonel Robert W. Madry, director of the University News Bureau (and also the elected mayor of Chapel Hill).

A good part of the freelance newspaper photo work that came my way during and after college was for the sports department of the *Charlotte News*. Through the years that I worked for the paper, it had an amazing sports staff that included—in addition to now-famous historian Burke Davis—Ray Howe, Furman Bisher, Bob Quincy, Ronald Green, Sandy Grady, and Max Muhleman. On the news side, the paper employed people like Julian Scheer, Charles Kuralt, Pete McKnight, and Tom Fesperman. I was all ears every time I was around any of them. It was obvious that each was already a talented journalist and that every one of them wanted to be better. I also gained valuable experience freelancing for John Derr and Smith Barrier at the *Greensboro Daily News*, Dick Herbert at the *Raleigh News and Observer*, Frank Spencer at the *Winston-Salem Journal*, Carlton Byrd at the *Winston-Salem Sentinel*, and Jake Wade at the *Charlotte Observer*.

The Unites States entered World War II in December 1941. It was apparent that I would soon be in the military, and I wanted it to be in photography. By enlisting, rather than waiting to be drafted, I had a better chance of receiving my preferred assignment. After I enlisted in October 1942, my first posting following Basic Training was in the photolab at the U.S. Army Anti-Aircraft School at Camp Davis, North Carolina, not far from home at Wilmington. Those of us working in the lab not only did photography for U.S. anti-aircraft artillery training manuals, but also did work for anti-aircraft units from Great Britain that were training at Camp Davis. It gave me great satisfaction to know that I was really contributing something to the war effort.

To that point in my life, I had always been a still photographer. That was soon to change, however. When I arrived on New Caledonia in the South Pacific to report to the U.S. Army 161st Signal Corps Photo Company, I learned that one of the combat newsreel photographers for that unit had been killed at Bougainville the previous day. The captain to whom I reported said, "Morton, you look like a movie man," and from that point I did my shooting with a movie camera. After briefly being sent to Guadalcanal and Bougainville, I had the pleasure of accompanying Bob Hope, Frances Langford, and Jerry Colonna as they entertained Army and Navy personnel at installations on New Caledonia.

The 25th Infantry Division was staging on New Caledonia for the invasion of Luzon in the Philippines, and I was made a member of a four-man

photo team assigned to the 25th Division. Fighting was pretty fierce when we went ashore on Luzon. I shot hundreds of feet of movie footage that was shipped directly back to Washington before I was even given a chance to view it. Weeks later, however, reports came back from Washington on the amount of usable footage made by each cameraman, and I was pleased to learn I had a very high percentage of good footage.

In March 1945 I was assigned to cover General Douglas MacArthur when he inspected the fighting by the 25th Division. The war ended on a low note for me personally, however. I was wounded a few days after the MacArthur visit, and later that same day a fellow photographer sat on the edge of my field hospital canvas cot and read me a letter from my mother saying that my father had died unexpectedly of a heart attack. I idolized my father, and losing him, especially on the day that I was wounded, was the low point of my life.

June 30, 1945, the date of my honorable discharge from the Army, is one I will not forget. I imagine every veteran can remember the date of his or her release. I returned to North Carolina, free to work in earnest to photograph the many people and subjects that interested me in our state. North Carolina was at that time flooded with homebound veterans, and when I married Julia Taylor in Greensboro in December 1945, almost all of our groomsmen had served in the military. Returning servicemen came back with a great deal of experience, maturity, and discipline, ready to get to work and put their lives back together.

The arrival of Charlie Justice, also back home from military service, brought great excitement to Carolina football and to me and a crowd of other photographers on the Kenan Stadium sidelines. At N.C. State, Coach Everett Case arrived in 1947 from Indiana to introduce big-time college basketball to the Land of the Longleaf Pine. In the next few years I would get more involved with tourism—this was the time North Carolina took as its slogan "Variety Vacationland"—and have many opportunities to appreciate the state's great natural beauties. It was a great time to be a photographer in North Carolina.

If I were asked to finger the one person who most whetted my interest for making pictures of and for the state, it would have to be Bill Sharpe. He was the head of the North Carolina travel and tourism program, and no person has done it better. Sharpe was an excellent writer and a down-to-earth storyteller and charmer who truly loved our state. And he stayed in touch with the best news photographers at the national level, as well as those within the state. Sharpe worked with Richard Tufts to bring Johnny Hemmer, a topnotch cameraman from the *New York Daily News*,

to work summers for North Carolina and winters for the resort of Pinehurst at a time when neither could have afforded Hemmer year-round. Hemmer was a close friend of another *Daily News* cameraman, Joe Costa, president of the National Press Photographers Association, who had the same standing with news photographers that Babe Ruth had with baseball players. The contacts with Hemmer and Costa led to our Carolinas Press Photographers Association establishing the Southern Short Course in News Photography, which helped upgrade the quality of news photography in the region considerably. My own photography noticeably improved, and the same could be said for that of others who learned from first-class speakers from *Life Magazine, National Geographic,* and other leading publications.

The many good news photographers that I know study each situation carefully, not just for the best angle, lighting, and peak action, but also for how the image will convey the main message of the story. Sometimes the cameraman has to know more about the subject of the picture than does the editor or reporter who asked that the picture be taken. So working as a news photographer broadened my horizons in a number of ways. It added greatly to my education, and it certainly helped build my circle of friends.

Photography led to other types of on-the-job-training. I learned a great deal from fine leaders like Governor Luther Hodges and Governor Terry Sanford, whom I photographed and with whom I worked on several projects. Hodges was a stickler for being on time, for absolutely avoiding conflicts of interest, and for telling the truth even if it might be hurtful to one's own interests. He kept a level head in tense times, as when he made certain no North Carolina schoolchild missed a day of class as a consequence of the Supreme Court decision on integration, while other states, which lacked that brand of leadership, closed schools. Sanford showed real courage in promoting a food tax that was needed for education even though that decision haunted him politically throughout his career. Both men were hard workers who measured every issue and every project with a strict test. It was not "What is best for me politically?" but "What is best for the state?"

My first photography jobs were in sports photography, as I noted above, and that area, too, provided me with lessons for living. The importance of sportsmanship is probably the most valuable lesson one can learn from athletic competition, even surpassing the need for competitiveness itself. The rogues and bums in sports sometimes sell more tickets, but the true heroes in the public eye carry themselves well, and above all they are good sports in their deeds and in their statements. Team-

work, competitive spirit, dedication, and loyalty—you see all of that in sports, and as a sports photographer you are privileged to see it up close and personal. I feel very fortunate, for example, to have been able to observe the devotion Dean Smith continues to show to his former players and the reciprocal loyalty the players have for the coach. This has been an inspiration for me.

My friend since childhood, Rye Page Jr., became publisher of the *Wilmington Star-News* soon after World War II. His strong support of two projects in which I became involved, the Azalea Festival and saving the battleship *North Carolina*, was vital to their success. As one might guess, we leaned heavily on photography. The Azalea Festival was originally the idea of Dr. W. Houston Moore. There were more than a million azaleas total in the gardens of Greenfield Park, Orton Plantation, and Airlie Gardens in 1948 when Dr. Moore nudged the community into celebrating the beauty of those great displays; the people of Wilmington embraced the idea behind the festival, and it is anyone's guess how many millions of azaleas are in the region now. One of my fellow Jaycees, Jimmy Craig, originated the idea that the state should save the USS *North Carolina* from being scrapped, and it is now established as a fitting memorial to the 10,000 North Carolinians who died in World War II.

Along the way in the past twenty years I was sometimes afraid I was spending too much time trying to increase public awareness of the damage air pollution is doing to our forests, streams, and particularly human health. Today it is gratifying that there is widespread understanding of the problem, as was demonstrated by the resounding margin in both houses of the North Carolina General Assembly for passage of the Clean Smokestacks Bill in June 2002. The other half of the job is to persuade neighboring states to enact similar legislation. We know the air pollution from upwind that is crossing our borders is a significant challenge. There is still work to do, and photography can be an important medium for telling the story that must be told.

Going through literally thousands of prints and negatives to choose the images to be collected in this book has afforded me the opportunity to reconnect with some old friends and to remember how fortunate I am to have lived my life in this state and to have been here to record some of the personalities and events that have made this such a remarkable time in our state's history. It has also been a great deal of fun. If you are reminded that North Carolina is a marvelous, interesting place, that will add immensely to the pleasure photography has given me.

The best photographers that I know are ones who know how to work with other people. I see this time and time again, and I believe that some of my best photographs benefited from help of one kind or another from others. I know for certain that this applies to publishing books as well. This book would never have happened were it not for several very kind friends.

Journalist-historian Howard Covington originated the idea for this book. My photography is a mixture of people, sports, politics, events, scenics, and wildlife, and I was not convinced that such a diverse collection would be successful. A stubborn Covington challenged my argument, however, by enlisting the help of Dr. William Friday. Covington knew that I consider Bill Friday the most respected person in North Carolina. Not only did Dr. Friday endorse the idea of the book, the clincher for me was his agreement to help select the pictures the book would include.

When Tom Kenan heard about the work in progress on the book, his reaction was that the book he had not seen, that nobody had yet seen, belonged in every high school library and every public library in the state. At Kenan's urging, his family's William R. Kenan, Jr. Charitable Trust advised the University of North Carolina Press that the trust would fund placement of the book in every one of the aforementioned libraries. I am overwhelmed by Tom Kenan's belief in the merit of the book and his confidence in those of us who have worked to make it a reality.

In addition to those already mentioned, a number of folks need to be thanked for their essential contributions to this book. Ed L. Rankin Jr. has always been the guy I have leaned on when checking facts about North Carolina, but I have also relied on Dr. H. G. Jones, Dr. Bob Anthony, and Jerry Cotton at the North Carolina Collection at Wilson Library in Chapel Hill. The staff at Grandfather Mountain was key to locating many of the photographs, scanning them for printing, and typing copy. Principal among them were Jim Morton, Sabrina Stout, Sandy Wilkins, Lou Ella Hughes, Catherine Morton, and Harris Prevost. Last and certainly not least, the marvelous staff of the University of North Carolina Press, directed by Kate Torrey, has been a true pleasure to work with. In particular, David Perry, the editor in chief of the UNC Press, and Ron Maner, the managing editor, were instrumental in moving the project forward. To all of these friends I say a loud and clear thank you.

Hugh Morton

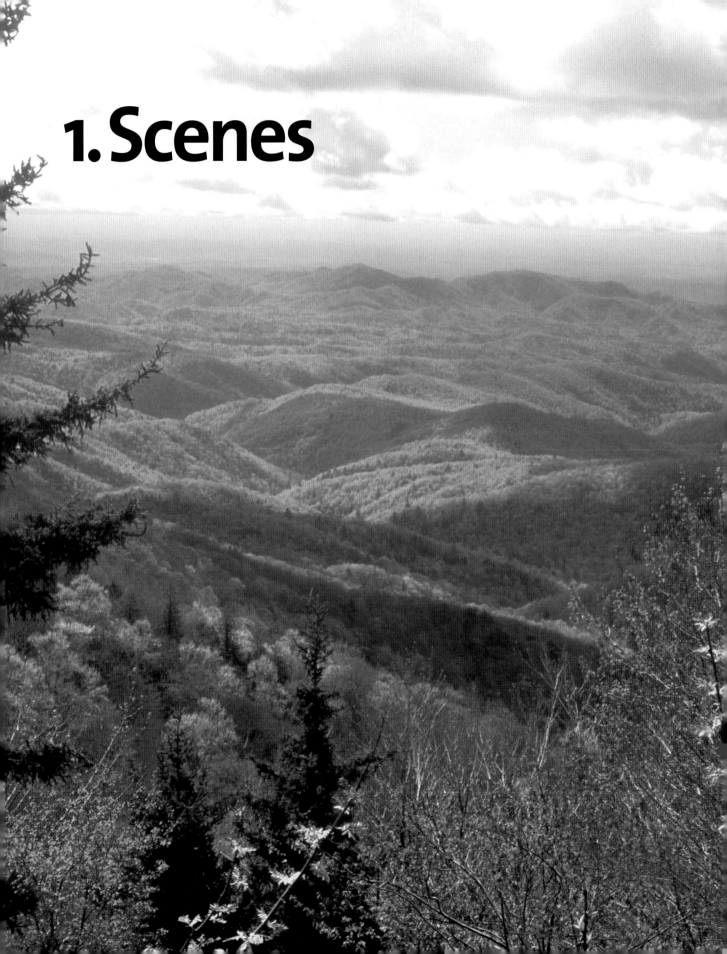

1. Scenes

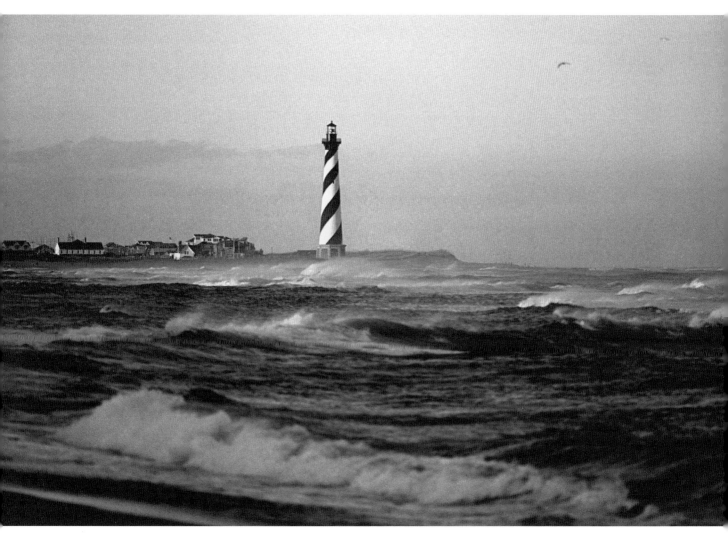

Of the hundreds of pictures I have taken of Cape Hatteras Lighthouse, this is my favorite. North Carolina lost a lot when the lighthouse was moved half a mile to its new site in the bushes by a cell tower. It's good that it did not crumble during the move but sad that it is no longer structurally sound enough for visitors to climb the stairs. The Golden Gate Bridge, the Statue of Liberty, and Cape Hatteras Lighthouse were America's most famous coastal landmarks, but it's hard to count the lighthouse in that company now. I was disappointed by the lack of earnest official effort to protect Hatteras Light at its historic site.

Hatteras Island on the Outer Banks is known for the many shipwrecks that occurred on its beaches or on the shoals offshore. The Graveyard of the Atlantic Museum at Hatteras Village, slated to be completed in 2004, will devote itself exclusively to the history of the more than 2,000 ships that wrecked in the turbulent seas off the Banks.

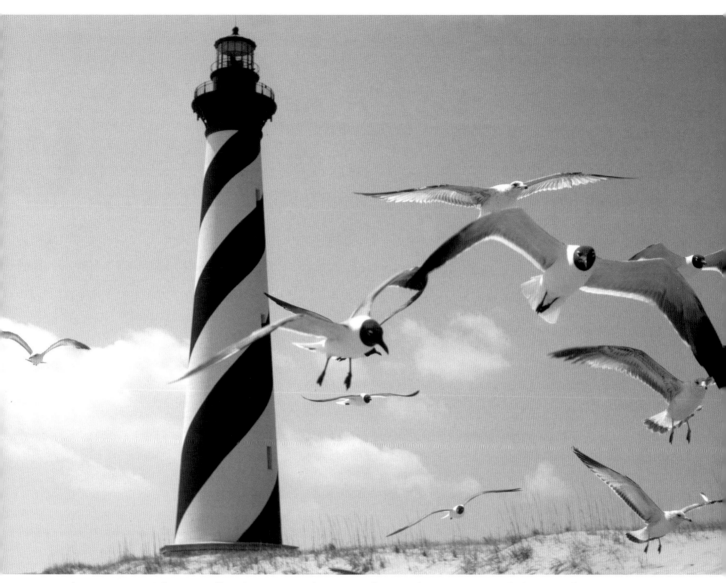

When Hatteras Light was still at the water's edge, it was fun to take its picture with the seagulls. First you buy a loaf of bread; then you go to a spot on the beach that is directly upwind from the lighthouse, break the bread into small pieces, throw the pieces into the wind, and seagulls will come soaring.

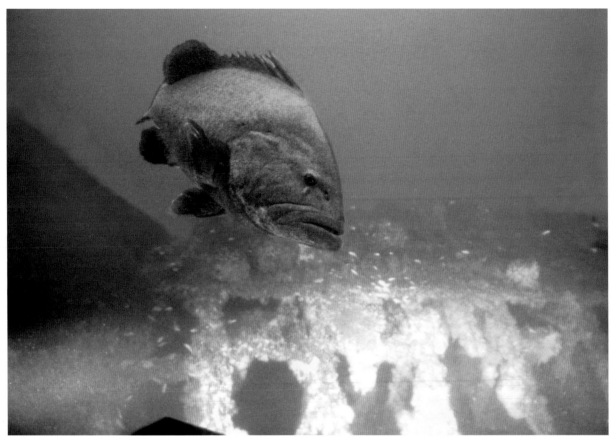

The USS *Monitor*, which rests 220 feet below the surface of the sea fourteen miles off Cape Hatteras, is probably the most famous shipwreck along the North Carolina coast. Governor Jim Hunt made me a member of the commission to study the feasibility of raising and preserving the wreck of the *Monitor*, and in that capacity I went down to view the wreck in a two-passenger submarine. Since my friend and business associate John H. Williams had taken me on an exciting trip north of the Arctic Circle when his company was building the northern third of the Alaska Pipeline, I decided to return the favor by inviting him to join me in inspecting the remains of the world's first ironclad battleship. As a practical matter, I figured his engineering expertise and his naval experience as a Seabee during World War II would be useful in helping me appreciate what we would see and come to a conclusion about what the state should do. It was immediately apparent that what remained of the historic ironclad was in no condition to be raised and restored. Americans mistaking the wreck for an enemy submarine had dropped numerous depth charges on the *Monitor* during World War II, leaving it in multiple pieces, now covered with barnacles and rust. We left the *Monitor* in the protection of a big grouper, who seemed to feel that it was rightfully his territory anyway.

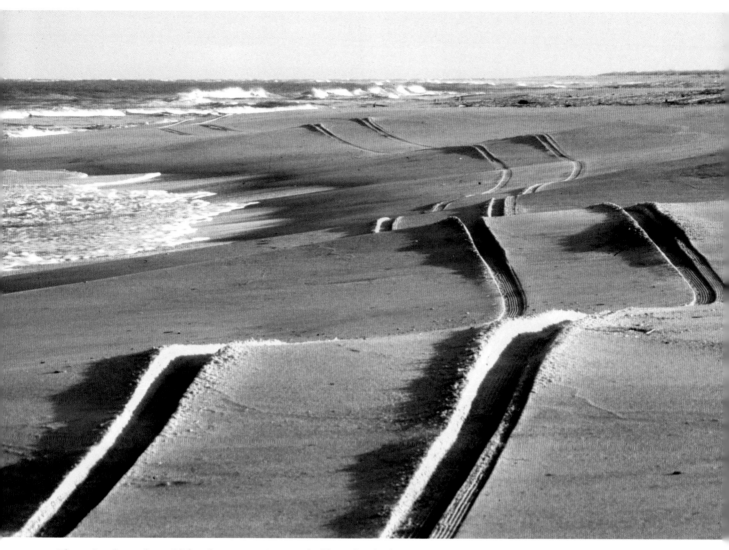

There is a lot to be said for the convenience of off-road vehicles when it comes to hauling fishing rods, coolers, or heavy camera gear. But this photograph of Bald Head Island could also be used as evidence by the folks anxious to protect the fragile shoreline for nesting turtles and other sea life. Leaving the earth better than when we found it may be a goal that seems impractical and unachievable, yet it is undoubtedly a worthwhile mission.

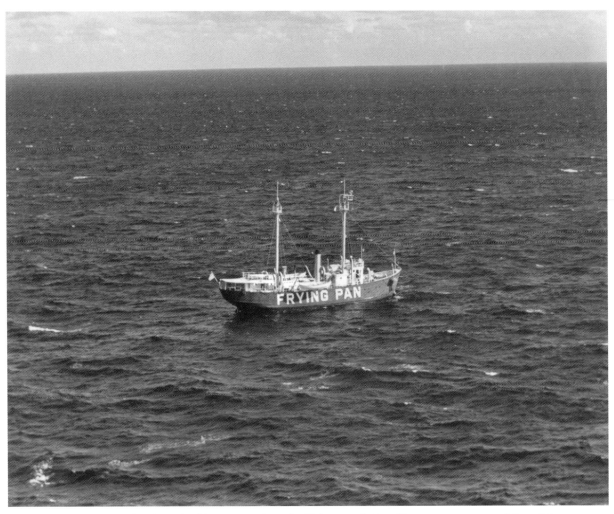

For years Frying Pan Shoals Lightship was anchored off the North Carolina coast to warn ships of the shallow shoals and point to the proper channel for the Cape Fear River. My childhood friend Ben Washburn, who in World War II had been a pilot in the Navy and a colonel in the U.S. Air Force, rented a Piper Cub to fly me offshore for this picture. When we headed home, the northeast wind blew the light plane further to the south than we realized. We barely had enough gas to make it back to the airport at Wilmington.

(opposite)
Photographers who appreciate the way the columns of historic Orton Mansion are perfectly framed by the limbs of a magnificent live oak are indebted to the late J. Lawrence Sprunt. One day as he and I strolled along the walkway in front of the mansion, I casually mentioned that the best view of his lovely home was blocked by a twenty-foot-high camellia bush. A week later when I went back, the camellia was gone. Now each time I visit Orton Plantation it rekindles fond memories of J. Lawrence Sprunt.

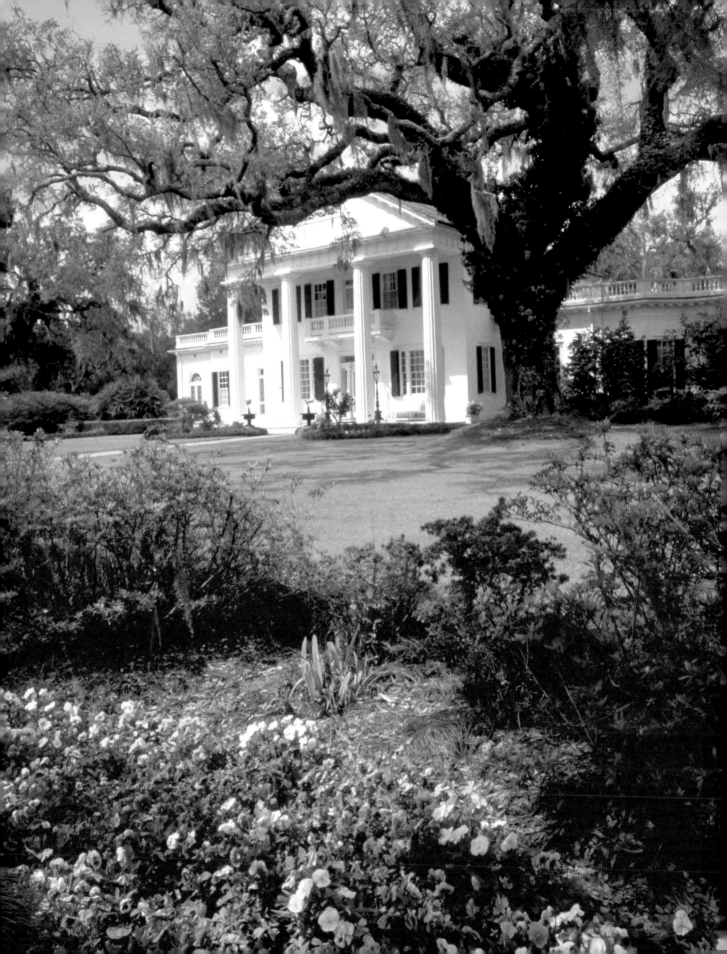

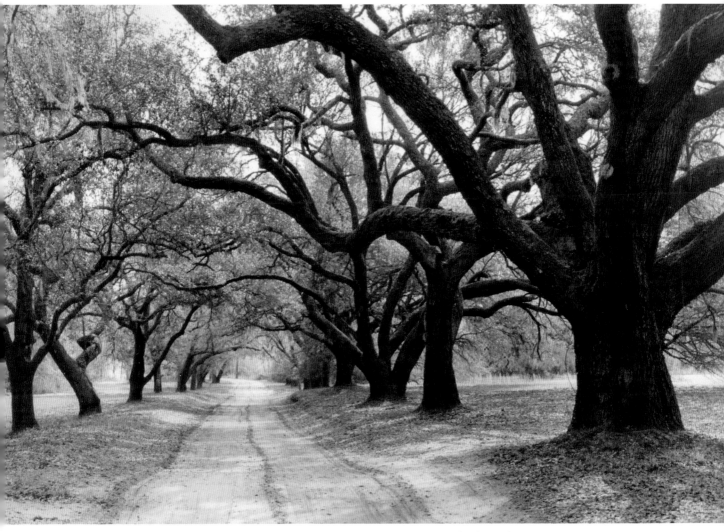

The arch of live oaks that frames the entrance to Orton Plantation north of Southport appears more natural because the Sprunt family, which owns the plantation, wisely has not covered the sand road surface with asphalt.

(opposite, bottom)
In 1948, when Wilmington was promoting its first Azalea Festival, very few North Carolina newspapers were using pictures in color, so this black-and-white photograph of azaleas and cypress trees at Greenfield Gardens Municipal Park got wide use in the upstate papers. The festival's slogan, "More Than One Million Azaleas," took advantage of the total number of plants at Airlie Gardens, Orton Plantation, and Greenfield Gardens. Private property owners were urged to plant azaleas as well, and five decades later it would be difficult to say how many millions of azaleas are in the Wilmington area now.

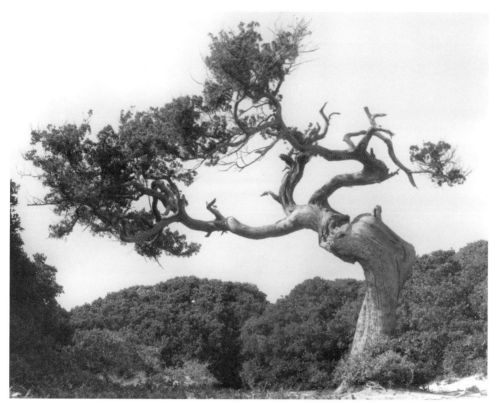

Native Outer Bankers call the Atlantic white cedar by the name juniper. This particular cedar was on Ocracoke Island between the ferry landing and Ocracoke Village. A serious student of the history of the area, Danny Couch of Buxton, says he fears the tree is no longer there. It clearly came through some severe coastal storms in its lifetime.

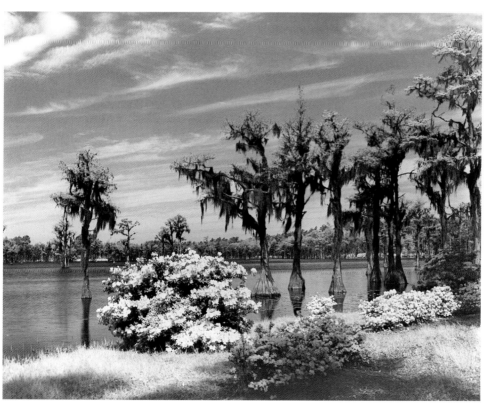

The wild horses on the Outer Banks are descendants of those that went wild after the ships transporting them wrecked on the Banks in the nineteenth century. The relatively large herd here excites visitors to Shackleford Banks near Beaufort and Morehead City.

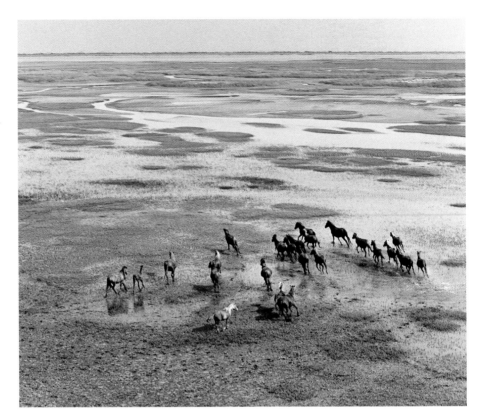

On hot summer days fifty years ago it was not unusual to see Outer Banks ponies cooling themselves and avoiding biting insects in Ocracoke harbor. Today the National Park Service frowns on such freedom for the ponies.

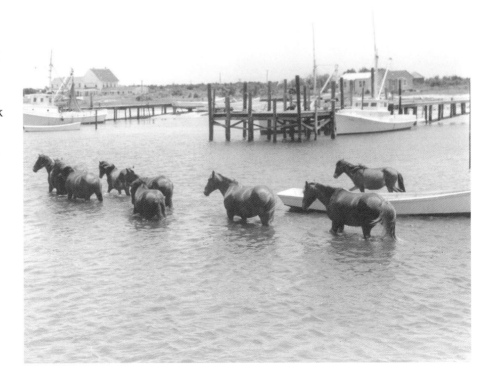

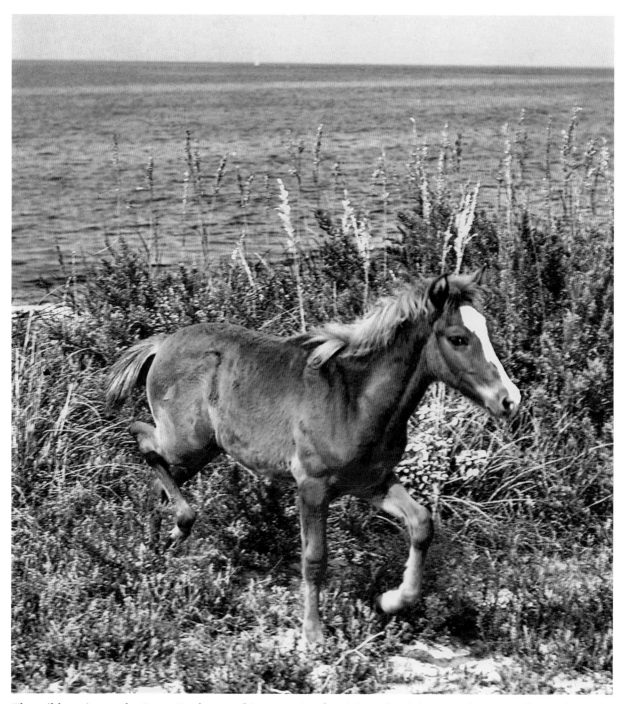

The wild ponies on the Outer Banks are a big attraction for visitors, but it is somewhat rare to be as close as I was to this one. The ponies seem to take care of themselves very well in the wild. The main threat to their well-being is government officials, who have conducted several highly unpopular campaigns to get rid of them. I hope good judgment will continue to prevail, so that wild horses will add appeal to the Outer Banks for years to come.

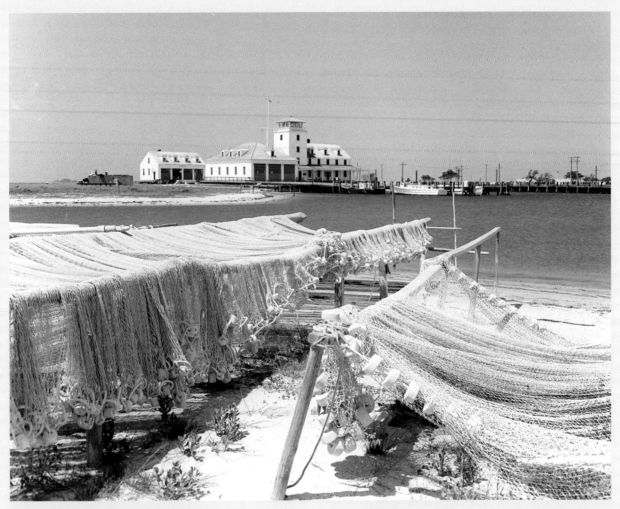

Commercial fishermen's nets drying in the sun on the waterfront add charm to the village of Ocracoke on North Carolina's Outer Banks.

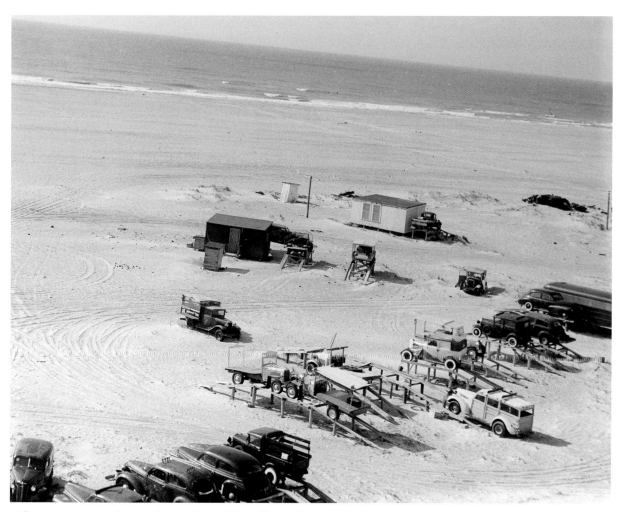

Fifty years ago on the northern edge of the village of Ocracoke there was a colony of dune buggies, parked on raised platforms to avoid damage from high tides. The dilapidated vehicles were used mainly by sports fishermen to reach locations on the beach. There were no roads on Ocracoke Island at that time.

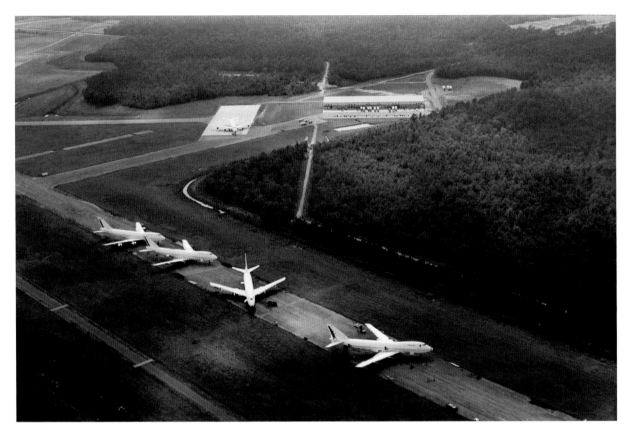

The North Carolina Global TransPark at Kinston overcame formidable hurdles to build one of the longest civilian airport runways on the East Coast. Roads now under construction will give the TransPark excellent connections with the interstate highway system. Industry leaders believe that the TransPark is now in a position to thrive. Jobs at the TransPark itself and in nearby industries it will attract are expected to boost the economy of the region and the state, and the TransPark will be an important asset for the nation's defense.

(opposite, bottom)
Times do certainly change, for dwarfed now by skyscrapers and completely in their shadows is the Sir Walter Hotel (in the center of the photo, just to the right of the tall white building), once, for all practical purposes, the State Capitol of North Carolina. A substantial number of legislators roomed in the Sir Walter during sessions of the General Assembly, and many statewide campaigns for political office or other causes were headquartered in the hotel. Lobbyists knew that the Sir Walter coffee shop or lobby would be the place to find most of the people they wanted to see. Raleigh has grown tremendously, but no single new residential or meeting facility can match the political influence of the Sir Walter in days gone by.

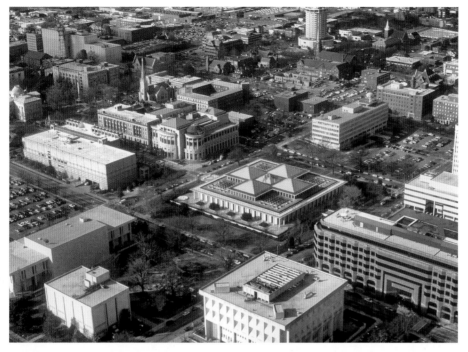

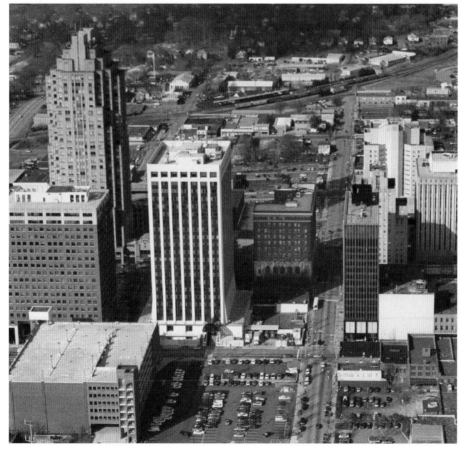

In the course of the year more visitors and school groups converge on the four-city-block complex of buildings in this aerial view of downtown Raleigh than on any area of similar size in the state. The building with the green roof in the center is the State Legislative Building, and the green-topped building at the upper left is North Carolina's State Capitol. Between the Capitol and the Legislative Building are the light-colored North Carolina Museum of History and the cream-colored North Carolina Museum of Natural Sciences. Other buildings around the perimeter contain the Capitol Area Visitor Center, the State Archives and State Library, the North Carolina Division of Travel and Tourism, and various state offices.

The area around the Old Well in Chapel Hill was hallowed ground when I was in school at UNC in the early 1940s, but it was not nearly as well landscaped as it is today. Now dogwoods, azaleas, and other flowering plants bloom in mid-April, and at that time the Old Well is at its best.

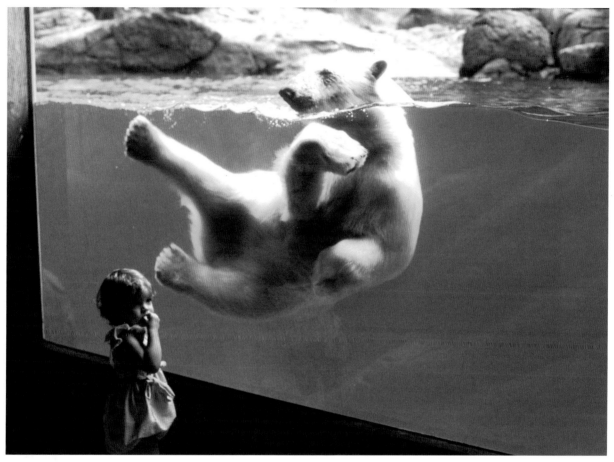

The polar bear habitat at the North Carolina Zoological Park at Asheboro is one of the finest such exhibits anywhere. This polar bear did a U-turn at the window, right in front of a young visitor.

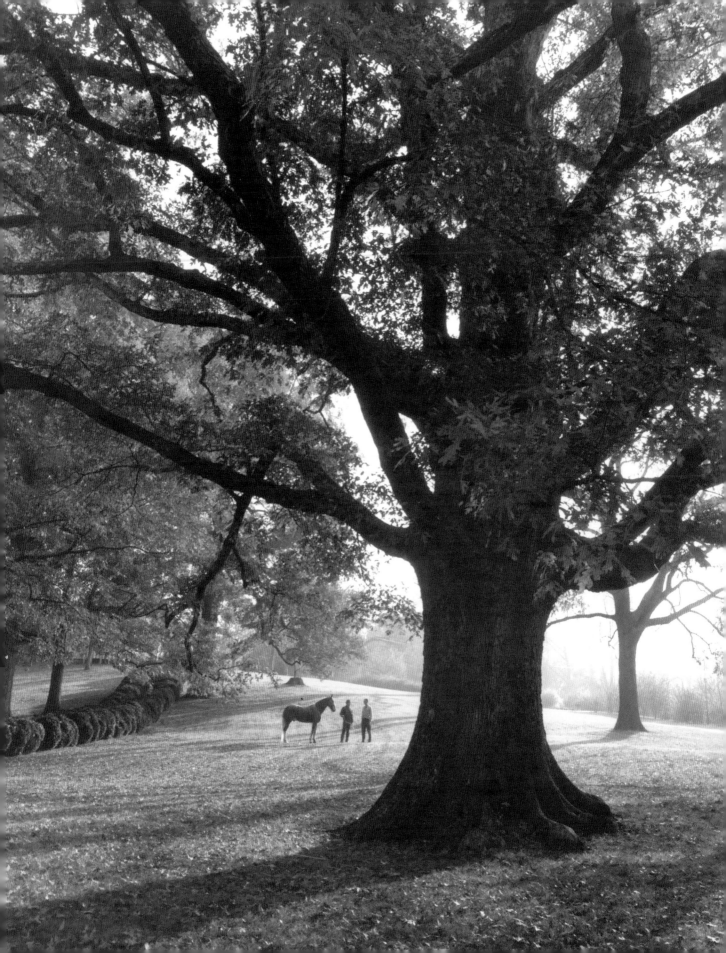

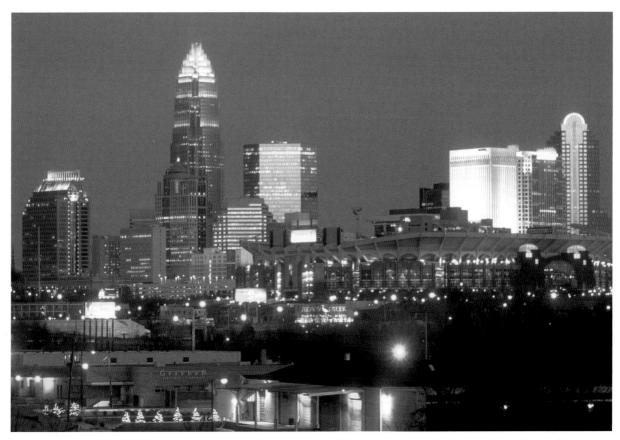

This photograph of the Charlotte skyline at dusk was made from a park beside the WBTV studios. I like this picture, but it is not my favorite one of the Charlotte skyline. (For the one that is my favorite, see the next photo.)

(opposite)
Years ago, I gave this photo to the North Carolina Tourism Office, and I still see the picture in the lobbies of rest stops across the state. I took the photo at Tanglewood Park near Winston-Salem. A brochure promoting tourism in the ten southeastern states, however, mistakenly stated that the scene was in Camden, South Carolina. North Carolina tourism officials kidded their colleagues in South Carolina for being so short of scenic views that they had to swipe one from North Carolina.

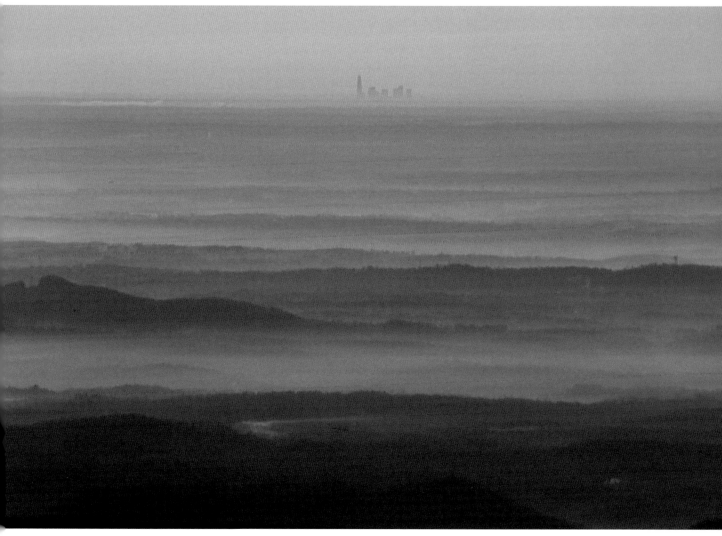

My favorite picture of the Charlotte skyline was made from a spot near the Mile High Swinging Bridge on Grandfather Mountain. According to FAA air maps, Charlotte is 87 air miles from Grandfather. I took the picture in mid-December when a cold front had just cleared the air. It would be exciting to have air quality like this every day, but unfortunately this sort of visibility is rare.

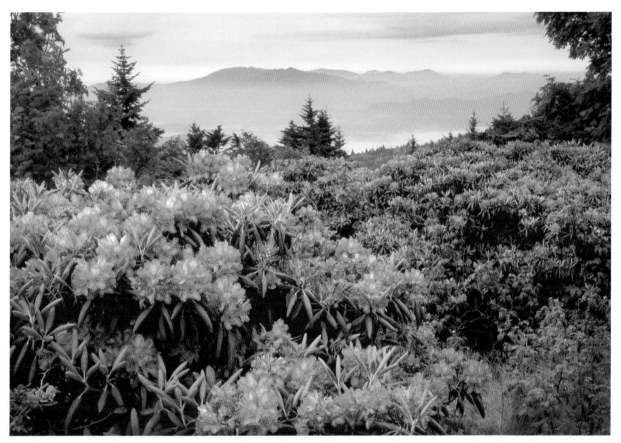

The largest natural red rhododendron garden in the world is on top of Roan Mountain, where the North Carolina–Tennessee state line runs along the crest of the ridge. Most of the garden is located above 6,000 feet in elevation, which makes the peak of the blooming season there June 20 and later.

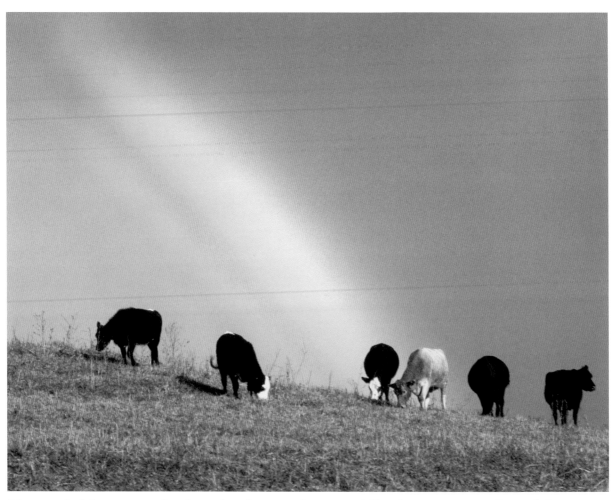

Pictures of rainbows cannot be planned, and one needs to act quickly when one appears. I rounded a curve on N.C. 18 between Morganton and Shelby, saw this one, and grabbed the camera just in time. The cows were still there seconds later, but the rainbow was gone.

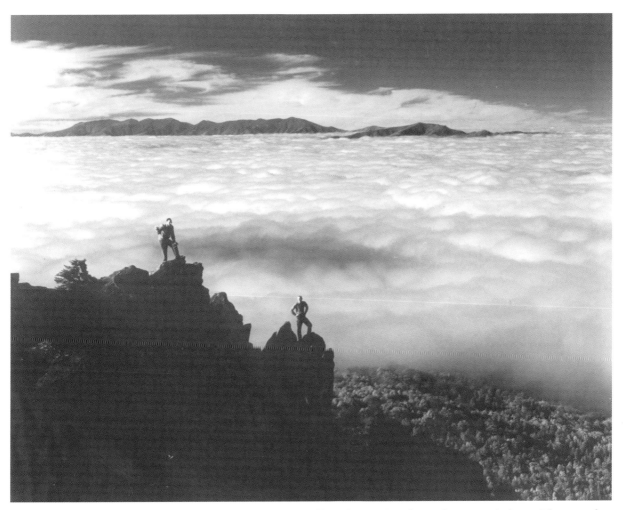

Kodak infrared film was not easy to use, but it was excellent for cutting through mountain haze. The sea of clouds behind these people on Grandfather Mountain stretches all the way to the Black Mountain Range and Mount Mitchell.

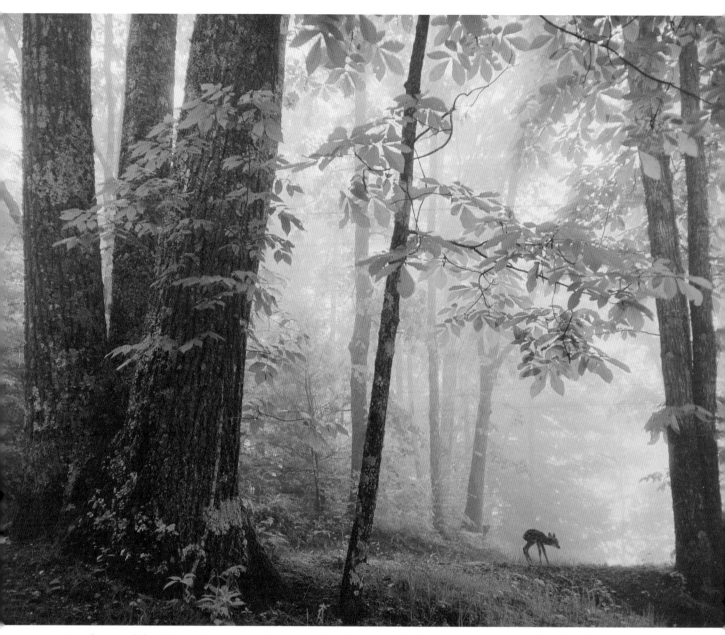

I understand that it is not unusual, when a doe has fawns for the first time, for her to abandon the second one born. My wife Julia and I bottle-fed this abandoned fawn in our home for three days. When the first fawn died from birthing injuries after three days, though, Julia and I presented the second-born fawn to its mother, and she welcomed it.

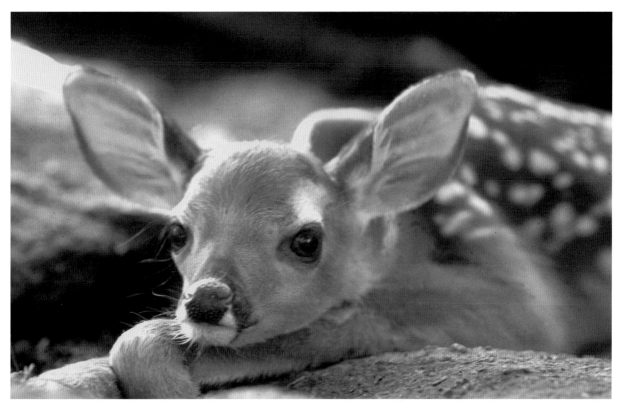

A whitetail fawn that is less than one day old, its ears backlighted pink by the afternoon sun, provides an adorable sight.

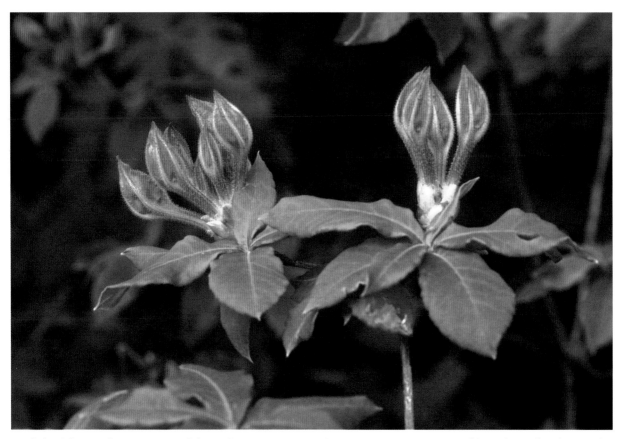

André Michaux, the great French botanist, came to America over 200 years ago, seeking plants for the royal gardens at Versailles. He had a letter of introduction to the president of the United States, George Washington, from General Lafayette, and Benjamin Franklin and Thomas Jefferson helped Michaux transport his plants back to France. Michaux identified and named some 300 plants in the Carolinas, including the plant whose buds look like a flame, the flame azalea. Some of Michaux's other plants are among the best-known in North Carolina, including buttercup, fringed phacelia, spring-beauty, Catawba rhododendron, Carolina rhododendron (also known as Punctatum), giant chickweed, umbrella leaf, large-flowered trillium, and ironweed.

(opposite)
The bud of *Rhododendron maximum* (white rhododendron) is beautiful even before it begins to flower, yet catching the first flower open from the bud was a lucky unplanned event that added beauty to this photograph.

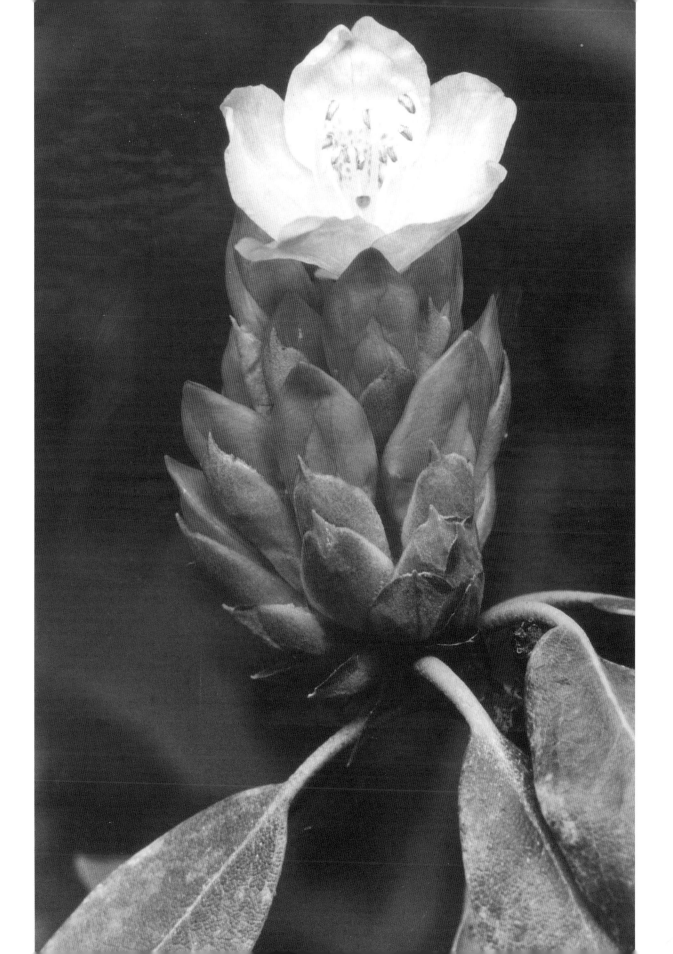

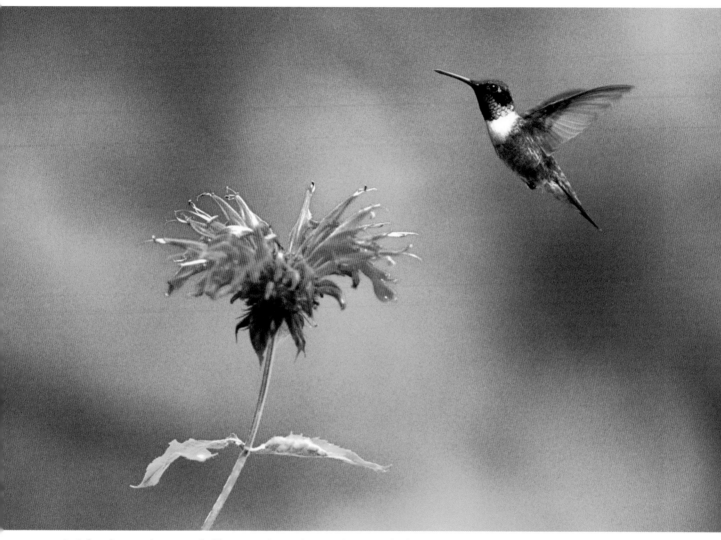

It is hard to say how much film I ran through over the years before I succeeded in photographing the male ruby-throated hummingbird in flight. Unless light is coming from the right direction, his throat shows up black; a shutter speed of at least 1/1000 of a second is needed to stop the wing action; and the blossom of Oswego tea is a nice complement. Bringing all of these elements together in one picture was for me a happy moment.

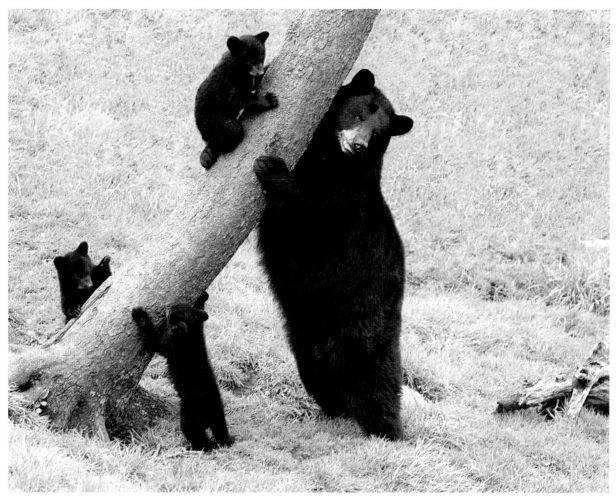

Over the years Jane the Bear had fourteen cubs, a record for the Grandfather Mountain habitat. She was extremely protective of her cubs, which meant that I had to use my 300mm telephoto lens to make this picture. One cub appears to be helping Jane prop up the leaning tree while the other two cubs are climbing on it.

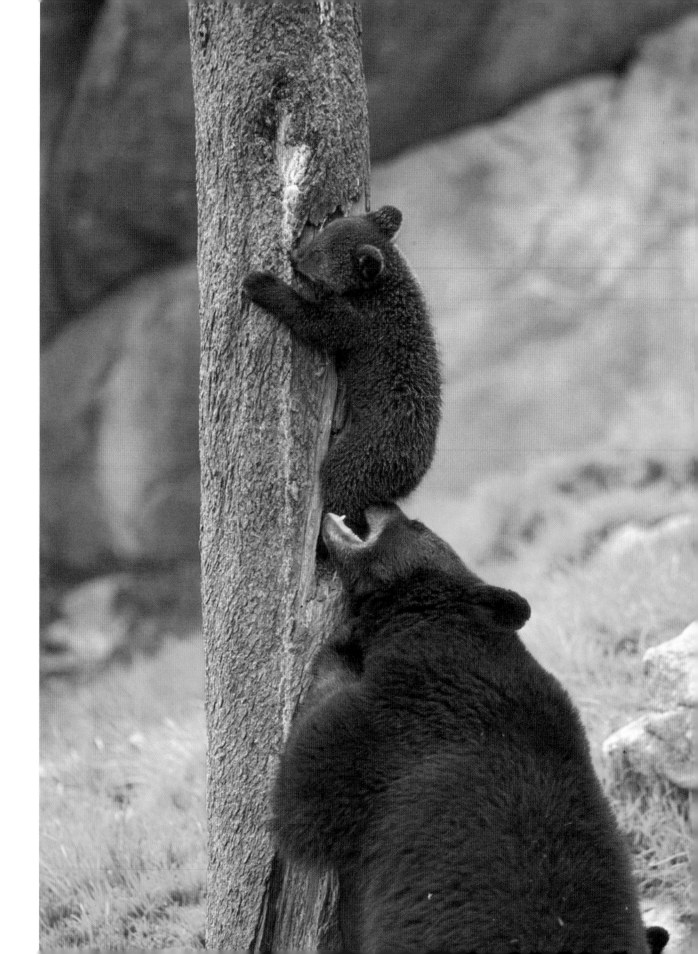

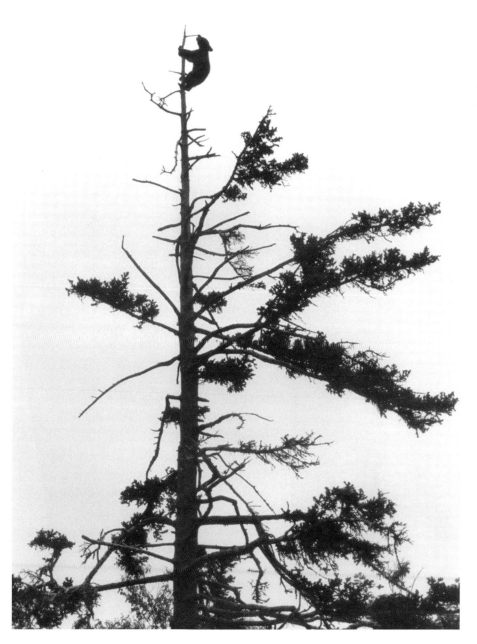

Black bear cubs are as bold and mischievous as the young of any species. Every tree is a challenge. They will climb to the tip-top, and they scramble down backwards. Older bears can climb too, but they do not climb nearly as often or as high because their weight will not allow it.

(opposite)
Jane the Bear is teaching her cub to climb a tree. I know I would have learned to climb a tree sooner if I had had this kind of encouragement.

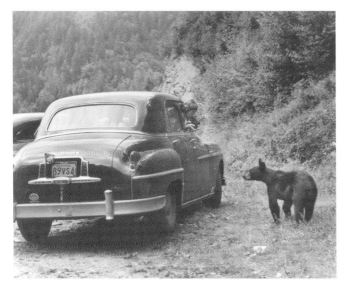

(top)
This visitor to the Great Smoky Mountains National Park in the 1950s was shooting movies of a black bear that probably expected food. Bears are less plentiful now in the Great Smokies, but they can still cause a real traffic jam when they show up beside U.S. 441, which runs through the park.

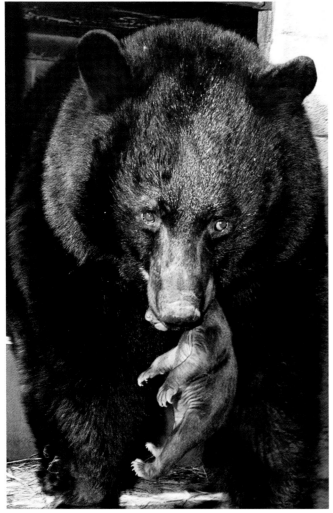

(bottom)
The eyes of a black bear cub do not open for forty days after birth, and during that time the mother bear picks the cub up by the head when she needs to change locations. The day I made this photograph of Mildred, our longtime mascot at Grandfather Mountain, I learned that bears have remarkable peripheral vision, because one of Mildred's eyes was aimed straight ahead at me and the camera and the other eye was on Grandfather Mountain manger Robert Hartley, who was near me at my right. Over the years, Mildred had ten cubs of her own and three she adopted. The one she is carrying in her mouth was named Honey.

(opposite)
Dr. Lynn Rogers, America's leading authority on the black bear, dealt with more than 400 bears in his research, including one he named Gerry, short for Geraldine. Gerry was unafraid of humans, and when Rogers retired to his sleeping bag at night, the bear would curl up beside him. When the study ended, wildlife officials in Minnesota feared a bear unafraid of humans would cause trouble, and they actually thought of putting her to sleep. Rogers arranged to bring Gerry to Grandfather Mountain's bear habitat, where she and the public would be safe. When Rogers visited a year later, Gerry immediately recognized the wildlife scientist. The way she embraced him proves to me that a wild animal, the same as a faithful dog, can love a human friend.

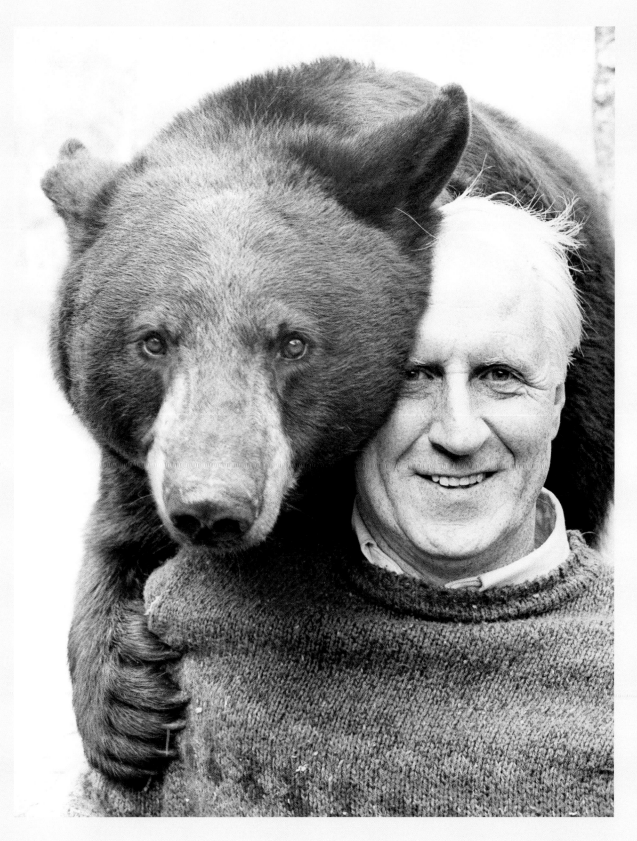

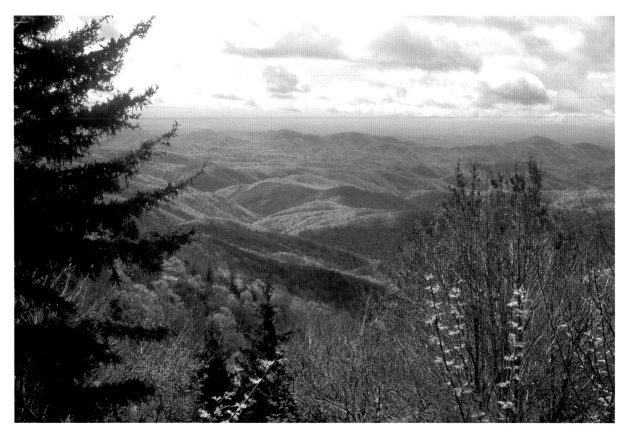

Watching the transition of spring beginning in the valley and gradually working uphill to the higher elevations is always exciting. Here the budding red maple at Stack Rock Creek Bridge on the Blue Ridge Parkway dominates the foreground. In the green foothills below spring is already well established.

(opposite)
The zigzag split rail fence has always been popular in the mountains. Just as popular are two of André Michaux's great discoveries of 200 years ago, the Catawba rhododendron and the flame azalea.

Partridge berry, growing alongside shortia, one of André Michaux's botanical discoveries, adds brilliant color to this photo.

Huckleberries are the delight of bears and other wildlife when they ripen in July and August. The purplish blue ones are ripe, and the pink ones will ripen soon.

(opposite)
The wild pink *Azalea vaseyi* were in bloom at a lower elevation overlook on Grandfather Mountain, where the hardwoods were already beginning to be green, when I took this photo. Spring had yet to arrive at Linville Peak, elevation 5,350 feet, in the upper right of the photograph. There the hardwoods were still dormant.

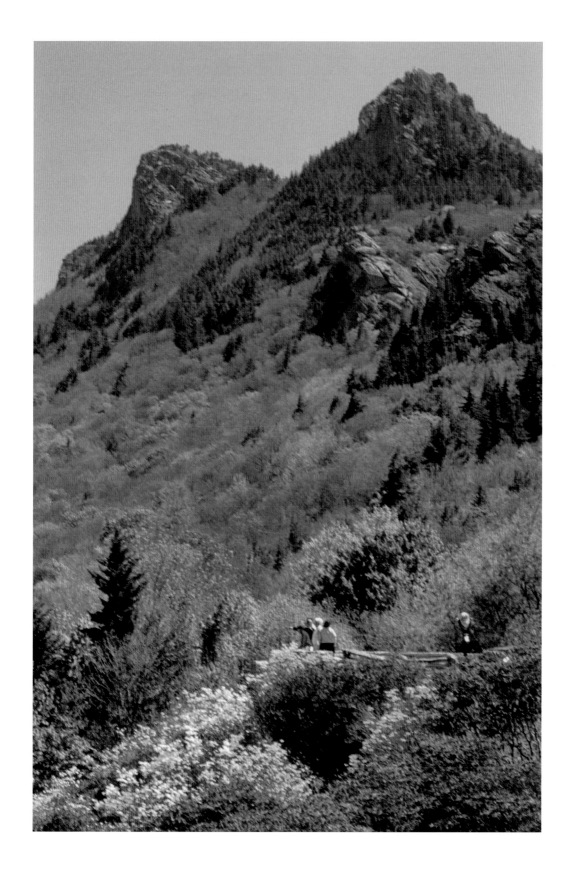

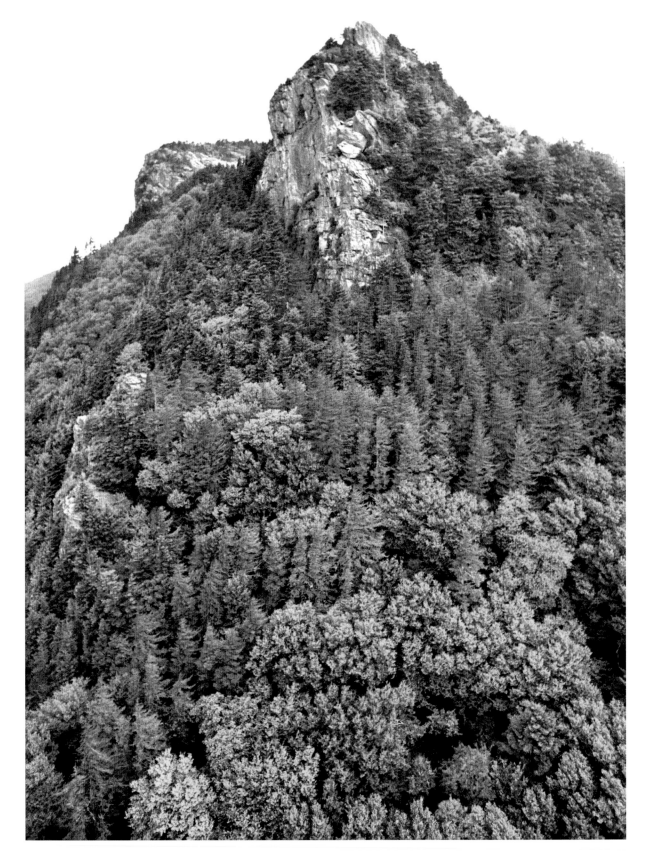

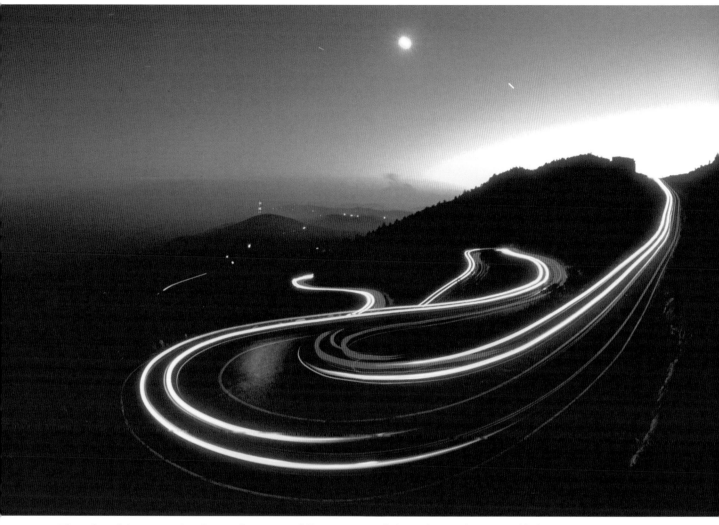

The advertising agencies that make automobile commercials love the road up Grandfather Mountain, because the camera can follow the cars around several curves from a single location. Bill Hanna, Grandfather's security guard, and I had fun making this picture. He drove my car up and down the road while I stayed at the camera to open the shutter for a time exposure.

(opposite)

In Spring 2001 the hardwoods at 5,000 feet on Grandfather Mountain leafed out in pale green, revealing a great number of newly killed red spruce. To the surprise of the U.S. Forest Service and almost everyone, the spruce had been killed by the southern pine beetle, a pest that had never before survived the winter cold to kill trees that grow only at elevations of 5,000 feet and higher. The spread of the pine beetle on Grandfather as well as Roan Mountain and Mount Mitchell is further evidence that global warming is a reality.

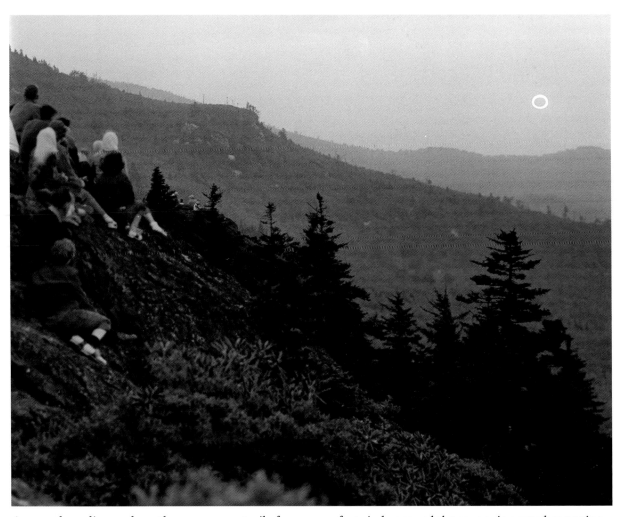

An annular eclipse, where the sun momentarily forms a perfect circle around the moon, is a rare happening. One occurred on September 1, 1951, and the only time to see it was right at sunrise. Grandfather Mountain was the highest point in the United States in the direct center of the annular eclipse path and therefore the ideal location from which to view the eclipse. In 1951 the road did not extend to the crest of the mountain, so those who saw the eclipse at Grandfather had to make a rugged hike in pitch dark.

Army helicopter pilots preparing to go to Vietnam needed a place to practice landings and takeoffs in the thin air of high elevations, so Grandfather Mountain roped off its parking lot near the Mile High Swinging Bridge to facilitate that training.

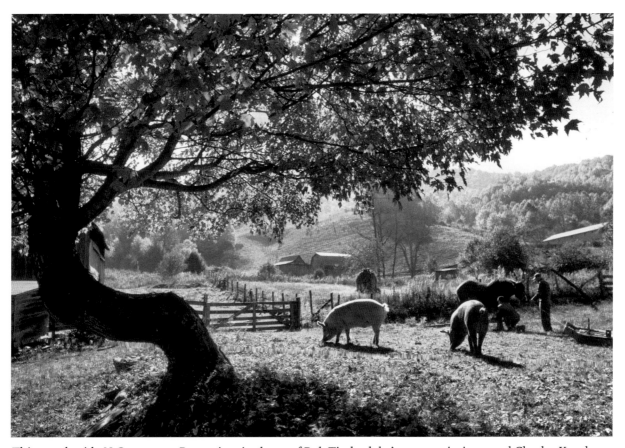

This spot beside N.C. 105 near Boone inspired one of Bob Timberlake's great paintings, and Charles Kuralt and Loonis McGlohon used this photograph for the cover of the audio version of their tribute to their native state, "North Carolina Is My Home." The pigs may be hogging the foreground, but that did not bother Charles. He particularly liked the sled and the two men shoeing a horse.

(opposite)
I have asked a few friends, "If you were me, would you admit that you built this road?" Most of them have said they like it, but some have suggested that I keep quiet about who built it. It is a stretch of the road leading to our house from Linville.

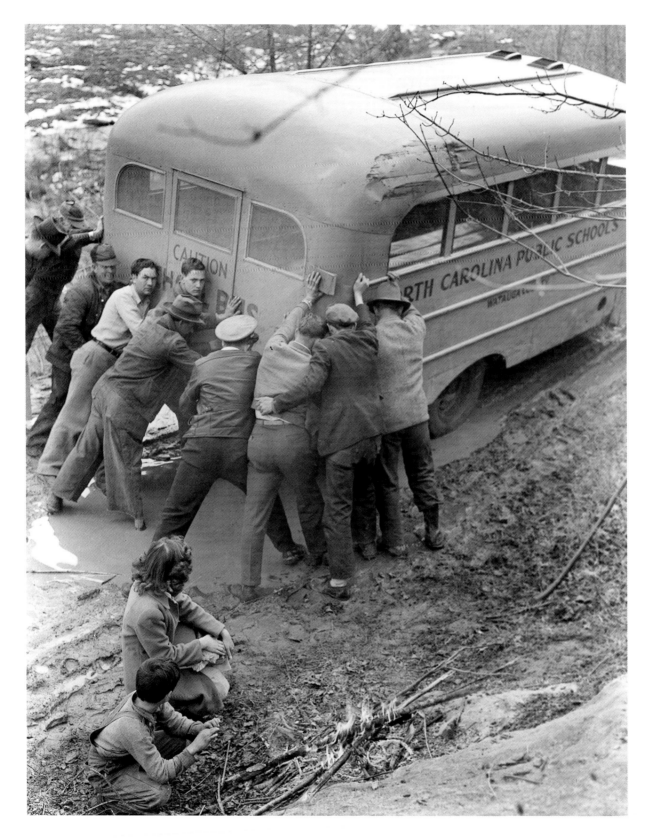

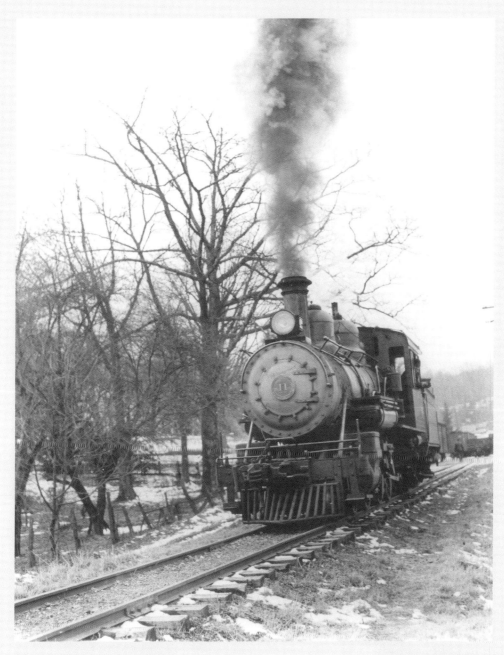

When a flood washed out its track in 1940, the East Tennessee & Western North Carolina Railroad reached only as far as Elk Park, North Carolina, rather than its former destination of Boone. The shortened rail route was soon abandoned entirely, and the engine and some of the cars became a part of the Tweetsie Railroad tourist attraction at Blowing Rock.

(opposite)
After a big flood in 1940 washed out rail connections between Boone and Johnson City, the community of Foscoe became virtually isolated from the rest of the world. It was not unusual to see students warming by a fire at the edge of the rutted road while sturdy folks rallied to push the school bus out of the mud on what is now N.C. 105, one of the most traveled roads in the mountains.

In 1952 Avery County sheriff Wilburn Hughes (left) and his deputies wrecked a rather large still in the Pisgah National Forest on the lower slope of Grandfather Mountain. Employment in moonshining dropped off considerably when the state established its ABC stores for the controlled sale of alcoholic beverages.

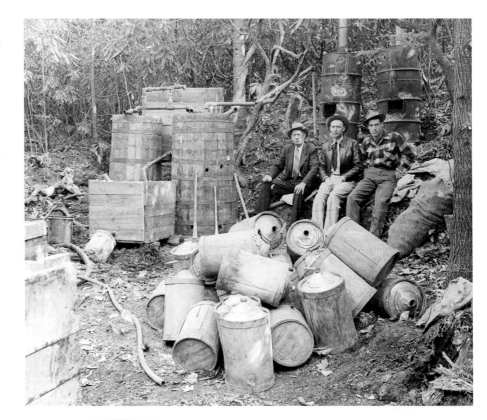

Burley tobacco, grown in North Carolina's mountains, is harvested differently from the bright leaf tobacco of piedmont and eastern North Carolina. Burley is placed on stakes to dry in the sun prior to additional curing in barns. This scene is in Watauga County.

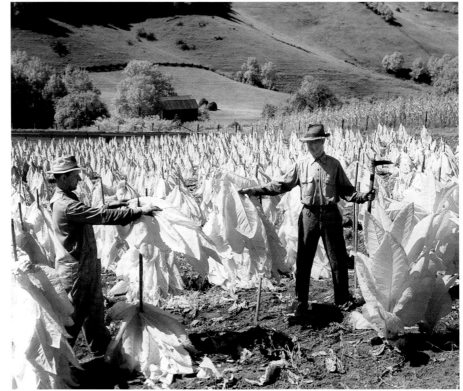

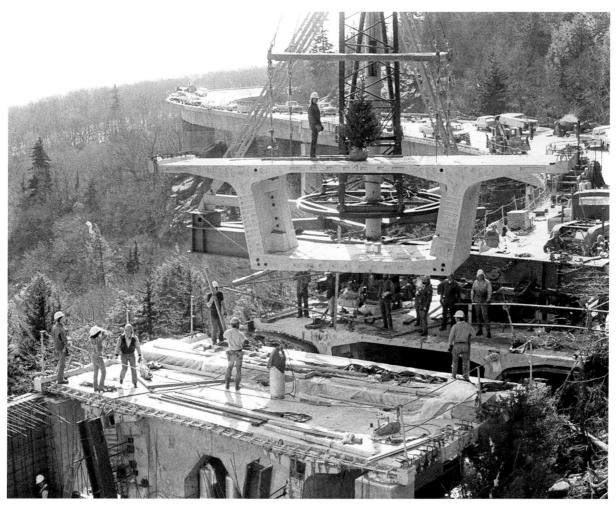

The Blue Ridge Parkway Viaduct was constructed with 153 fifty-ton precast concrete segments, and it was a happy day when number 153 was hoisted into place. The National Park Service, which has a reputation for sometimes being hard to deal with, would not allow Jasper Construction Company to cast the huge parts on parkway property, so my family cooperated to clear a site for that work on our land nearby. Jasper worked with an engineering tolerance of 4/1,000 of an inch in forming the big segments, and not a single one of them was rejected.

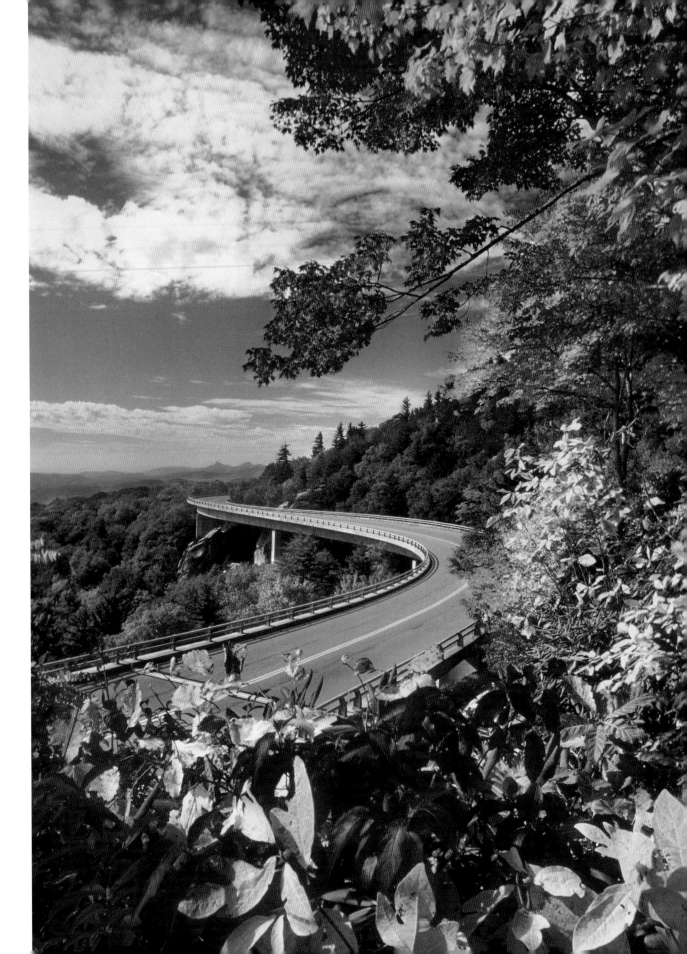

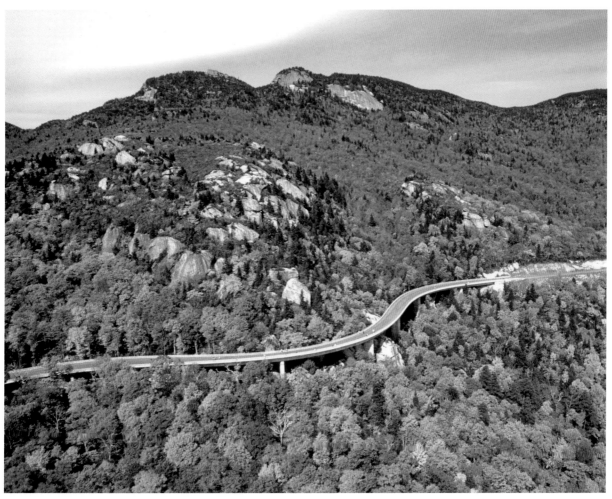

Precast segmental bridges like the Blue Ridge Parkway Viaduct had been constructed earlier in the French and Italian Alps, but the viaduct on Grandfather Mountain was the first such structure in the United States. The National Park Service won twelve national awards for the beauty and design of the viaduct, a cantilevered span that devoted special attention to protecting the natural beauty of the mountain.

(opposite)
There is perhaps a greater variety of fall color immediately above and below the Blue Ridge Parkway Viaduct than at any other place in the North Carolina mountains. A profusion of red is provided by gum trees, maples, and huckleberries, with yellow added by birch, beech, poplar, and sassafras. This picture appeared on the cover of the 2000 Rand McNally Road Atlas of the United States, Canada, and Mexico.

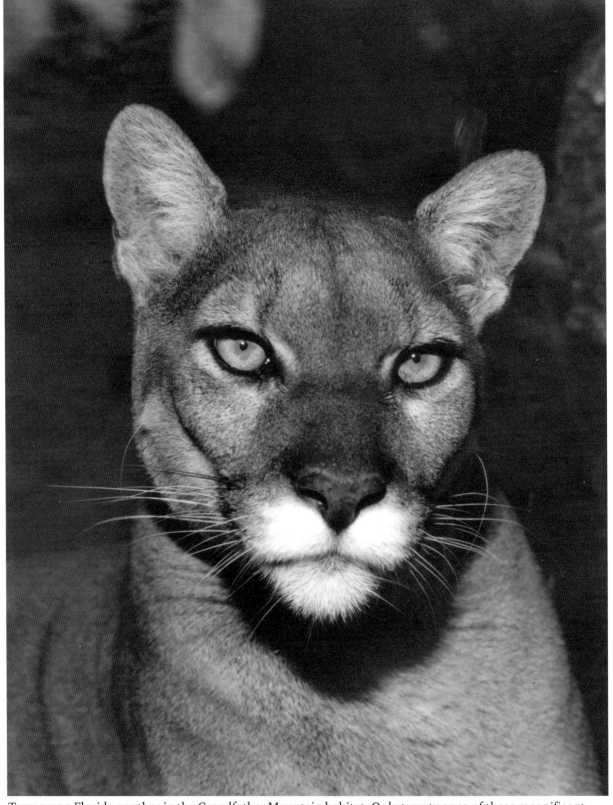

Terra was a Florida panther in the Grandfather Mountain habitat. Only twenty or so of these magnificent animals remain in the wild in Florida. The U.S. Fish and Wildlife Service considers the species extinct in all other states, and it is the rarest and most endangered mammal in North America.

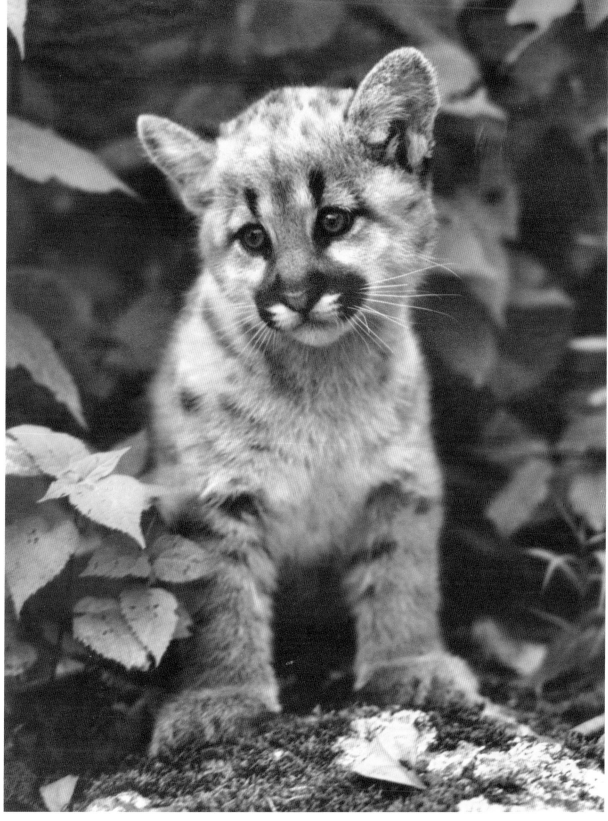

This cougar kitten had a western cougar as its father and Terra, the Florida panther at Grandfather Mountain, as its mother.

Before chestnut
blight swept
through in the late
1920s and 1930s,
one out of every
four trees in the
North Carolina
mountains was a
chestnut. Losing
these great trees
was a severe blow
to the wildlife that
had thrived on the
nuts and to the
timber industry.
The contribution
of the golden
chestnut leaves
to the fall color
season has also
been sorely missed.
The American
Chestnut Founda-
tion believes it is
on the verge of
developing a
blight-resistant
chestnut tree,
and I hope such
is the case.

Mount Mitchell State Park, at an elevation of 6,684 feet, is the highest point in the Eastern United States, and for years it has served as a poster child for the damage that air pollution is doing to our forests. Dr. Robert Bruck, noted forest scientist at North Carolina State University, has conducted more than twenty years of research on Mount Mitchell. I asked Dr. Bruck, "If all air pollution on Mount Mitchell ceased today, how long would it take for the soil on Mitchell to cleanse itself?" His reply was that he did not know, and nobody else knew, but he guessed 200 years.

I have been interested in mountain wildflowers since childhood, but I never knew about sedum live-for-ever until it showed up on a list of plants identified and collected by André Michaux on his visit to Grandfather Mountain and the North Carolina Blue Ridge over 200 years ago. The list was compiled by North Carolina's leading wildflower authority, Dr. C. Ritchie Bell. I found this plant in an almost inaccessible crevice at the edge of the parking lot on top of Grandfather Mountain. It was worth the hunt.

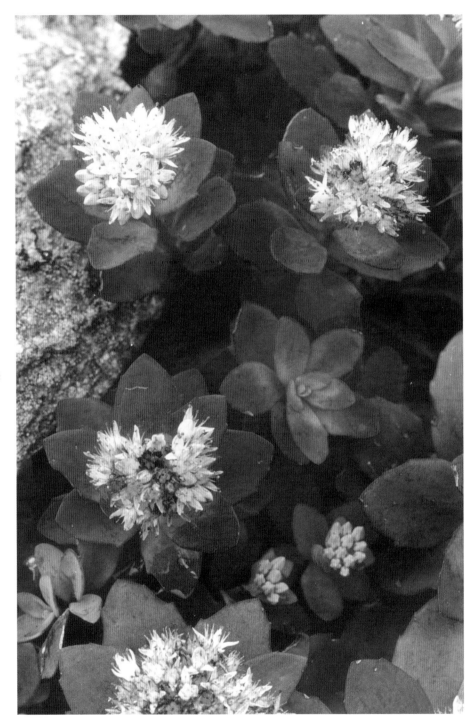

(opposite)
Green Mountain Creek Waterfalls at the edge of U.S. 221 between Blowing Rock and Linville makes a whirlpool at its foot, most noticeable when autumn leaves are in the stream. I used a very slow shutter speed and let the leaves do the rest.

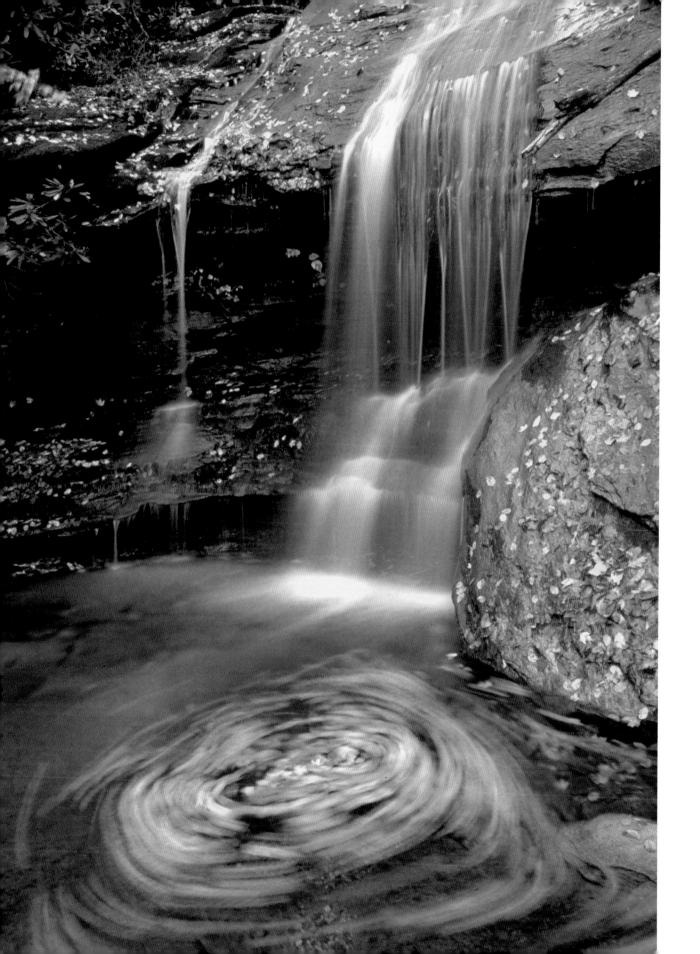

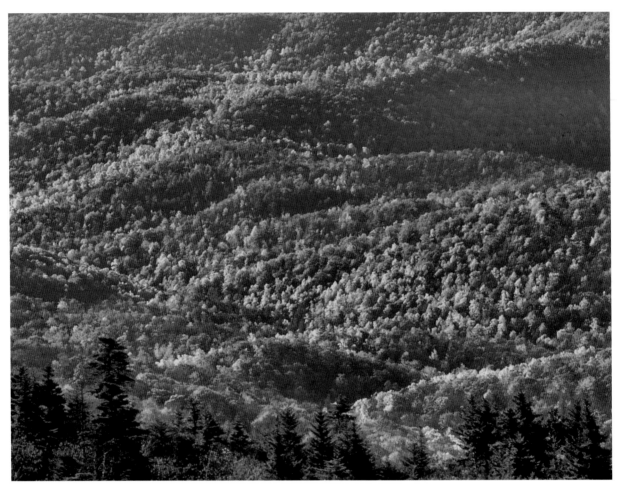

This view down into the Pisgah National Forest and Daniel Boone Wildlife Refuge from the Blue Ridge Parkway was taken in a year when the fall color was perfect. Some years the birch and maples, which are the first to change to autumn colors, lose their leaves to rain and high winds before beech and oaks look their best, but happily that did not happen this time.

(opposite)
This picture of a whitetail deer who was taking a drink from the pond at Grandfather Mountain on an autumn day might have been pretty ordinary. Then someone slammed a car door in the nearby parking lot and the deer looked up, striking this majestic pose.

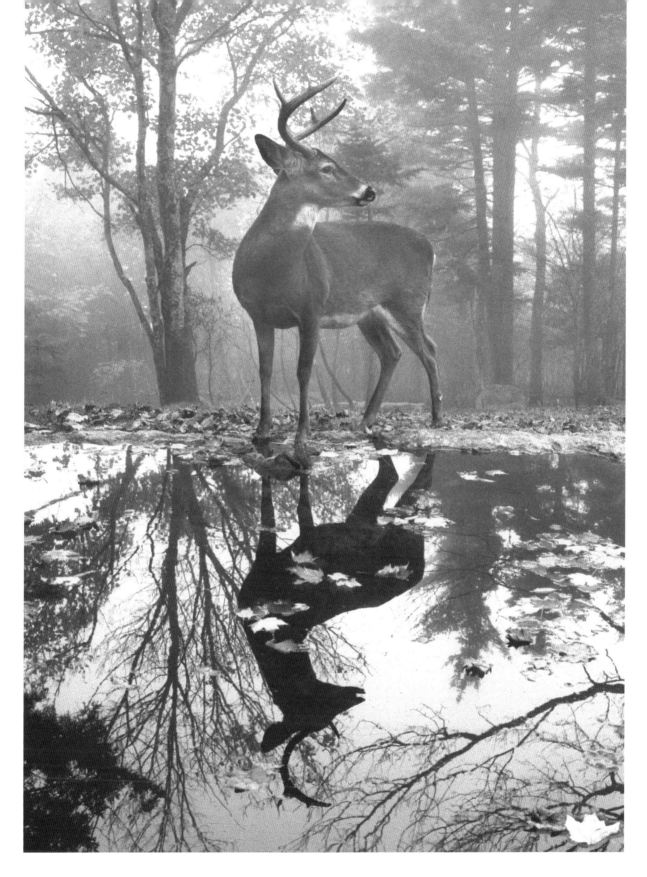

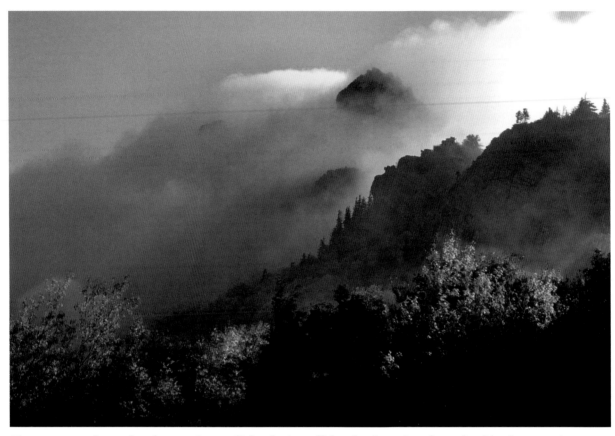

The autumn color and early morning sunlight playing off the clouds and peaks make this photograph special. The change of weather, seasons, and lighting seems to keep the mountains from ever looking the same way twice.

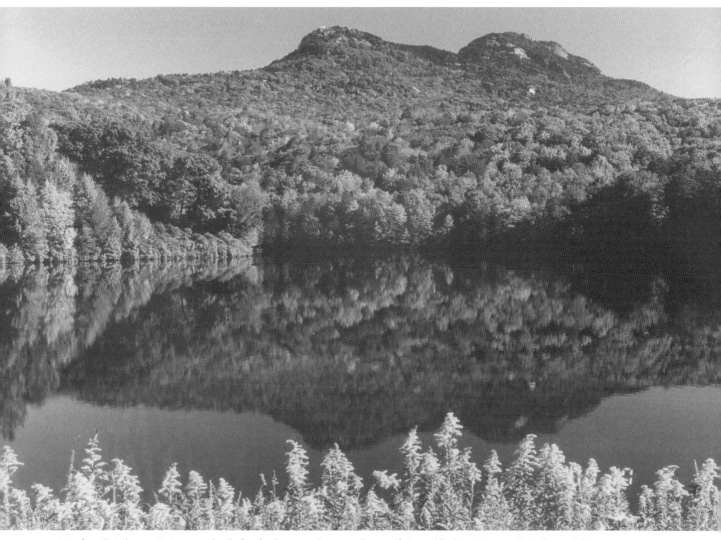

My family's home is just to the left of what can be seen here of Grandfather Mountain Lake, with Grandfather in the background. This photo was made at the absolute peak beauty of fall color. The next night the temperature dropped to 20° and the winds exceeded 100 miles per hour on top of Grandfather Mountain. Needless to say, that ended the fall beauty at that elevation for the year.

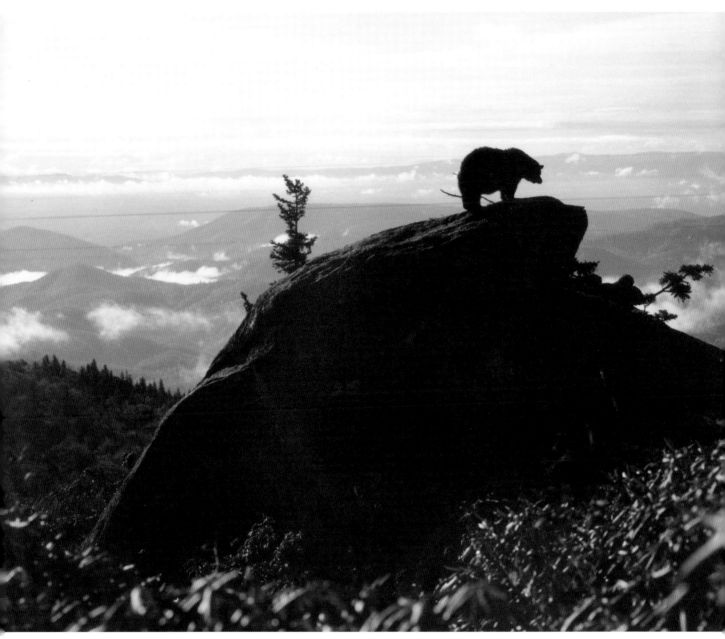

Mildred the Bear was the mascot for Grandfather Mountain for nearly twenty-five years. Here she is enjoying the scenery from a big boulder in her environmental habitat, soon after rain had left clouds hanging low in the Blue Ridge foothills. The picture was made into a popular postcard, and it is my favorite of the hundreds of pictures I made of Mildred.

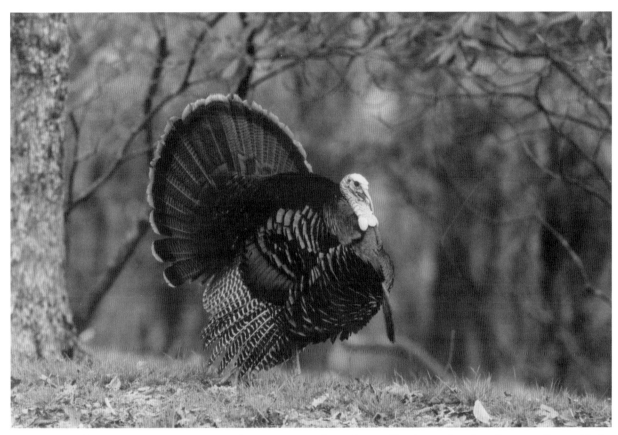

The Wild Turkey was rare or nonexistent in most parts of North Carolina just a few decades ago. Now, aided by a program of the State Wildlife Resources Commission, it can be found in all 100 counties of the state. Its return is a remarkable accomplishment for the commission.

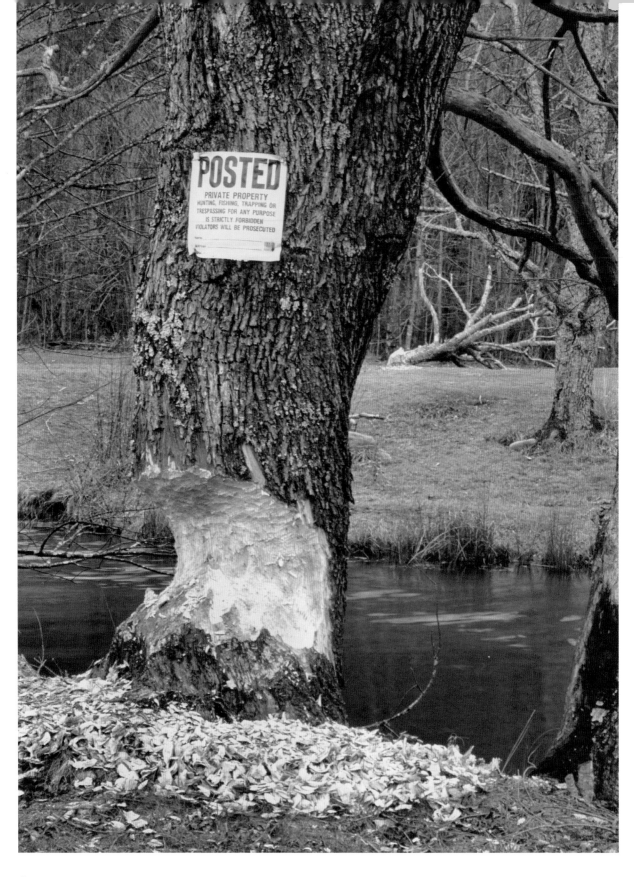

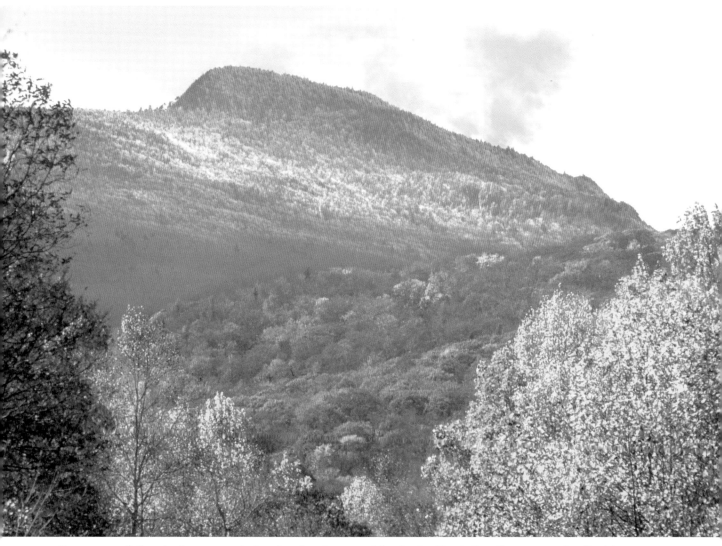

Some years fall and winter meet in head-to-head competition in the North Carolina mountains. In this case fall color is still peaking at the lower elevation of the Boone Fork bowl, while upstream at the top of Grandfather Mountain's Calloway Peak, the highest point in the Blue Ridge Mountain Range, clouds have frozen on the trees to create a blanket of rime ice.

(opposite)

The POSTED sign says no hunting, fishing, and trespassing, and it probably also should have said no chewing on trees. Anyway, I submit this as evidence that beavers are industrious little animals, and that they apparently cannot read.

In wintertime, when there are no leaves on the trees, it is obvious how Sitting Bear Mountain, which overlooks the Linville Gorge Wilderness, got its name. While it may appear small in the distance from N.C. 181, the Sitting Bear is a tremendous boulder approximately fifty feet tall. It is in rugged territory that is part of Pisgah National Forest.

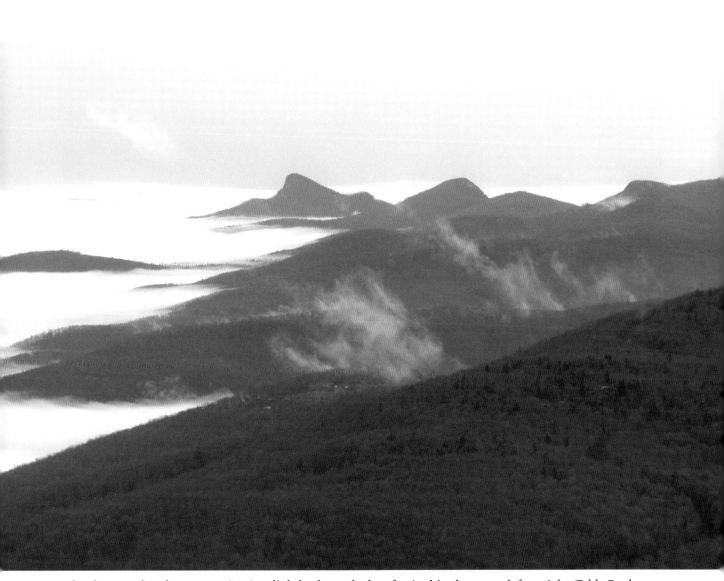

The three peaks whose summits rise slightly above the low fog in this photo are, left to right, Table Rock, Hawk's Bill, and Sitting Bear, as seen from Grandfather Mountain. The peaks are on the eastern rim of spectacular Linville Gorge, and this view reminds us why the area is appropriately named the Blue Ridge Mountains.

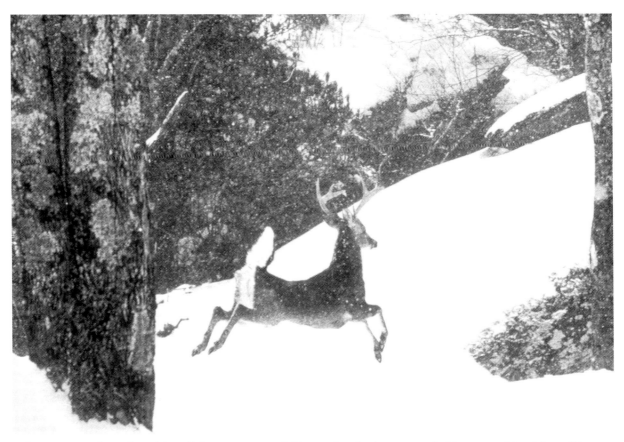

It is easy to see how the whitetail deer was named. Even when he is surrounded by snow, his white tail is displayed conspicuously as he bounds away.

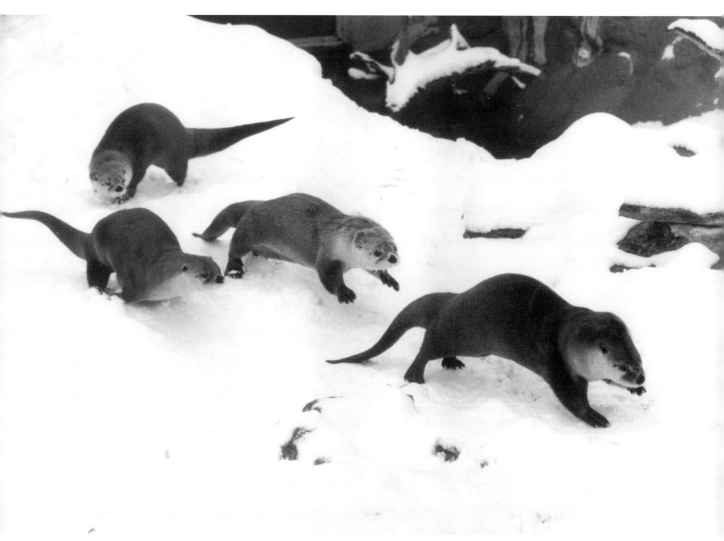

The river otters in the otter habitat vie with the bears for the title of most popular animals in Grandfather Mountain's natural habitats. The otters make a game of everything. In the winter, they make tunnels under the snow, and they have fun rolling snowballs down the bank into their pond.

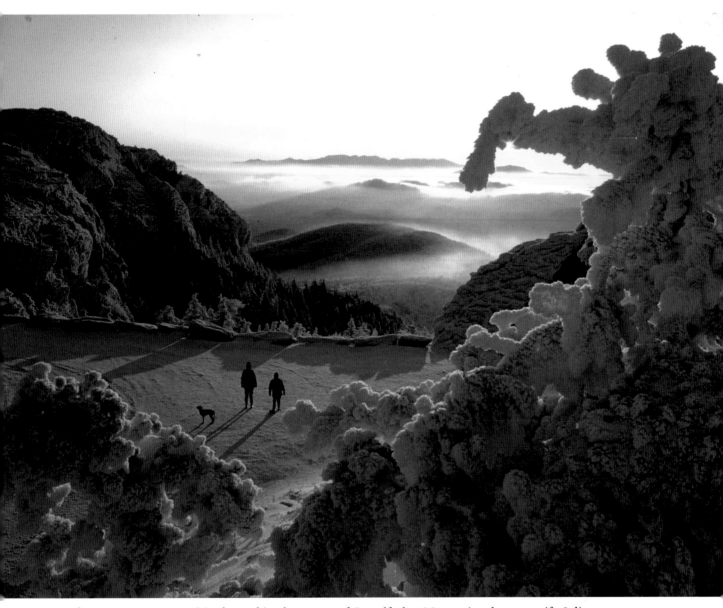

The temperature was 2° in the parking lot on top of Grandfather Mountain when my wife Julia, our daughter Catherine, and our dog witnessed a beautiful sunset in icy surroundings. We were the only people on the mountain that day, and Catherine had the time of her life sledding down the road.

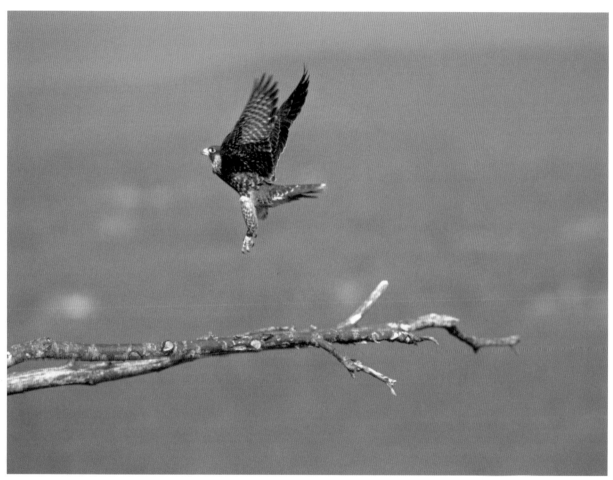

A great bird of prey, the peregrine falcon, was extinct in North Carolina until 1984, when the Peregrine Fund, the U.S. Fish and Wildlife Service, and the North Carolina Wildlife Resources Commission conducted a reintroduction program to bring the peregrine back. Eighty newly hatched peregrine chicks were raised in locations isolated from humans and then released, with a goal of producing at least five nesting pairs. Twenty of the eighty young falcons were raised and released at a remote spot on Grandfather Mountain. The cooperative program exceeded its goal for nesting pairs.

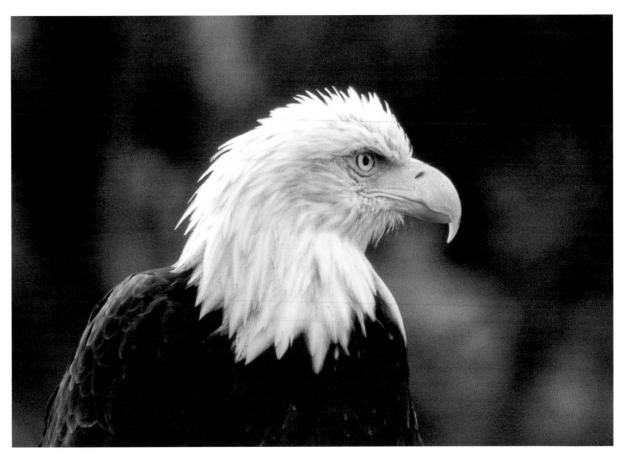

I have hundreds of pictures of the bald eagle, America's emblematic bird, but this may be my favorite. She looks as if she has just heard about some threat to America, and she doesn't like it. I say "she" because this, the larger of the pair of bald eagles at Grandfather Mountain, is a female, and to most people it is a surprise that female eagles are usually bigger than the males.

2. People & Events

W. Kerr Scott, governor of North Carolina from 1949 to 1953, looked very much the old-fashioned politico in this picture from the 1956 Democratic Convention. As governor, however, he was considered quite progressive. He launched an ambitious program for paved farm-to-market roads to benefit the rural areas of the state, where great need existed, and he also made an aggressive push to bring electricity to rural regions that had little or none. After his term as governor ended, he served in the U.S. Senate.

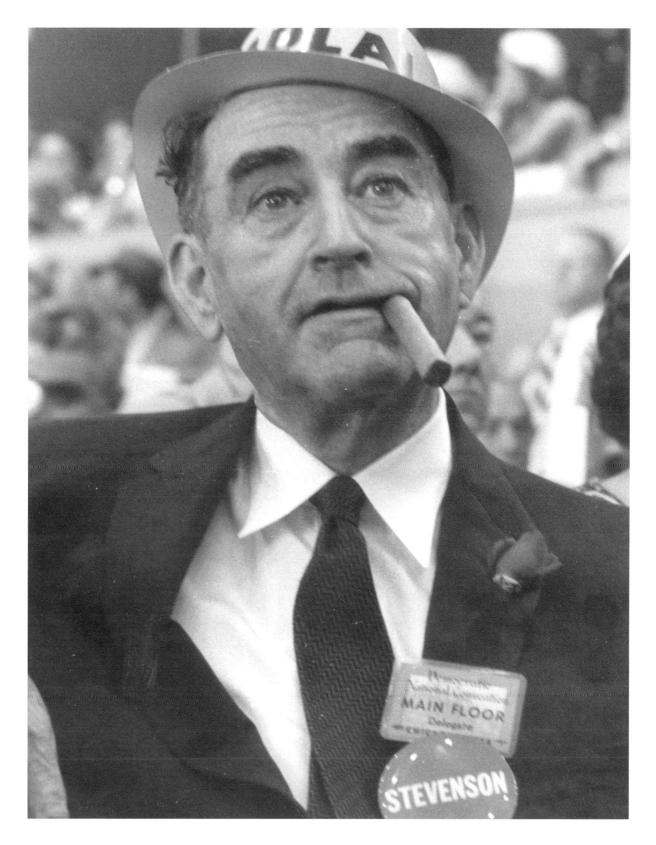

Governor J. Melville Broughton (1941–45), on the right, was a proud alumnus of Wake Forest, but he enjoyed immensely being chairman of the UNC Board of Trustees at events like Graduation Day in 1942, when Dr. Frank Porter Graham was his host in Chapel Hill.

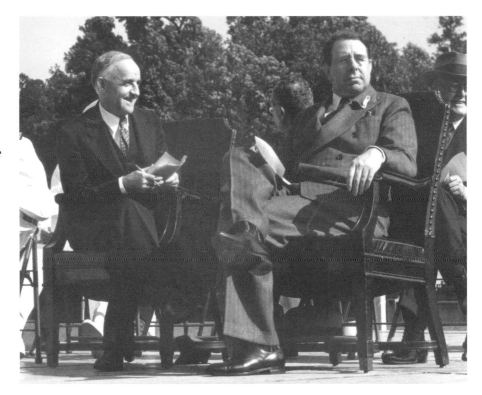

In April 1948, Governor R. Gregg Cherry (1945–49) crowned movie actress Jacqueline White as the queen of the first Azalea Festival in the Lumina Ballroom at Wrightsville Beach. The crown was so elaborate that the governor did not know up from down, and he placed it on her head upside down.

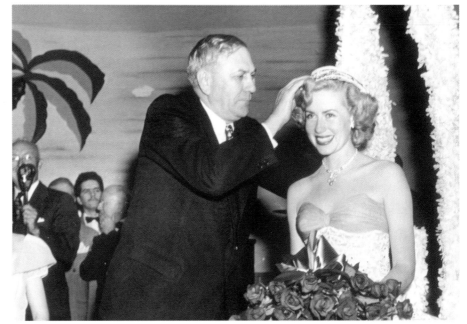

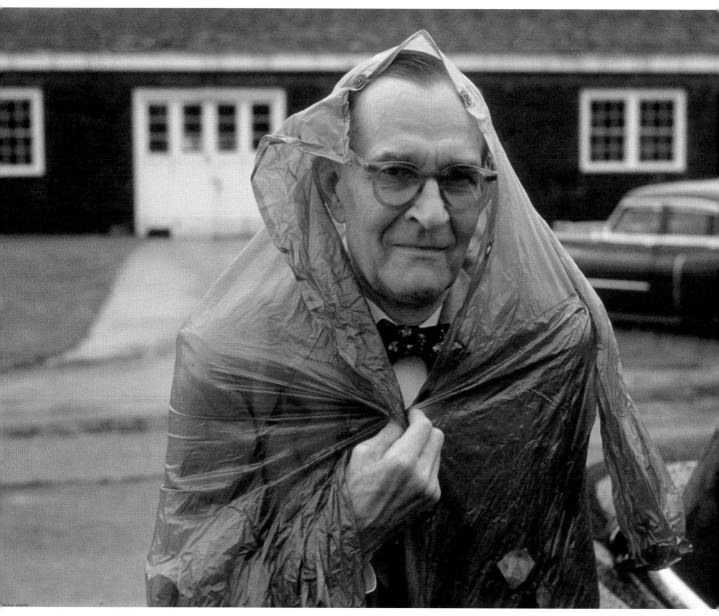

Governor William B. Umstead (1953–54) was seeking shelter from a sudden thundershower at a Conservation and Development Board meeting in Morehead City when I took this photo. Umstead was a warm and friendly person, but for some reason it was difficult to make a photograph of him that showed it. This one does.

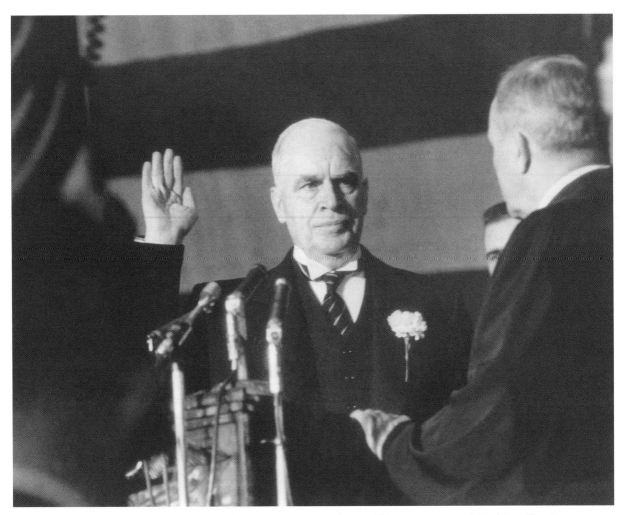

Lieutenant Governor Luther H. Hodges became governor when William B. Umstead died in office in 1954. Reelected in 1956 for a full four-year term, he was sworn into office in January 1957 by Chief Justice of the North Carolina Supreme Court Wallace Winborne.

(opposite)

The birthplace of Governor Luther H. Hodges, founder of the magnificent North Carolina Research Triangle, was a humble tenant cabin two miles north of the state line between North Carolina and Virginia, near what is now Eden, North Carolina. When I photographed the cabin for use in the governor's 1956 reelection campaign, his wife Martha rather jokingly suggested, "At least you should have said the cabin was new when Luther lived in it." Thereupon the governor cheerfully scolded her, "Look, we are running for election, not for social standing."

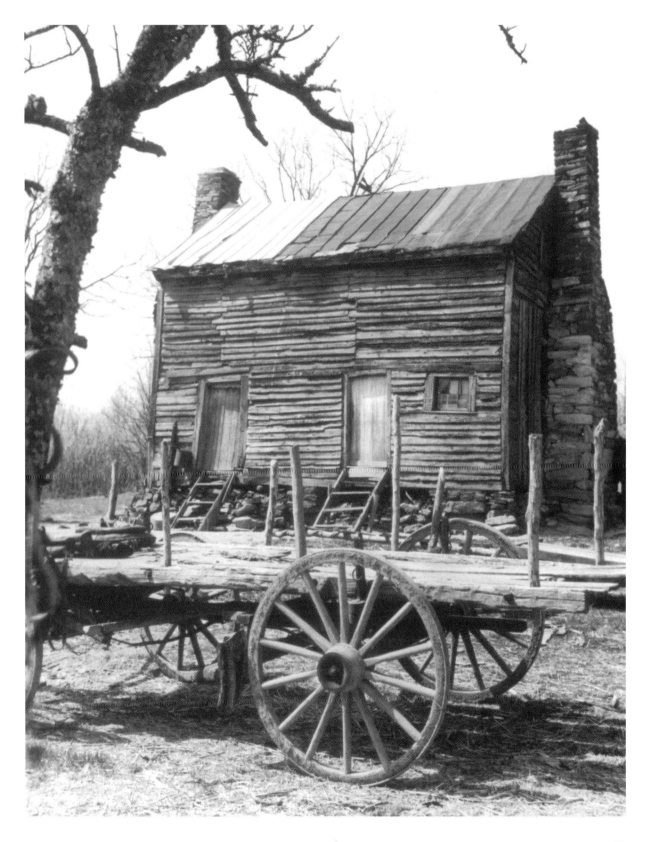

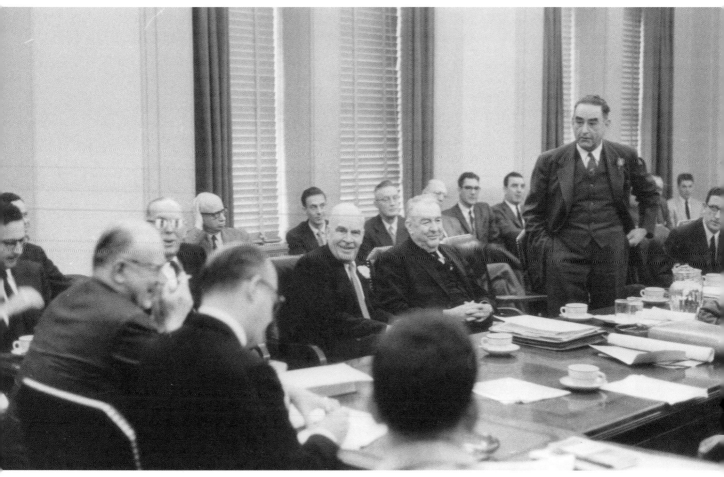

Conrad L. Wirth, director of the National Park Service (seated at the corner of the table, back to camera and cigarette in hand), earned the wrath of North Carolina's travel and government leaders by attempting to place a toll on the Blue Ridge Parkway in the mid-1950s. The parkway is crossed by twenty-five U.S. highways and was not built to be a limited-access toll road. The indignant North Carolina group that met with Wirth and Secretary of the Interior Fred A. Seaton (right of Wirth) included U.S. Senators W. Kerr Scott (standing) and Sam J. Ervin (at table, left of Scott) and Governor Hodges (at table, left of Ervin). Wirth and the Interior Department stonewalled the group at this meeting, but President Eisenhower eventually killed the toll idea at the request of former UNC president Gordon Gray, who, as secretary of the army during World War II, had been Eisenhower's boss.

(opposite)

As Governor Hodges was fishing with a friend on the lake where he and I had homes, the friend in the front of the boat caught the governor in the cheek with a trout fly. The governor came up from the lake to my doorway to ask me to cut the fly from his cheek. Lacking a medical degree, I agreed only to drive him to the hospital. While we waited for the doctor to arrive at the emergency room, I made this picture, which Hodges wanted to show to his children. It is my favorite of the many pictures I have of him.

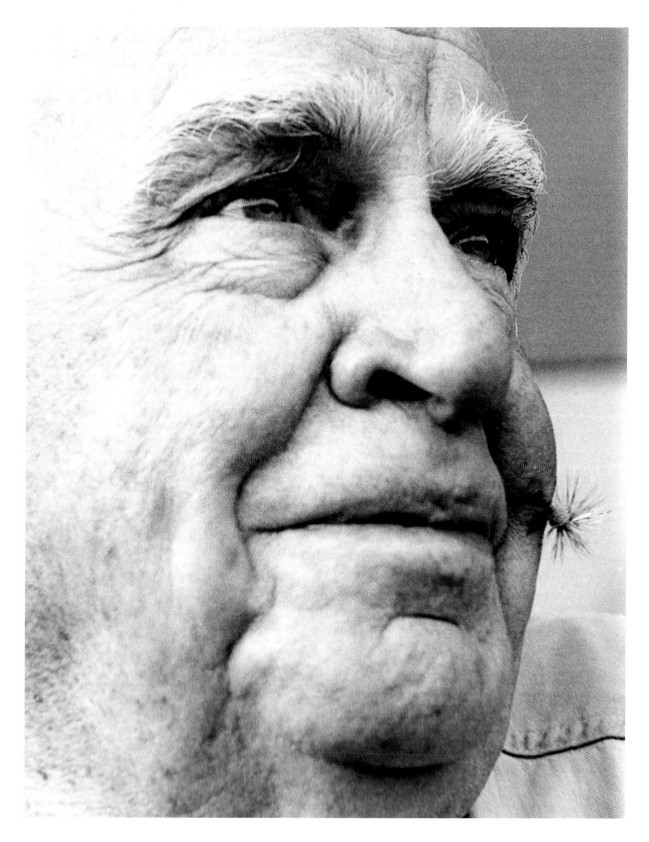

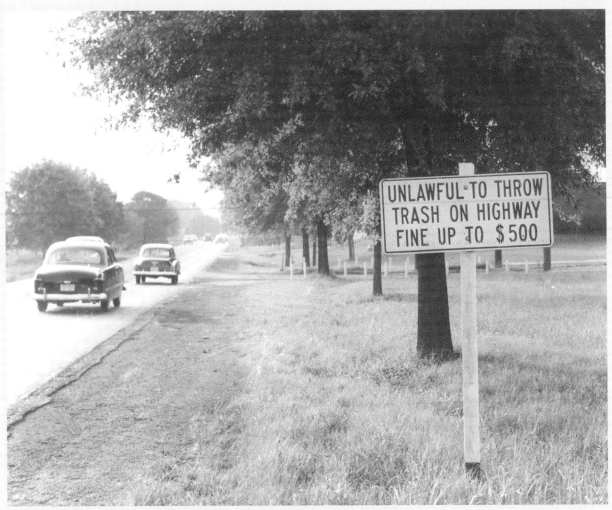

Governor Hodges was an absolute stickler in observing laws and rules of ethics and so forth. When I once tossed an apple core out of the car window, the frightening scolding the governor gave me almost caused me to drive off the road. A few days later I was near Roanoke, Virginia, and I saw the sign in this picture. I sent the picture to Governor Hodges, and he was on the phone the next day asking for six more copies. He sent a copy to every state agency having anything to do with roadside law enforcement. Apparently North Carolina already had the needed litter laws, and in nearly no time there were similar signs from one end of our state to the other.

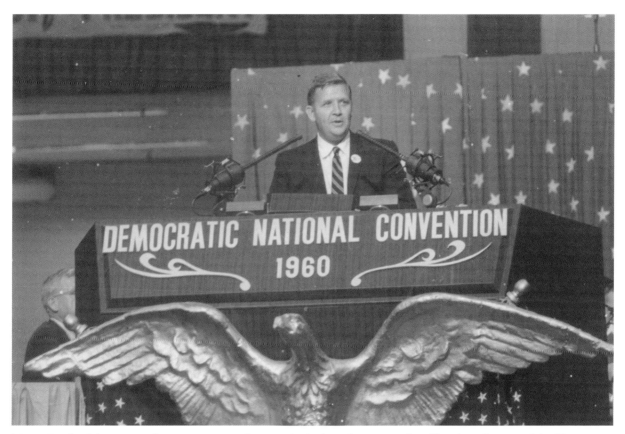

Terry Sanford (governor from 1961 to 1965) was relatively unknown nationally when Senator John F. Kennedy invited him to endorse his nomination for the presidency at the 1960 Democratic Convention, and it solidified a lifelong friendship between the two. That friendship was to prove beneficial for North Carolina in many ways.

Admiral Arleigh Burke, pipe-smoking chief of naval operations, was seated at the head of the table as a group of North Carolina senators and congressmen and Governor Terry Sanford (right of Burke) negotiated for the battleship *North Carolina* in 1961. With their backs to the camera are (left to right) Senator Sam J. Ervin Jr., Congressman Hugh Alexander, and Congressman Alton Lennon. At that point in the negotiations the Navy was unsure that the state of North Carolina had the will and ability to carry out the restoration of the ship successfully. Governor Sanford later visited the White House to name President John F. Kennedy the first admiral in the North Carolina Navy, which led to the Navy's full support of the Tar Heel project to establish the ship as a memorial to the 10,000 North Carolinians who died in World War II.

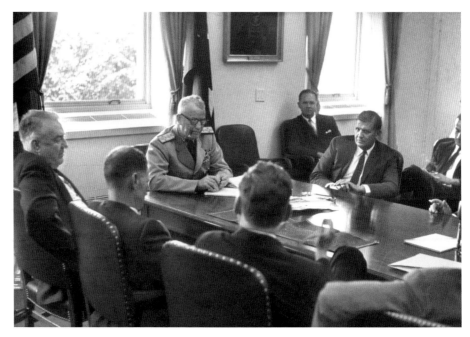

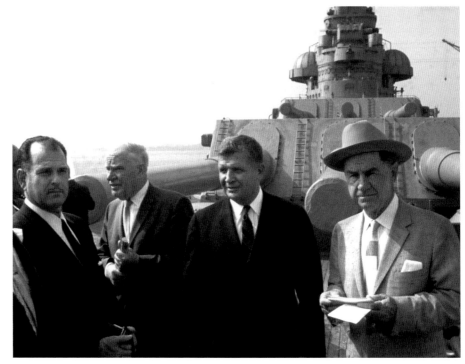

Great effort on the part of the state had gone into the battleship *North Carolina* project, so Governor Terry Sanford was anxious to see the ship finally in North Carolina waters at the mouth of the Cape Fear River off of Southport. Governor Sanford boarded a U.S. Coast Guard vessel in order to view the battleship, and when it began raining, he borrowed a Coast Guardsman's rain gear and cap. The most fun of the day came when a lieutenant who did not recognize the governor barked, "Hey, sailor, clear the deck, the governor will be here in a minute."

(opposite, bottom)
Lowell Thomas, the best-known radio newsman in the nation, was master of ceremonies in Bayonne, New Jersey, in 1961 when the Navy gave the USS *North Carolina* to the state. Left to right are: Cyril Adams, skilled maritime engineer from Houston who berthed the battleship in Wilmington; Luther H. Hodges, former North Carolina governor, at the time secretary of commerce in President Kennedy's cabinet; Governor Terry Sanford; and Thomas. General Kenneth Royall, the battleship commission's fund-raiser in New York, invited Thomas to take part in the happy event.

The battleship
North Carolina
as it rounded
third and headed
for home to its
dredged slip across
from downtown
Wilmington,
nudged into place
by the power of
eleven tug boats
on October 2, 1961.

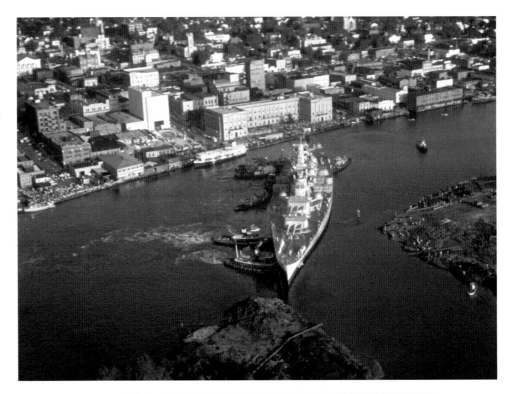

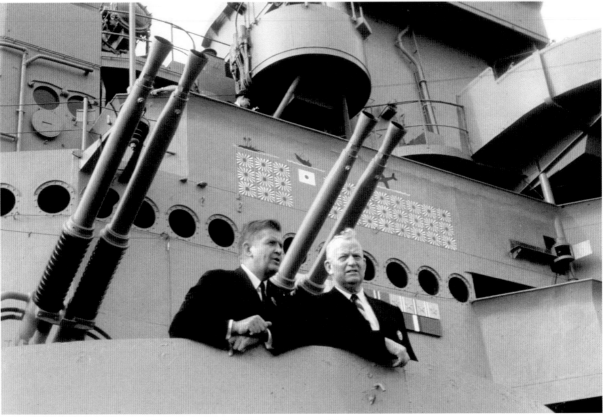

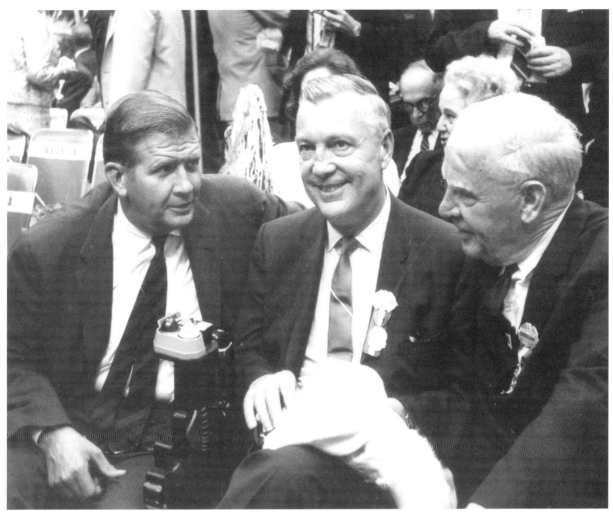

North Carolina enjoyed general prosperity, with notable advancements in education and industrial development, during the terms of (left to right) Governors Terry Sanford, Dan K. Moore, and Luther H. Hodges in the 1950s and 1960s.

(opposite, bottom)

Framed by 40mm guns and the USS *North Carolina*'s battle record, Governor Terry Sanford (left) and Admiral Arleigh Burke, chief of naval operations, were two happy gentlemen on April 29, 1962, when the battleship memorial was dedicated. Admiral Burke had done everything in his power to assist in preserving the ship, including leaving aboard 1.5 million gallons of fuel oil, which he said was needed for ballast on the trip from Bayonne. He knew that the money that was made when the fuel oil was sold on arrival at Wilmington would be helpful in maintaining the ship. Known as "31-knot Burke," the admiral was a Navy hero in World War II.

Dan K. Moore (left), governor from 1965 to 1969, leaned heavily on the remarkable government experience of Ed L. Rankin Jr., who served as his secretary of administration. Rankin had earlier been private secretary to Governor William B. Umstead and Governor Luther H. Hodges. After serving in the Moore administration, Rankin was secretary to the North Carolina Broadcasters Association and executive vice-president of the North Carolina Citizens Association (now North Carolina Citizens for Business and Industry) and later vice-president of Cannon Mills.

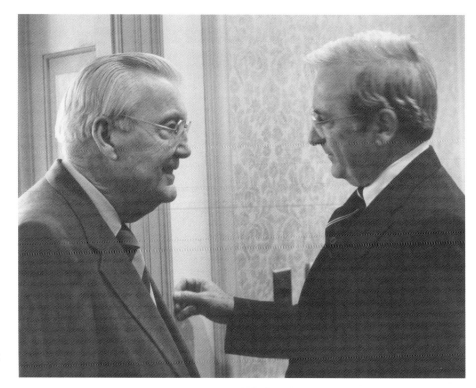

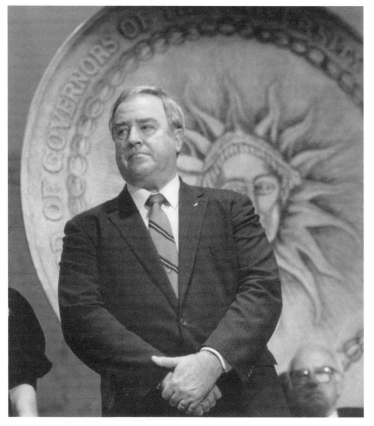

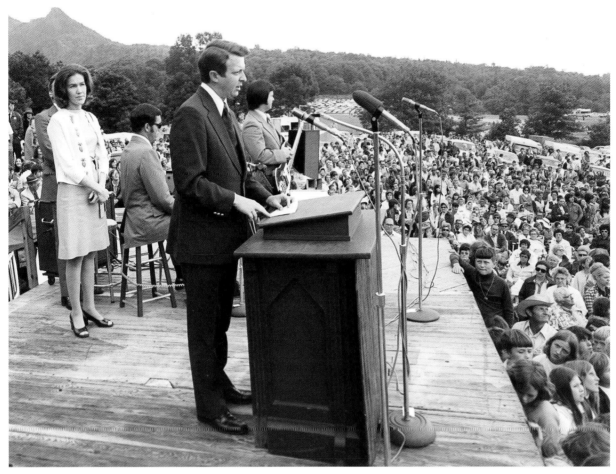

A big crowd was on hand in 1975 when Governor James E. Holshouser (1973–77), from Boone, returned to the mountains to be principal speaker at the annual Singing on the Mountain, with his wife Pat standing in the background at the left. After his term as governor, Holshouser served as a member of the Board of Governors of the University System. He was on the search committee that recommended C. D. Spangler Jr. to replace retiring Dr. William Friday as president of the University of North Carolina.

(opposite, bottom)

In 1987 former governor Robert W. Scott (he was governor from 1969 to 1973) received the University Award in recognition of his lead role in bringing the sixteen state-supported institutions of higher learning together in the consolidated University of North Carolina. Before the General Assembly made that wise move, each of the institutions had to compete for state appropriations, which made for disagreeable chaos. The North Carolina setup that Scott helped create is admired by other systems nationwide. He also did a splendid job after his term ended in heading the state's community college system.

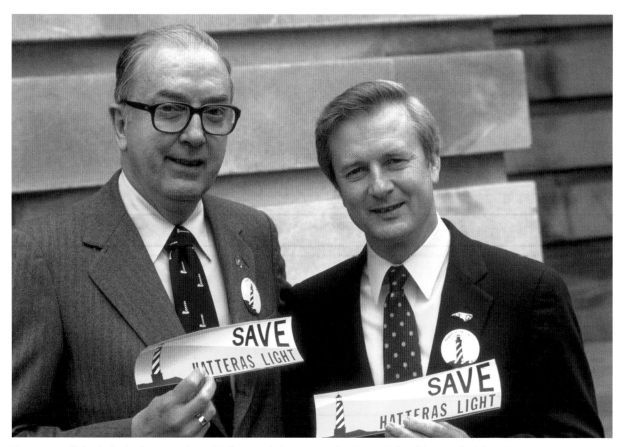

In 1981, political rivals Senator Jesse Helms and Governor Jim Hunt joined in co-chairing the Save Cape Hatteras Lighthouse Committee, which raised private money to help protect the world-famous beacon. Perhaps folks thought that if Helms and Hunt could work together, the cause must be a worthwhile one, and over $500,000 was raised. The private funds were used to carry out projects recommended by the National Park Service, which included the use of sandbags, sand fences, and synthetic seaweed, and the effort helped protect Hatteras Light at its historic site for an additional fifteen years before its eventual relocation.

(opposite, bottom)
Red tide killed millions of fish in 1988 along the East Coast, and even after health officials said it was safe again, the public remained reluctant to eat fish. Governor Jim Martin and Tourism Director Hugh Morton Jr. launched a campaign to aid North Carolina's fishing and tourism industries by calling together to a seafood feast one of the most impressive groups of celebrities ever gathered in one place in the state. The folks behind the table set by the governor and Morton include Jesse Haddock, Charlie Justice, Bill Friday, George Hamilton IV, Captain Frank Conlon, Kyle Petty, Clyde King, Richard Petty, Loonis McGlohon, Shirley Caesar, Bones McKinney, Tommy Amaker, Tommy Burleson, Daniel Boone (portrayed by Glenn Causey), Bob Timberlake, Bobby Jones, Phil Ford, and other loyal North Carolinians. Seafood consumption experienced a noticeable upsurge.

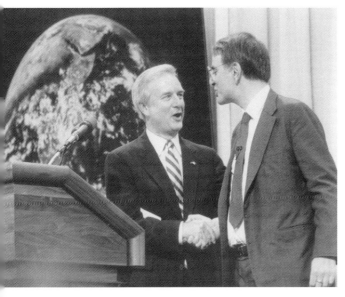

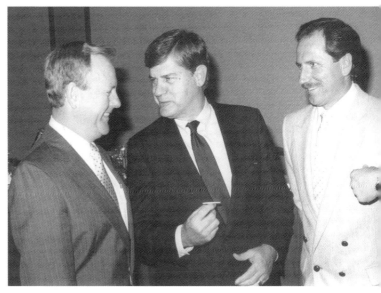

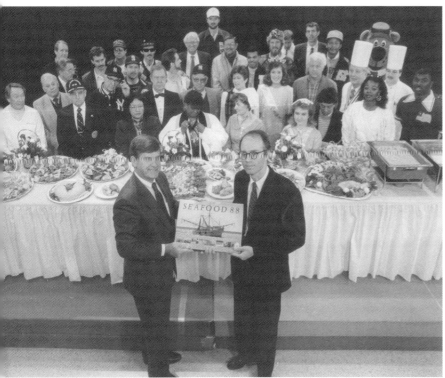

(top left)
Dr. Carl Sagan (right), a scientist trained in both astronomy and biology, is enthusiastically thanked by Governor Jim Hunt for his address on the environment at the Emerging Issues Forum at North Carolina State University in 1990. Sagan's book *Cosmos*, the companion piece to his Emmy- and Peabody Award–winning television program, was the best-selling science book ever published in English.

(top right)
The Tar Heel State's most savvy promoter, Humpy Wheeler (left) called on two of the best-known local boys, Governor Jim Martin (1985–93) and race car driver Dale Earnhardt (right), to help boost an upcoming race at his Charlotte Motor Speedway. Humpy enlarged his track so that it now seats over 170,000, a far greater capacity than that of any other stadium or arena in the state, and he fills it for every major race.

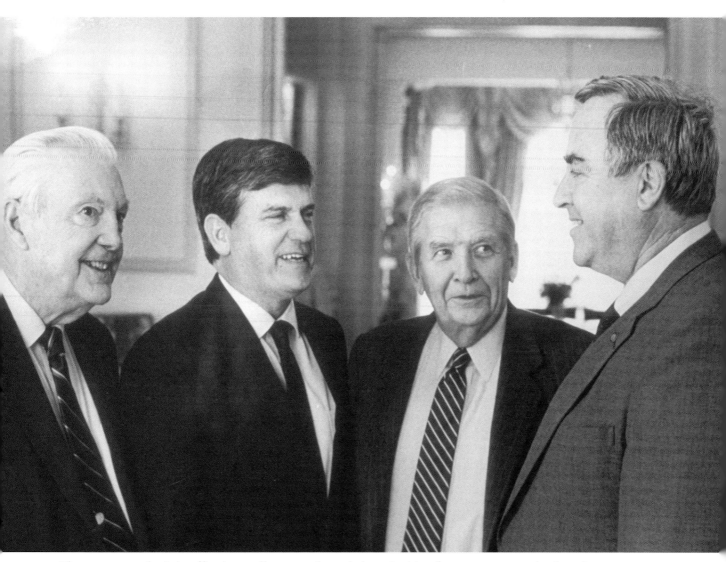

The governor who is in office is usually pretty shrewd about inviting former governors back to the Executive Mansion for social events, because he knows it offers an opportunity for him to receive advice from wise and experienced public servants. Left to right are Governors Dan K. Moore, James Martin (then the sitting governor), Terry Sanford, and Robert Scott.

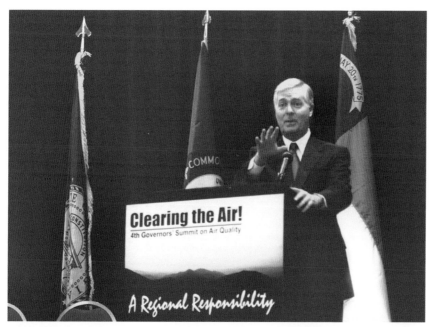

In May 2002, Governor Mike Easley hosted the fourth Governor's Summit on Air Quality in Charlotte, where he spoke forcefully in support of the Clean Smokestacks Bill that was ultimately passed by the North Carolina General Assembly. Medical testimony on the serious threat to health posed by air pollution highlighted the 2002 meeting. We can hope that the states upwind from North Carolina will pass legislation similar to the Clean Smokestacks Bill.

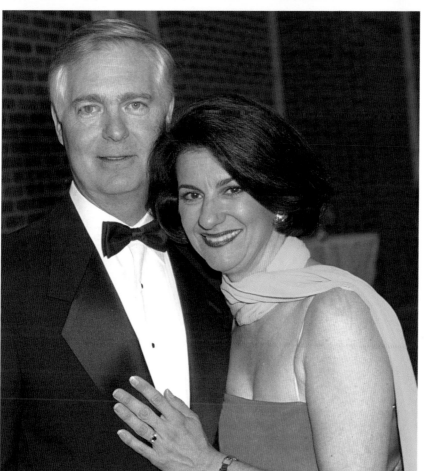

I had just photographed Governor Michael Easley with some other folks when I asked First Lady Mary Easley if I could take her picture with the governor. She did not hold back as some first ladies might have done, and Michael received a snuggle for all of us to see. It is my favorite picture of the Easleys.

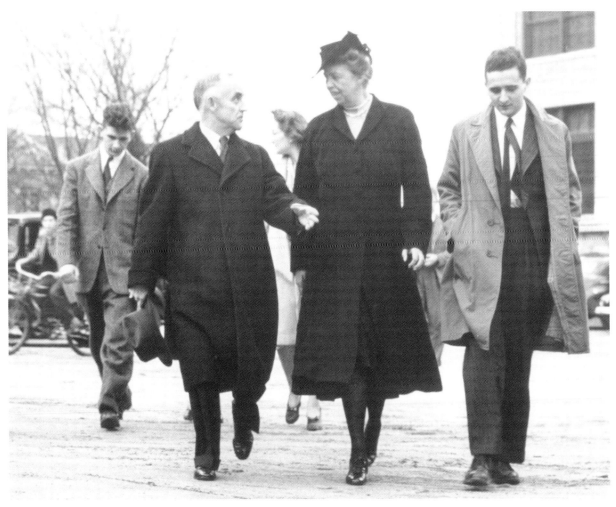

In 1941 Eleanor Roosevelt visited the Chapel Hill campus. President Frank Porter Graham and Louis Harris, a student leader who later became nationally prominent as a pollster, escorted Mrs. Roosevelt to a luncheon at the Carolina Inn. Eleanor Roosevelt was a friend of my grandfather, and when Dr. Graham introduced me as Hugh MacRae's grandson, she could not have been more friendly. President Franklin D. Roosevelt, who was confined to a wheelchair, was limited in his travels, but his very active wife made certain that the family was represented at events around the nation.

(opposite)
Vice-President Harry S. Truman became president in 1945 on the death of President Franklin D. Roosevelt. In 1948 he campaigned in Raleigh for a term of his own. Truman (left) is shown with Governor R. Gregg Cherry at the State Fairgrounds, where they are observing a Hoover cart. Farmers in the Depression jerry-built the primitive Hoover carts for farm transportation.

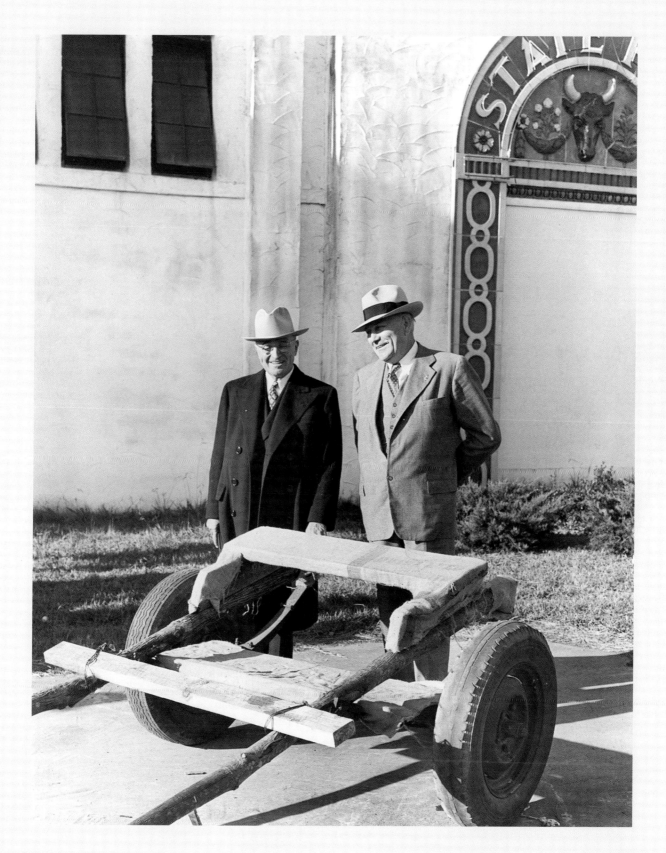

95

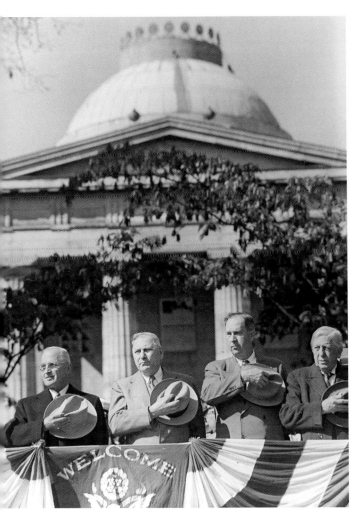

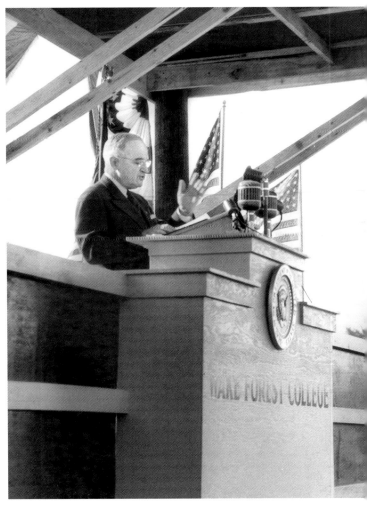

(left)
North Carolina staged a big parade in front of the Capitol for the campaign visit to Raleigh of President Harry S. Truman in the fall of 1948. On the reviewing stand, left to right, are President Truman, Governor R. Gregg Cherry, General Kenneth Royall, and U.S. Senator Clyde R. Hoey. Truman was the underdog in the race with Republican Thomas E. Dewey, but he won.

(right)
Gordon Gray of Winston-Salem, who had been secretary of the army in World War II, invited President Harry S. Truman to be the featured speaker at the Forsyth County groundbreaking for Wake Forest University when it was decided to enlarge and relocate the Baptist school from its original home in Wake County in 1951. President Truman, a lifelong Baptist, promptly accepted.

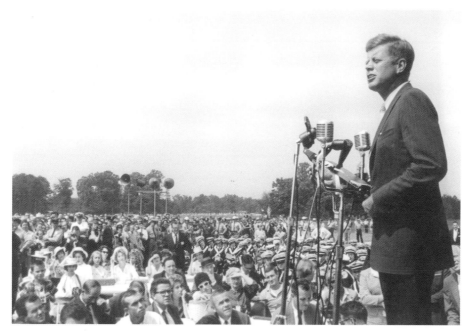

A large and enthusiastic crowd welcomed U.S. Senator John F. Kennedy at the Greensboro Airport as he campaigned for the presidency in his successful 1960 race against Richard M. Nixon. Kennedy's North Carolina swing began earlier that day in Greenville and ended in Charlotte in late afternoon.

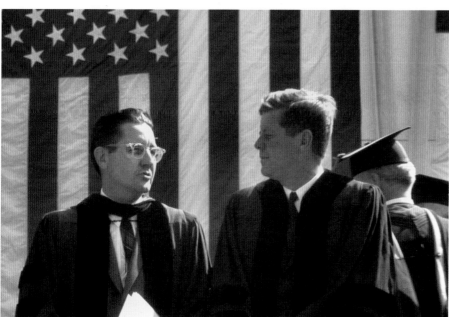

The largest University Day gathering in UNC's history took place in Kenan Stadium on October 12, 1961, when President John F. Kennedy was principal speaker. Two days before the event, university president Bill Friday (left) learned from the Secret Service that no more than 10,000 people were expected. That prompted Friday to call every school principal for miles around, telling them this might be the only opportunity for most of the schoolchildren to see a president of the United States. An overflow crowd of more than 30,000 turned out to see Kennedy.

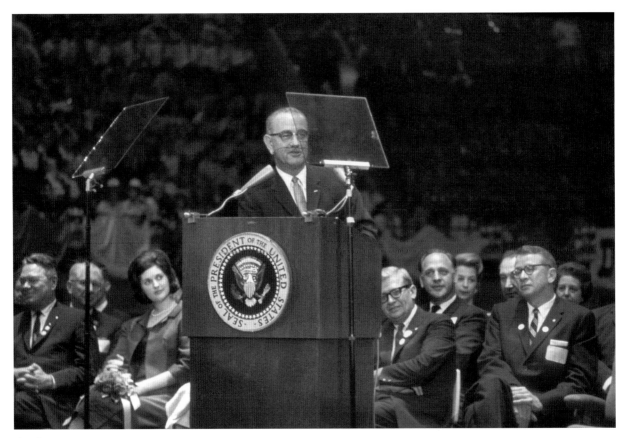

(top)

President Lyndon B. Johnson's campaign for election came to Reynolds Coliseum in Raleigh on October 6, 1964, where 13,000 enthusiastic supporters were on hand. On the Raleigh platform in the right portion of the photo are, left to right, Governor Terry Sanford, Congressmen David Henderson and Horace Kornegay, and North Carolina Democratic Party chairman J. Melville Broughton Jr. The president's daughter Linda and North Carolina school superintendent Dr. Charles Carroll are in the left portion of the photo, and at the extreme left is U.S. Senator Hale Boggs of Louisiana. Senator Boggs, father of television news personality Cokie Roberts, later died in a plane crash in Alaska.

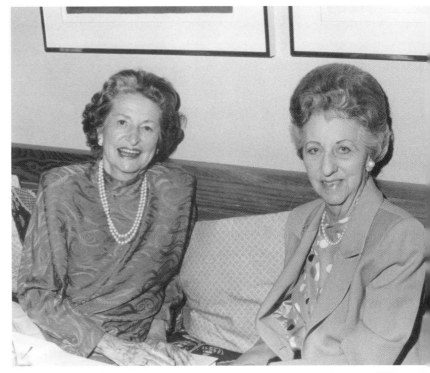

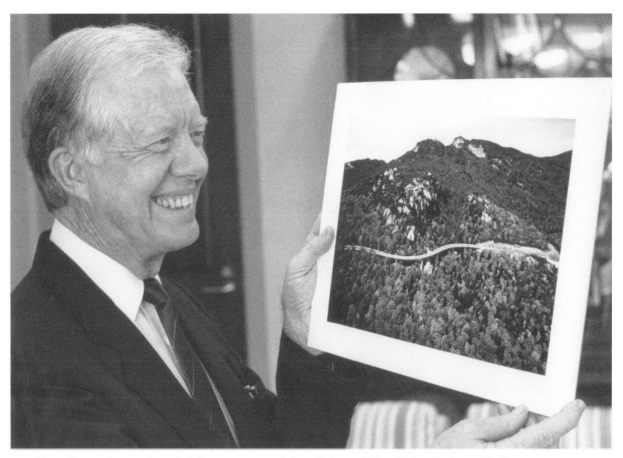

President Jimmy Carter, here holding a picture of the celebrated Blue Ridge Parkway Viaduct, was president when the contracts for the engineering and design of the structure, and for its construction, were let. Completion of the viaduct and the parkway itself came during the Reagan administration, so the Republicans enjoyed taking most of the bows.

(opposite, bottom)
At a North Carolina Botanical Garden banquet at Fearrington, near Chapel Hill, in 1988, I was honored to be seated beside Lady Bird Johnson, wife of former president Lyndon Johnson, with Jeanelle Moore, wife of former governor Dan Moore, across the table from us. When Mrs. Johnson found out I was from Grandfather Mountain, she said, "Oh, Grandfather Mountain. I was on the National Park Service Advisory Board, and a fellow at Grandfather Mountain was blocking the Blue Ridge Parkway," referring to me, of course. I looked across the table at Mrs. Moore, whose husband had helped settle the twelve-year battle for the parkway right of way, but she smiled and said nothing. She was thoroughly enjoying seeing me squirm. When I saw no help was coming, I had to level with Mrs. Johnson. I was that guy, I told her, and Grandfather was a rugged, majestic mountain that would not have been enhanced by deep parkway cuts and fills high on its slope. I went on to tell her that I donated the right of way for the route where the parkway viaduct was located, and noted that the National Park Service had received twelve national awards for the beauty and design of the viaduct. We found we had a great deal in common that night and parted good friends.

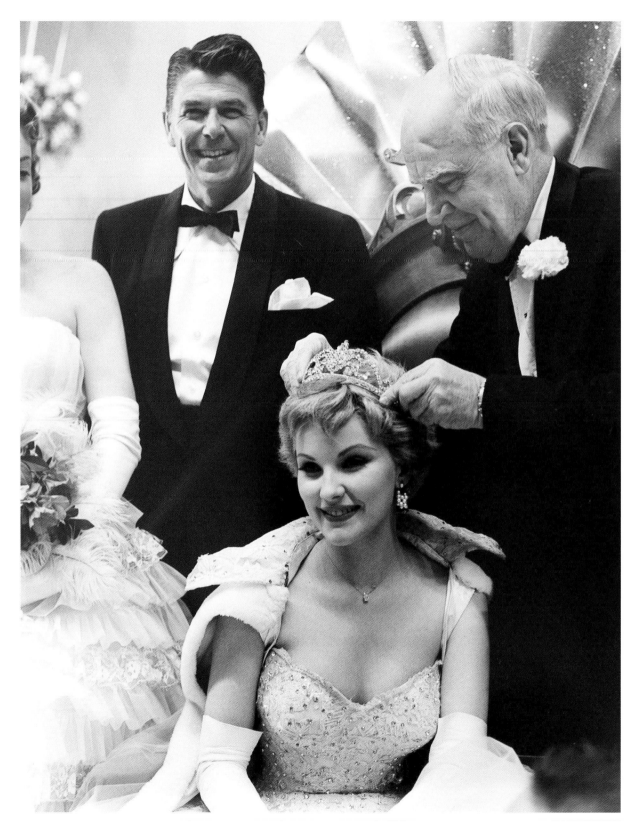

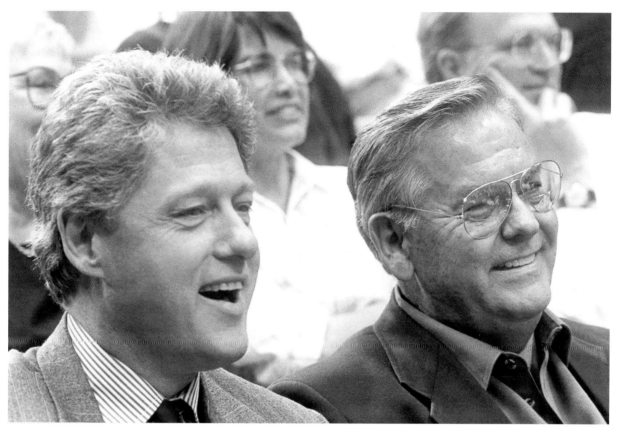

I was photographing the 1991 UNC-Kentucky basketball game in the Dean Smith Center when State Senator Bill Goldston (right) called, "Hey Hugh, come over here, I want you to meet Bill Clinton, the governor of Arkansas." Clinton was elected president the following year.

(opposite)
Hollywood actress Debra Paget was crowned azalea queen at Wilmington by Governor Luther H. Hodges in 1959. Master of ceremonies for the event was actor Ronald Reagan, then employed by General Electric Company as a motivational speaker for business meetings. Reagan enjoyed a rather intense conversation with Hodges about what it was like to have been a top executive in one of the nation's largest textile companies and then retire to go into public service. I have always felt that the persuasive comments Hodges made that day about the obligations of business people to render public service helped influence Reagan to run for governor of California and then president.

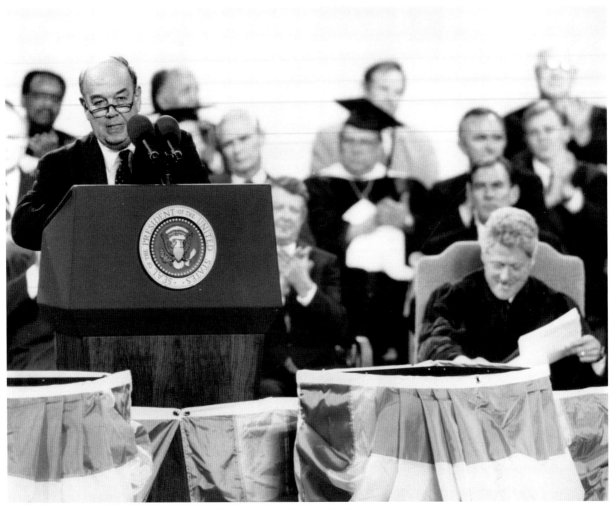

President Bill Clinton was penciling in last-minute changes in his speech in Kenan Stadium for the 200th Anniversary of the University of North Carolina in 1993, all the while laughing at what Charles Kuralt was saying at the rostrum. Kuralt said, "I am here to represent those who could not afford to go to Duke, and those who would not have gone to Duke even if they could have."

(left)

The Blue Ridge Parkway ran through Congressman Robert L. Doughton's congressional district in northwestern North Carolina, so the boss of the powerful House Ways and Means Committee during the Franklin D. Roosevelt administration saw to it that the parkway was adequately funded throughout his days in Congress. One of the most beautiful sections of the parkway, Doughton Park, in Alleghany County, is named for him.

(right)

Representative Charles R. Jonas of Lincolnton, who served ten terms from 1953 to 1973, was the first Republican since the late 1800s to be elected and reelected to Congress in North Carolina. He was strongly committed to giving efficient service to all constituents, both Democrats and Republicans, and his congressional district, which included Charlotte, benefited from his fair-minded approach. Republicans who followed him, including Jim Broyhill, Jim Martin, Jim Holshouser, and Jesse Helms, often met with success when they were mindful of Jonas's example.

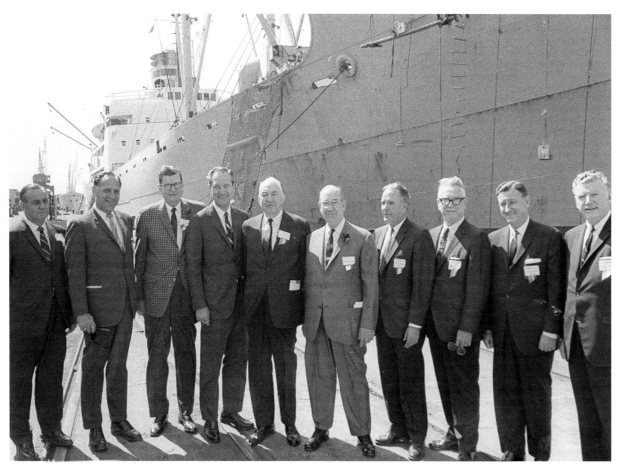

In earlier days, North Carolina's entire congressional delegation would visit the site of an important project, no matter whose congressional district it might be in, and put the full weight of the delegation behind the facility. In this case Senators Sam Ervin and Everett Jordan and all of the state's congressmen met at the State Ports Authority Docks in Wilmington when federal assistance was sought to expand the port facilities. From left to right: Congressmen Walter Jones, David Henderson, Basil Whitener, and Horace Kornegay; Senators Sam J. Ervin Jr. and B. Everett Jordan; and Congressmen Roy Taylor, Charles R. Jonas, L. H. Fountain, and Alton Lennon.

(opposite)
Senator Sam J. Ervin's brilliance in constitutional law was well known to his fellow U.S. senators, and they entrusted him with the chairmanship of the committee investigating the Watergate scandal in the second Nixon administration. I had the experience of watching part of the Watergate hearings on TV with General William Westmoreland and Bob Hope, both of whom were personal friends of Nixon, and Hope kept asking me, "Is this guy for real?" I assured him that he would learn that Ervin was indeed for real.

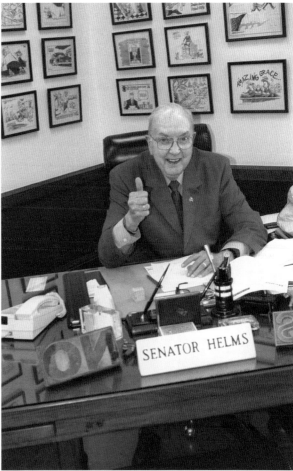

(left)

Senator Jesse Helms had two knees replaced in August of the same year when I had one knee replaced in September, so in November he invited me to his home in Raleigh to talk knees. He greeted me at the front door wearing his USS *North Carolina* cap. His first job in the military service in World War II was as the U.S. Navy recruiter in the Raleigh Recruiting Office. With our replaced knees, the military would not take either of us now.

(right)

It was his own idea for a classic photograph—"Senator No" with thumb up saying "Yes"—and I was happy to have been there to record this rare event. When he thought he was right, Senator Jesse Helms couldn't have cared less about how the nation's cartoonists portrayed him. The walls of his office were covered from floor to ceiling with cartoons that amused him and friends like me. Perhaps the highest compliment I have ever been paid was when Jesse told his environmental staff member, "Hugh Morton has never voted for me in his life, but I have worked with him on a lot of things and never regretted it."

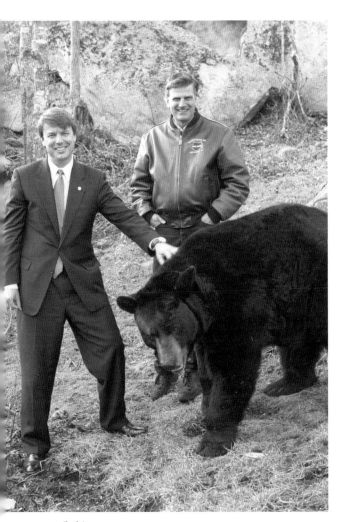

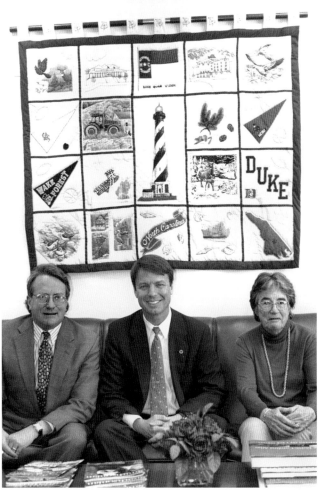

(left)
U.S. Senator John Edwards (left) and the Reverend Franklin Graham had to see for themselves that Mumbles, Grandfather Mountain's 582-pound black bear, was as gentle as I had assured them he was. Edwards had just spoken to a bipartisan audience in the Grandfather Mountain Nature Museum about issues before the U.S. Senate, and Franklin Graham, who a few days before had pronounced the invocation at the inauguration of President George W. Bush, delivered the invocation for John Edwards's talk as well.

(right)
The first thing you see when you walk into Senator John Edwards's office is a beautiful North Carolina quilt promoting the state from the mountains to the sea. Mimi Cecil of Asheville (right) and Michael Leonard (left) of Winston-Salem were there to see the senator on behalf of a project to obtain a large conservation easement to protect the Blue Ridge Parkway, and Edwards picked up quickly on the importance of that project. Many individuals and organizations have taken part in a program originally initiated by the Year of the Mountains Commission to obtain needed right of way protection for the parkway. By March 2002 an additional 26,000 acres of crucial buffer for the Blue Ridge Parkway had been obtained.

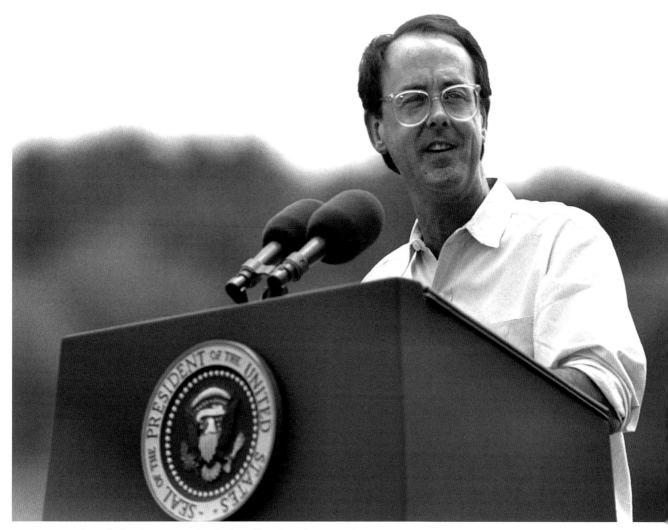

Erskine Bowles of Charlotte was chief of staff in the Clinton White House when he spoke in Ashe County at the dedication of the New River as the nation's first "Heritage River." Bowles's most significant responsibility as chief of staff was coordinating steps to balance the nation's budget and decrease the national debt, the first time the federal budget had been balanced since the administration of Dwight D. Eisenhower.

(opposite)
Elizabeth Dole, U.S. secretary of transportation, was the principal speaker in 1987 when the last section of the nearly 500-mile-long Blue Ridge Parkway was completed. The only location near that part of the parkway large enough to host the enthusiastic crowd was Grandfather Mountain's Highland Games Track, and a great time was had by all. Dole was elected U.S. senator from North Carolina, succeeding Jesse Helms, on November 5, 2002.

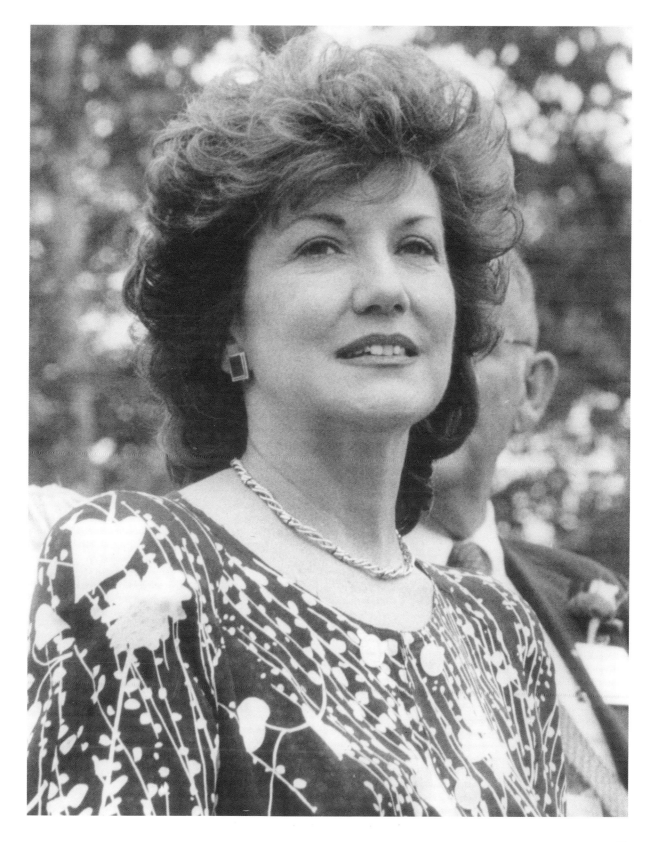

General George C. Marshall was America's chief military officer in World War II and author of the Marshall Plan that helped rebuild Europe after the war. In retirement, he and Mrs. Marshall lived in Pinehurst. The Marshalls were guests in the home of Episcopal Bishop and Mrs. Thomas H. Wright during the 1949 Azalea Festival at Wilmington when this photo was taken. Bishop Wright had been chaplain at Virginia Military Institute when Marshall was superintendent there, so theirs was a friendship of longstanding.

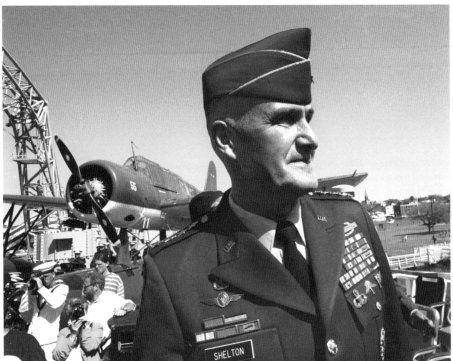

General Hugh Shelton, soon to become chairman of the joint chiefs of staff, attended the fiftieth anniversary of V-J Day (and the end of World War II) at the USS *North Carolina* Battleship Memorial in 1995. It is a source of great pride for Tar Heels that General Shelton is a North Carolinian.

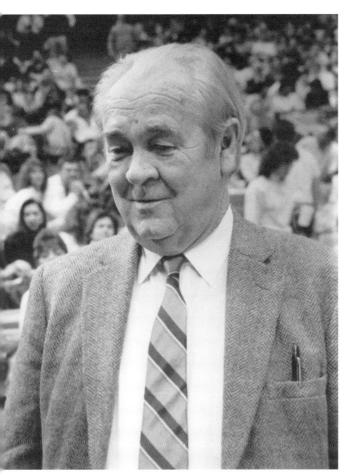
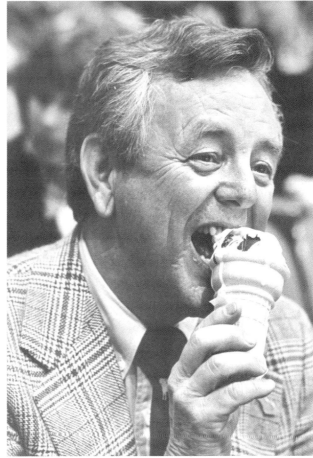

(left)

Representative Liston Ramsey, from Marshall in mountainous Madison County, was a rural populist determined to help the counties of North Carolina that were most lacking in commerce and employment. First elected in 1960, he became Speaker of the North Carolina House of Representatives in 1981. The first House Speaker from the mountains in modern memory, he served four terms in the post, still a record. The impressive Liston Ramsey Center on the campus of Western Carolina University is an appropriate monument to a fine public servant.

(right)

This picture of Hargrove "Skipper" Bowles was made in Philadelphia while Carolina was playing Indiana in the Final Four of the 1981 NCAA basketball tournament. Bowles compiled an outstanding record as director of the North Carolina Department of Conservation and Development in the Sanford administration, and in 1972 he lost a closely contested race for governor to James Holshouser. Over the years I have given at least a dozen copies of this picture to his son, Erskine Bowles, who wanted copies for every child and grandchild. It is Erskine's favorite picture of his father. When Skipper told me he was going to raise $30 million to build a basketball arena in Chapel Hill—what is now called the Dean Dome—I told him he was out of his mind, but he did it. He was a phenomenal promoter.

Shown here as delegates to the 1964 Democratic National Convention are two of North Carolina's most respected citizens, Congressman L. Richardson Preyer of Greensboro and Thomas Pearsall of Rocky Mount. Rich Preyer was so highly regarded by his fellow members of Congress that they named him chairman of the House committee to investigate the assassination of President John F. Kennedy. Tom Pearsall, a lawyer, farmer, and former legislator, worked with Governor Luther Hodges to develop the Pearsall Plan to keep North Carolina public schools open following the 1954 Supreme Court decision in *Brown vs. Board of Education* that called for the integration of public schools. While the court's decision resulted in the closing of schools in nearby states, the Tar Heel State kept a cool head, and not a single child missed a day of school in reaction to the Supreme Court action.

Wilbur Hobby was president of the North Carolina AFL-CIO and a candidate for governor in the 1972 Democratic primary. At the 1972 Democratic Convention in Miami most North Carolina delegates were supporting favorite son Terry Sanford for president, but Wilbur asserted his independence by plugging for George McGovern. Hobby's campaign slogan in his bid for governor was "Keep the Big Boys Honest." Much later, in 1981, Hobby was convicted of fraud and conspiracy, and served a year in federal prison.

Shown at an alumni reception in Chapel Hill in 1986, these former chief justices of the North Carolina Supreme Court, Susie Sharpe and William Bobbitt, were among the most distinguished and respected individuals ever to serve on that august body. Justice Sharpe was the first woman member of the Supreme Court, and the only woman to serve as its chief justice. Frequently sought for gatherings throughout the state, one was rarely seen without the other. Their deep and abiding friendship in itself was a pleasure to their friends and admirers.

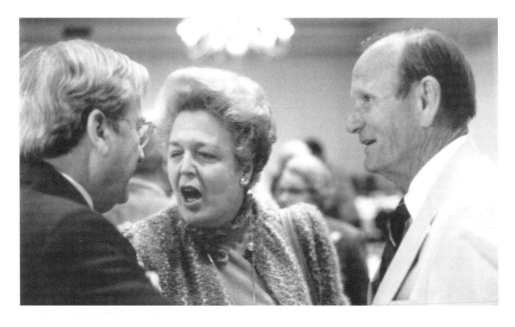

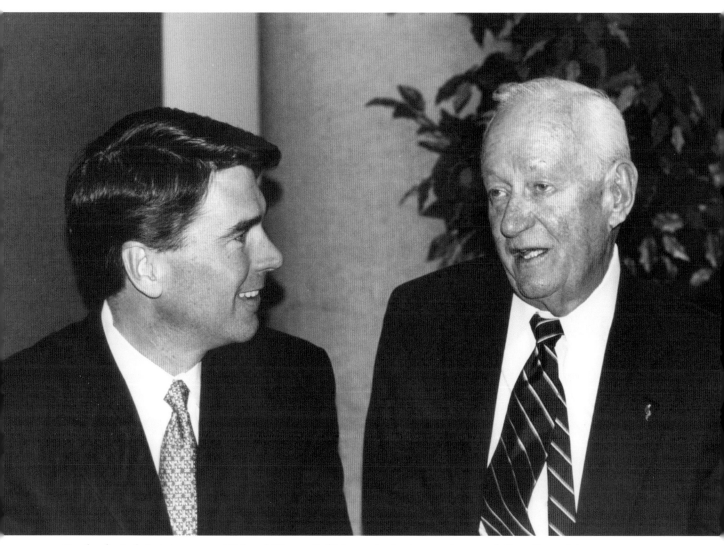

Newly elected state treasurer Richard Moore (left) knew he had a tough act to follow, for retiring state treasurer Harlan Boyles had served North Carolina well, caring for its finances for more than thirty years. Most important, Boyles protected the state's AAA bond rating, something it was hard for Treasurer Moore to do in the difficult budget year of 2002.

(opposite)
Betty Ray McCain is telling Ed Rankin what she thinks, as an amused Bert Bennett looks on. Bennett was the behind-the-scenes political boss in the Sanford and Hunt administrations, and Rankin held high posts with Governors Umstead, Hodges, and Moore. Betty McCain was a valued member of the Board of Governors of the University System and served with distinction as secretary of cultural resources for Governor Hunt. The trio was in the center of political activity for three decades.

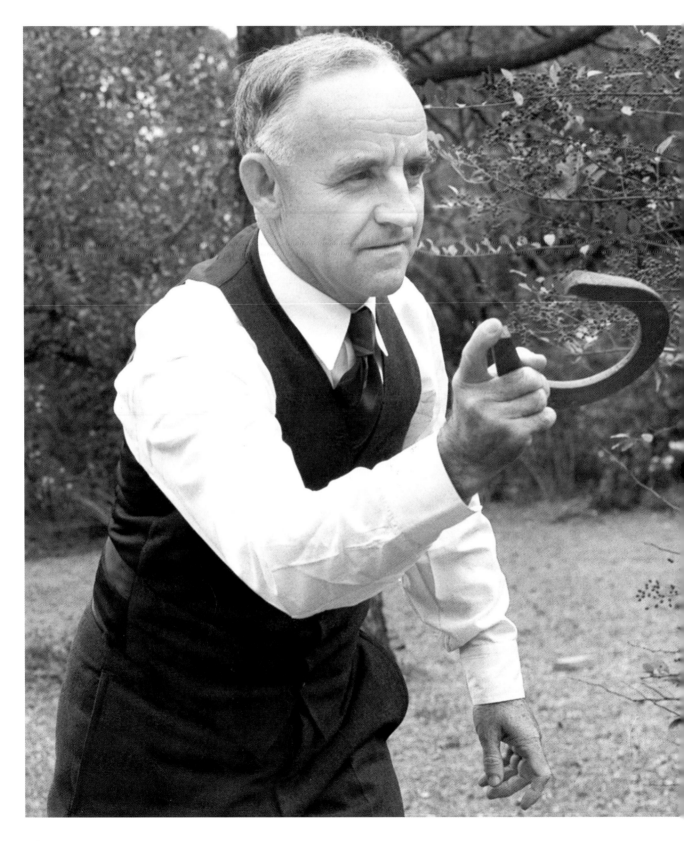

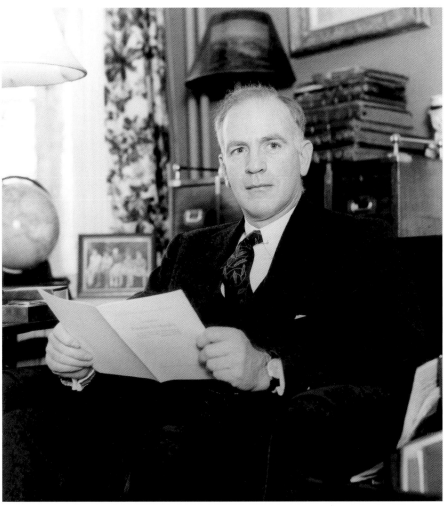

I photographed Gordon Gray, president of the University of North Carolina, at the request of Carl Goerch for the cover of *The State* magazine, of which Goerch was the editor. As secretary of the army during World War II, Gray had been General Dwight D. Eisenhower's boss. After the war, he succeeded Frank Porter Graham as UNC president. Helped by Billy Carmichael and Kay Kyser, Gray brought public television to the university and was instrumental in the formation of the Atlantic Coast Conference. He fine-tuned the organization and management of the university and headed the first national commission to study health care. He left the university at the request of President Eisenhower to serve the president in national security affairs. Gray's youthful assistant, Dr. Bill Friday, was named to succeed him as president of the university.

(opposite)

When I was a timid freshman at Chapel Hill in the fall of 1939, my grandfather, Hugh MacRae, asked his good friend Dr. Frank Porter Graham to invite me to the president's residence for his Sunday afternoon open house. Dr. Graham soon recognized that I was not at ease in the presence of the president of the university, and, attempting to make me more comfortable, he invited me to join him in a game of horseshoes in the back yard. We had fun, and he beat me. He also let me take his picture, which was widely published then and has been ever since.

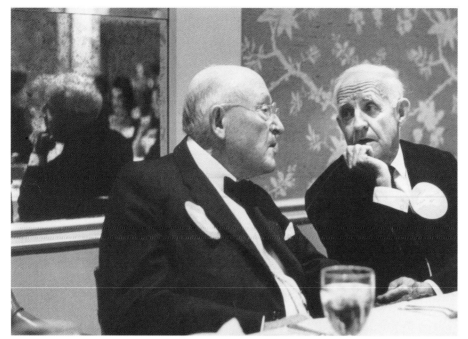

The UNC Alumni Association banquet in New York in 1964 was attended by John Motley Morehead (left), who endowed the Morehead Scholarships, and Dr. Frank Porter Graham. Mr. Morehead died within months of the Alumni Association gathering. The benefits of his scholarship program have made a tremendous contribution to higher education in North Carolina.

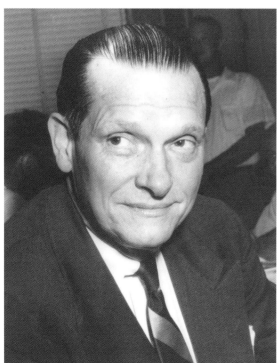

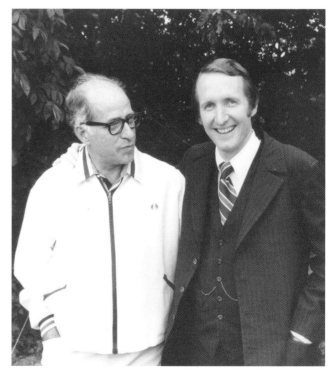

(left)
Wall Street broker William D. Carmichael returned to Chapel Hill to become comptroller, the business manager, of the University of North Carolina. The urbane Billy Carmichael was not a logical choice to make a hit with the good old boys in the legislature, but they loved him. The legislators treasured Billy's calling card which stated, "You Cannot Build a Vast University with a Half Vast Budget."

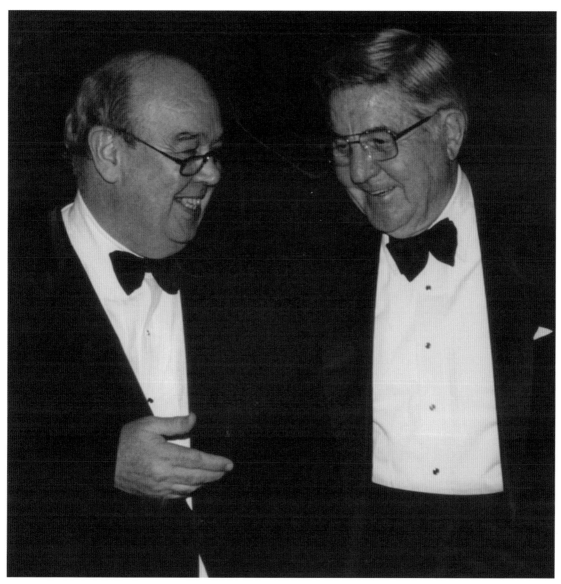

Charles Kuralt (left) joined William Friday to celebrate twenty-five years of Friday's show "North Carolina People," which airs on the state's public television network. The friendship between Kuralt and Friday began in the 1950s when Kuralt was editor of the *Daily Tar Heel*. It ended only with Kuralt's death some forty years later, when Friday accomplished the impossible by obtaining for Kuralt and his wife, Petey, plots in the old cemetery at Chapel Hill.

(opposite, bottom right)
Chapel Hill Newspaper publisher Orville Campbell (left) also had a recording company. George Hamilton IV, a UNC student from Winston-Salem, persuaded Campbell to record an original Hamilton song called "A Rose and a Baby Ruth." The record was an immediate hit nationwide, and Hamilton soon became a regular at the Grand Ole Opry in Nashville. George Hamilton IV has been popular on the American music scene for years, and "idolized" would be a better word to describe his standing as an entertainer in the British Isles.

UNC chancellor James Moeser and Governor Michael Easley listen attentively to Charlie Rose, a Henderson, North Carolina, native who is host of his own show on the Public Broadcasting System and a regular on CBS's "60 Minutes II." Rose was in Chapel Hill to serve as master of ceremonies for the thirty-fifth anniversary of Bill Friday's "North Carolina People."

(opposite)
Dr. William Friday and his wife, Ida (left), were honored in February 2003 by the creation of the Friday Institute for Educational Innovation, whose mission is to harness creativity to advance science and mathematics education, at North Carolina State University. Chancellor Mary Anne Fox (right) and College of Education dean Kay Moore said the institute, which will be housed in an impressive new building on the university's Centennial Campus, will serve students in middle school and high school, as well as those in college, and their teachers.

Chancellor Frank Borkowski of Appalachian State University is proud that Appalachian was named by *Time* magazine in 2001 as the College of the Year. The chancellor is also proud of the medal he is holding, that of Commander of the Cross of the Order of Merit of the Republic of Poland, the highest honor that that country can bestow on a noncitizen, which was awarded to Borkowski in recognition of his leadership in developing cooperative agreements between U.S. and Polish universities and promoting Polish arts and culture.

Everyone was amused by the comments of Michael Jordan and Charlie Scott, the former players whom Coach Dean Smith chose to be the main speakers when he received the prestigious University Award from the Board of Governors of the sixteen-unit University System in 1998. In the front row of the audience at the award ceremony are, left to right, Michael Hooker, UNC chancellor; William Aycock, former UNC chancellor; and UNC System president Molly Broad.

Banker Robert M. Hanes, of Winston-Salem, was justly proud that R. J. Reynolds named two of its cigarette brands Winston and Salem in the mid-1950s. Hanes was a valuable colleague for Governor Luther H. Hodges in the formation of the Research Triangle Park, and he was chairman of the extremely active Commerce and Industry Committee of the Board of Conservation and Development, which generated much new and expanded industry for North Carolina.

(left)

It was a rare opportunity, and I took quick advantage of it, to make a photo of three distinguished Belk brothers, all sons of William Henry Belk, founder of the Belk Stores empire, in 1993. Left to right are Irwin "Ike" Belk, John M. Belk, and Thomas M. Belk, all of whom have been active in countless ways in government, education, industry, and philanthropy. The Belk chain currently has over 200 stores in thirteen states, making it easily the largest department store chain with its origins in North Carolina.

(right)

In the 1940s and 1950s Richard S. Tufts, president of Pinehurst, Inc., did more than any other person to promote tourism and golf in North Carolina. Tufts was a member of the State Advertising Committee of the Board of Conservation and Development. This picture was taken in the late 1940s at Linville.

(opposite)

Winston-Salem-based Piedmont Airlines operated between 1948 and 1989, when the airline merged with USAir. Airline president Thomas Davis (right) and Bill McGee, his top assistant, were the gentlemen most responsible for Piedmont's popularity and efficient operation. North Carolinians had good air connections to most major destinations, and at reasonable prices, during the Piedmont Airlines era. It seems hardly a day passes that I don't hear someone say they wish Piedmont Airlines was still operating.

Frank H. Kenan (left) and George Watts Hill Jr. in their day were two of the University of North Carolina's most generous benefactors. Kenan was a particularly strong supporter of the business school, now officially designated the Kenan-Flagler Business School, and the sumptuous UNC Alumni Center is named for Watts Hill.

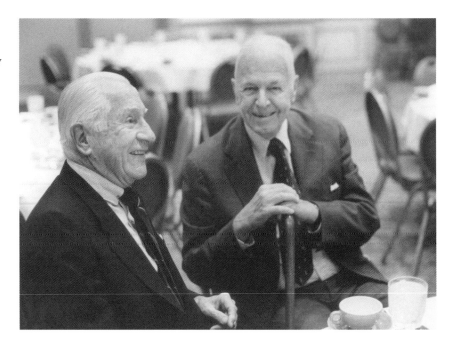

Norman Cocke (right), a summer resident of Linville and the CEO of Duke Power Company, hosted Charles E. Wilson, CEO of General Electric, for a game of golf in 1950. At high noon their caps cast deep shadows across their faces, so I had to use a flash bulb. When I looked at the bulb, to my relief it was a GE bulb, and I told Mr. Wilson that it was. "Yes, son," he said, "and there's nothing better but God's own sunlight." The largest lake in North Carolina, Lake Norman, is named for Norman Cocke.

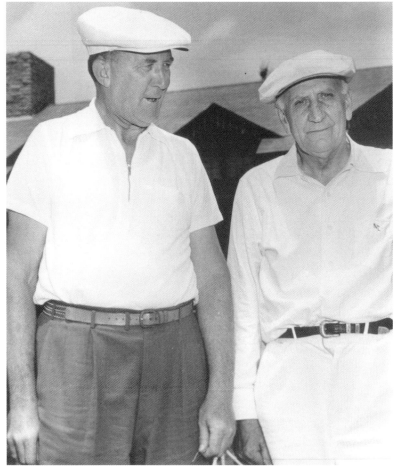

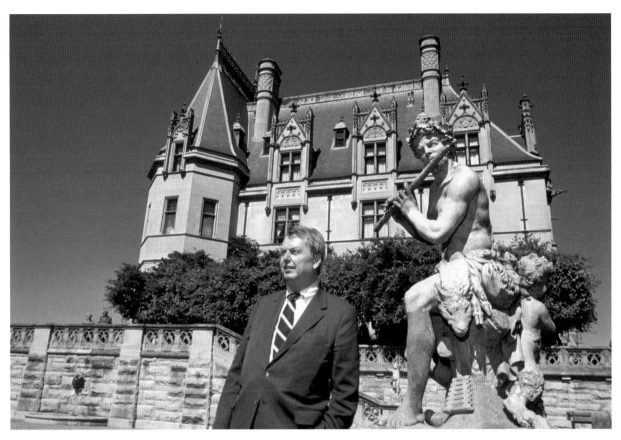

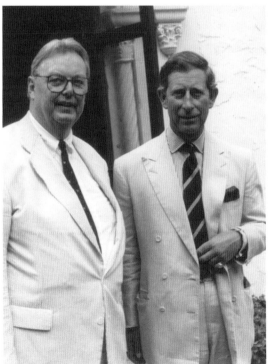

(top)
I have immense admiration for William A. V. Cecil, owner of Biltmore House and Gardens, for his success in preserving and operating the magnificent mansion built by his grandfather, George Vanderbilt. Vanderbilt constructed the Biltmore mansion in 1895, and Cecil has restored the mansion and grounds and maintained and operated the estate as one of America's foremost historic attractions.

(bottom)
Charles, Prince of Wales (right), active in preserving historic structures in Great Britain, came to Asheville to view the outstanding historic preservation work of William A. V. Cecil at Biltmore House and Gardens.

Hugh McColl (left), the CEO who led North Carolina National Bank in its rise to become one of America's largest banks, with the new name Bank of America, and Felton Capel, a resourceful North Carolina entrepreneur, are both strong supporters of the University of North Carolina System. They were all smiles upon being presented the 2001 University Award for their significant work.

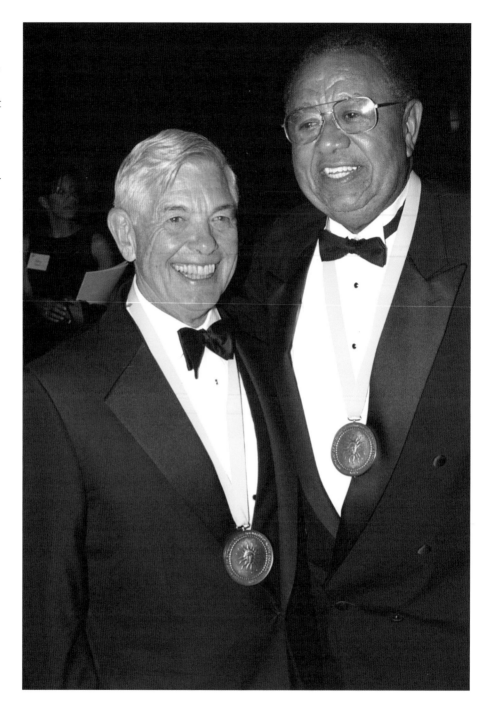

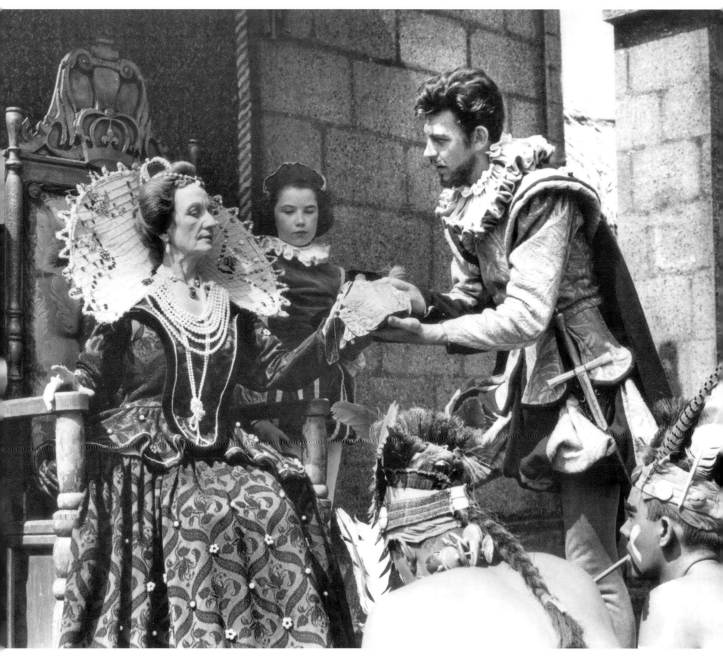

Paul Green's *Lost Colony* was the first outdoor historical drama, and it is still the longest running outdoor drama in the nation. In this scene from a late 1940s production, Andy Griffith as Sir Walter Raleigh is presenting to Queen Elizabeth tobacco that his colonists brought back to England from the New World.

(top)

Andy Griffith's entry into big-time show business resulted from the overnight success of the recording of his original recitation, "What It Was Was Football." In the early 1950s Griffith returned from Broadway, where he was starring in *No Time for Sergeants*, to perform his football recitation at halftime of a Kenan Stadium game, and the ovation he received was resounding.

(bottom)

On October 16, 2002, the North Carolina Department of Transportation honored Mount Airy's famous native son, Andy Griffith, by designating ten miles of U.S. Highway 52 from Mount Airy to the Virginia state line as the Andy Griffith Parkway. An enthusiastic crowd from Mount Airy and beyond—including Governor Mike Easley (right of Griffith, behind the sign)—gladly endured the drizzling rain to hear Griffith describe in detail his growing up in Mount Airy and the development of the "Andy Griffith Show."

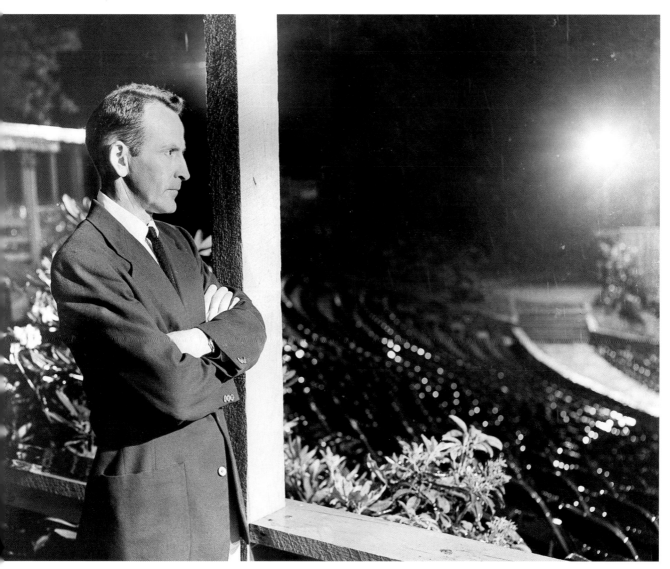

Kermit Hunter was the author of two successful outdoor dramas in North Carolina: *Unto These Hills* at Cherokee and *Horn in the West* at Boone. He is shown here checking out the *Horn in the West* theater before opening night.

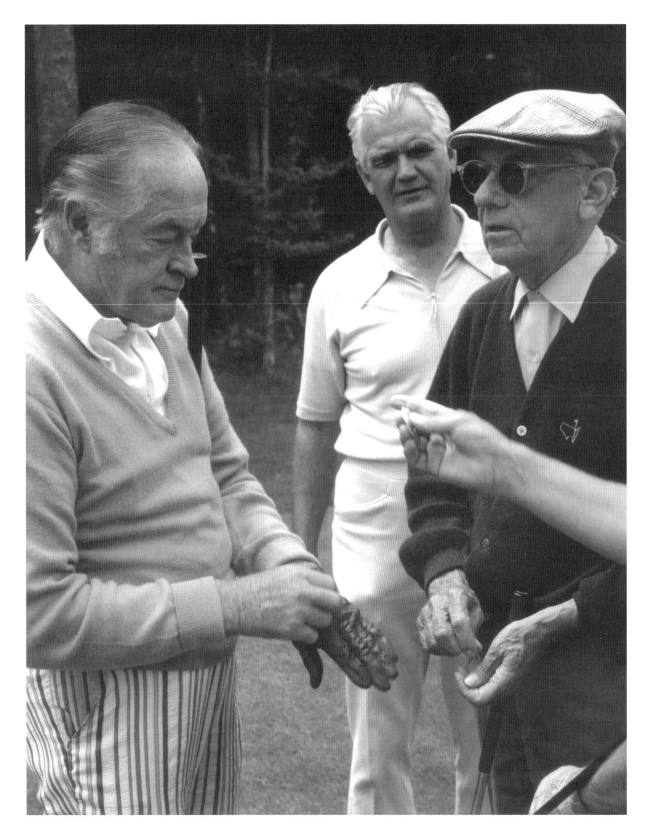

Lexington artist Bob Timberlake has often lent his considerable talents to worthy causes, and one of his best paintings was of actor Iron Eyes Cody in 1979 for a Keep America Beautiful poster. Here Bob compares my photograph of Iron Eyes with his own poster of the Native American who had appeared in scores of Hollywood films. Timberlake also painted a portrait of Iron Eyes for a U.S. postage stamp.

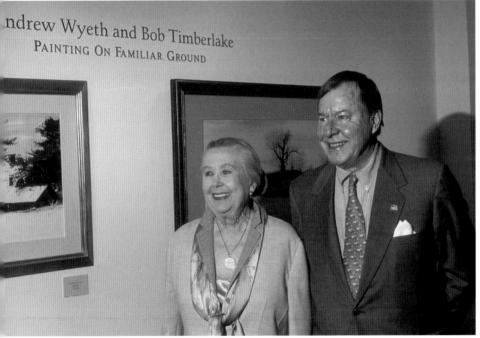

Betty Kenan, widow of Frank H. Kenan, and Frank's son Tom Kenan were hosts at a reception in the Chapel Hill Museum in 2002 for an exhibition of art by Andrew Wyeth and Bob Timberlake titled "Painting on Familiar Ground." The Kenans are carrying on the family tradition of supporting the arts and education in the state and throughout the nation. Over the years, no foundation has exceeded the generosity of the Kenan Foundation in North Carolina.

(opposite)
Bob Hope (left) entertained the troops of General William Westmoreland (center) during the Vietnam War, and after the war Hope visited the Westmorelands at Grandfather Country Club a couple of times. On this occasion, they were joined by Clifford Roberts, Grandfather member who, with golfing legend Bobby Jones, built Augusta National Golf Club. Hope had a personal rule that wherever he went, he remained on Los Angeles time. This kept the Westmorelands up late at night, but nothing was allowed to interfere with golf.

During a weekend at the beach in 1951 Carl Goerch (left), founding publisher and editor of *The State* magazine (first published in 1933), negotiated for skilled writer and author Bill Sharpe (right) to purchase the publication, with Sally Sharpe looking on. Sharpe, who had done an outstanding job promoting tourism as head of the North Carolina News Bureau, did a similarly fine job editing *The State* for a number of years.

In a photograph made in the late 1950s, David Stick (standing), noted historian of coastal North Carolina and the many shipwrecks in the "Graveyard of the Atlantic" offshore of the Outer Banks, is looking over the shoulder of the legendary Aycock Brown, "the Barker of the Banks," whose stories and photographs persuaded millions to plan visits to the Outer Banks.

(top)
Grady Cole was the early morning voice of WBT Radio in Charlotte in the period after World War II, when the 50,000-watt station was heard up and down the East Coast. Cole was so well known that *Collier's Magazine* did a feature on him, and I was assigned to do the photographs.

(bottom)
In 1959 Charles H. Crutchfield (right), president of Jefferson Standard Broadcasting, threw a twenty-fifth anniversary party for his early morning star on WBT Radio, Grady Cole. Crutchfield was the Carolinas' pioneer in advancing television at WBTV and other stations. Cole's booming voice reached millions of farmers and other early risers over the 50,000-watt airwaves of WBT, and he was a power in advertising and in molding public opinion over the radio before the new medium of television caught on.

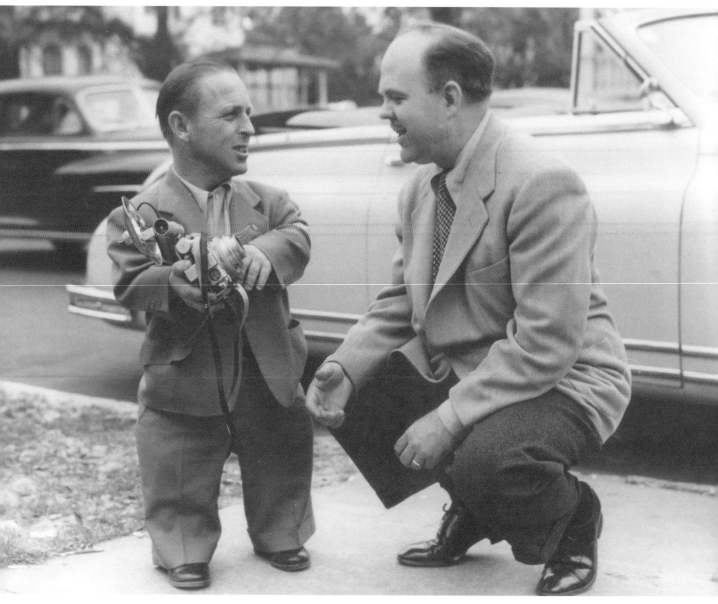

Billy Arthur (left) has held nearly every journalistic job—reporter, photographer, columnist, editor, and publisher. On this occasion he was lining up a picture of ABC Radio Network personality Ted Malone at the 1949 North Carolina Azalea Festival at Wilmington. In his college days Arthur was the head cheerleader at UNC, and he has never stopped cheering for everything good in North Carolina.

(opposite)
I don't remember setting this up. Frank Daniels Jr., publisher of the Raleigh *News and Observer*, just happened to strike the same pose as the statue of his illustrious grandfather, Josephus Daniels, which is located in the park across McDowell Street from the *News and Observer* building. Josephus Daniels founded the paper in 1894, and it has operated since with the apparent major interest of keeping the state's politicians honest.

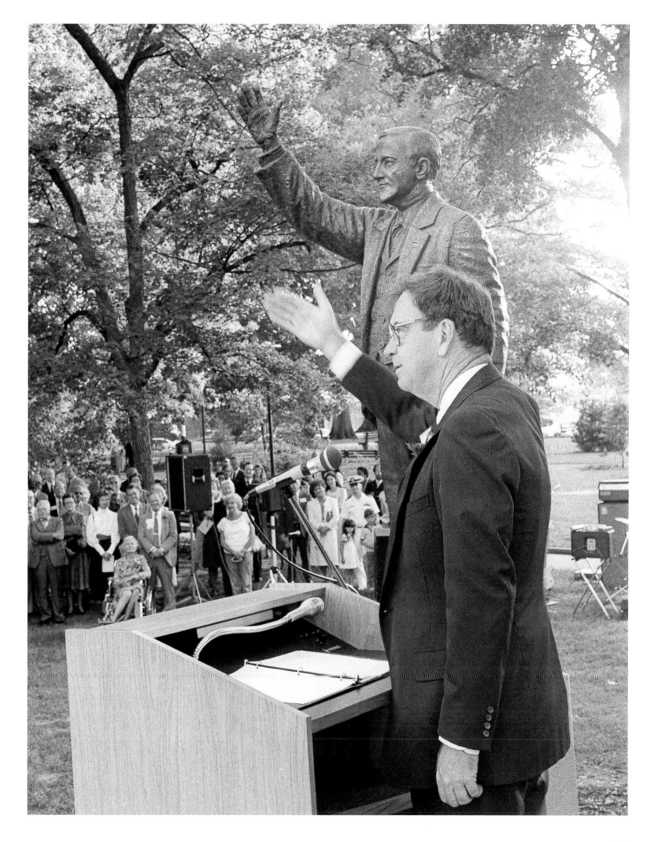

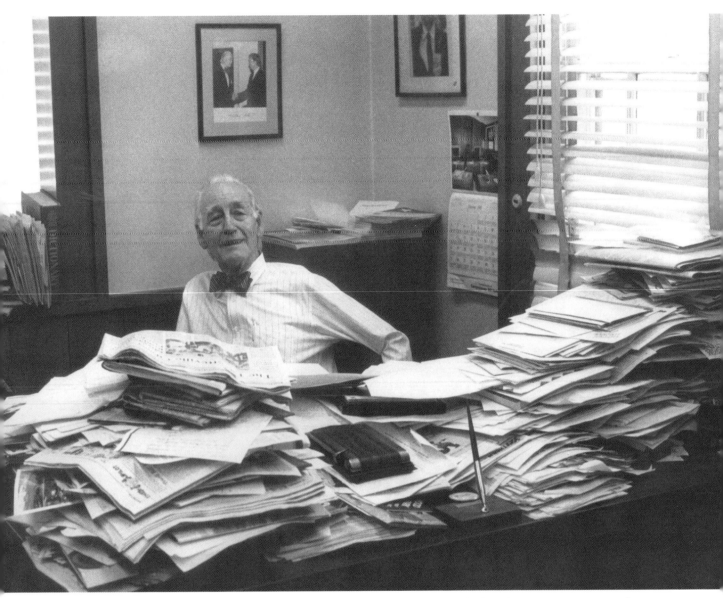

Sam Ragan gave comfort to those of us with desks like his when he edited *The Pilot* newspaper in Southern Pines, following years of service as managing editor of the Raleigh *News and Observer*. As state secretary of cultural resources Ragan was very active in literary affairs in North Carolina.

I caught Doris Betts (left), author and University of North Carolina professor of creative writing, and Mary Duke Biddle Trent Semans, chair of the Duke Endowment, at a meeting of the North Caroliniana Society in 1998. Betts was receiving the annual award of the society that year. Both ladies have been active for years in the advancement of educational, literary, and cultural affairs in our state.

Charles Kuralt (standing) wrote most of the words and Loonis Mc-Glohon set them to music, and they called their production "North Carolina Is My Home." Those who saw Charles and Loonis present it in person, and those who saw it on videotape or heard it on recordings, were in near unanimous agreement that it was the most patriotic and charming portrayal of the Tar Heel State that they could remember.

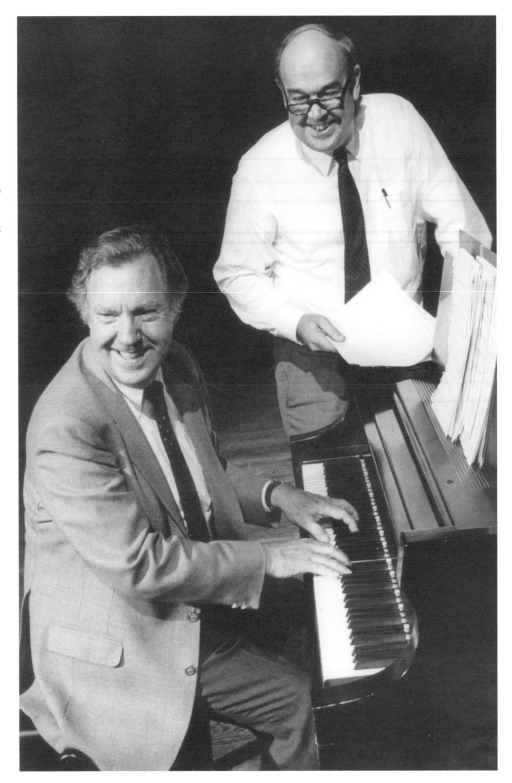

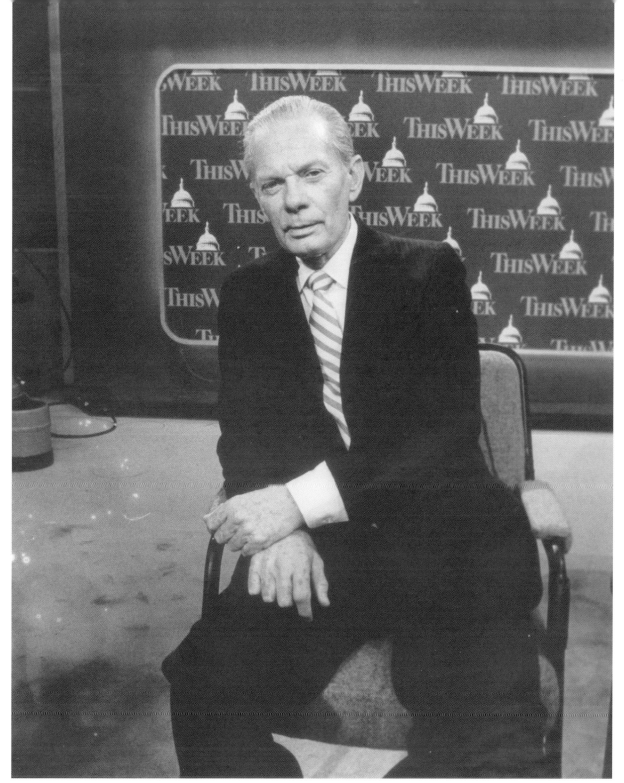

Almost to a man, other newspeople considered David Brinkley the most credible and reliable television news personality in Washington. Brinkley grew up in Wilmington and attended New Hanover High, and in the summertime he rented beach mats at Lumina Ballroom at Wrightsville Beach, where he became, like me, an ardent follower of the Big Bands that used to play there.

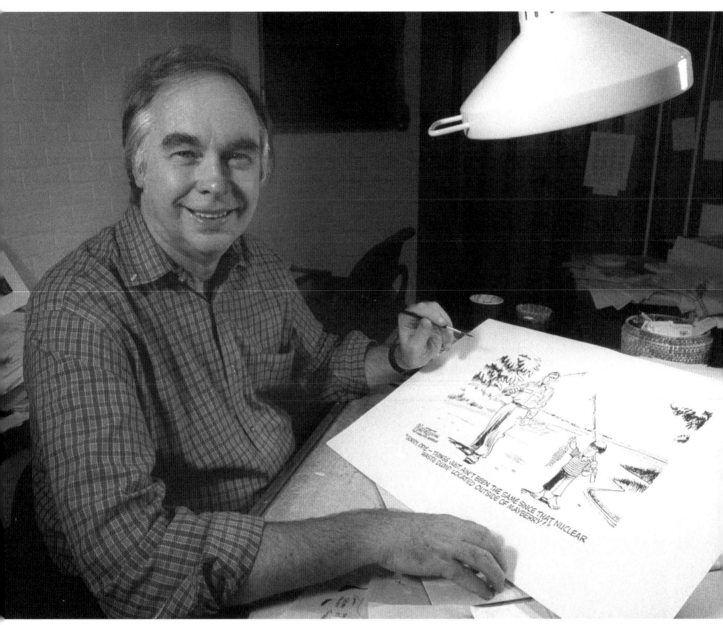

In his Hillsborough studio, Pulitzer Prize winner Doug Marlette, whose editorial cartoons are syndicated to more than 300 newspapers around the nation and world, puts the finishing touches on a cartoon highlighting a danger that North Carolina hopes to avoid. Instead of a fish on his stringer, Opie is holding a fish skeleton, and Andy is saying: "Sorry, Opie—things just ain't been the same since that nuclear waste dump located outside of Mayberry!"

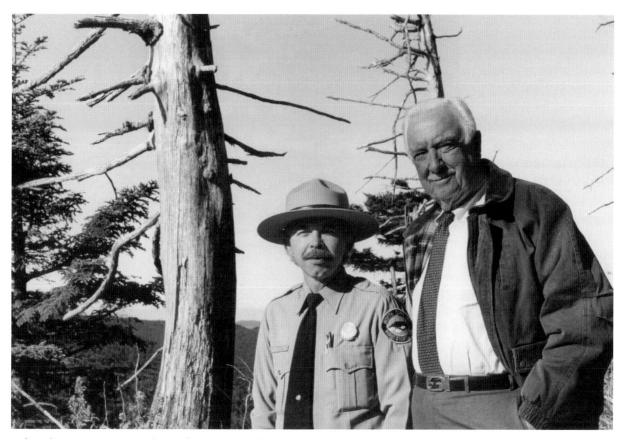

John Sharpe, superintendent of Mount Mitchell State Park, welcomed famous television newsman Walter Cronkite to the top of the highest peak in eastern America to narrate the opening and closing scenes for the hour-long PBS program titled "The Search for Clean Air." Acid rain from air pollution has created severe forest devastation on Mount Mitchell and other high mountains of the South.

The eye of Hurricane Hazel came ashore October 15, 1954, at Carolina Beach at full moon high tide, the worst scenario possible. It killed nineteen people in North Carolina, and caused property losses totaling $125 million. This scene at Carolina Beach during the peak of the storm won first place in the spot news category of the North Carolina Press Photographers competition. Wading through the debris is Julian Scheer, reporter for the *Charlotte News*, who later became public relations director for NASA during exciting days of space exploration and the manned moon landing.

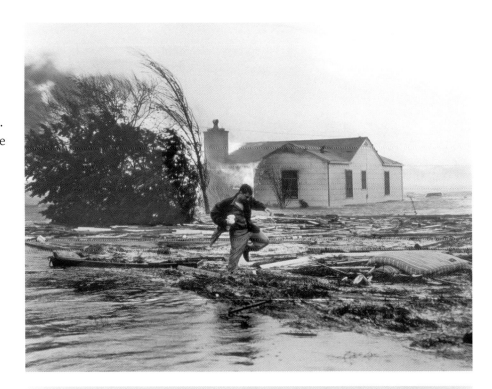

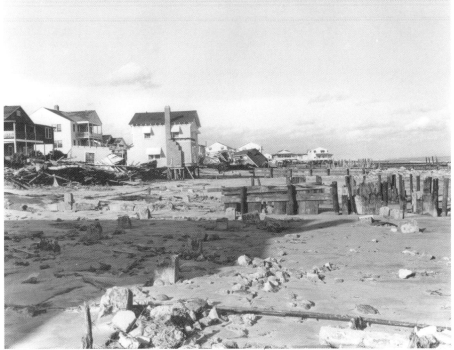

When Hurricane Hazel struck Wrightsville Beach in October 1954, the front surfside homes were knocked from their pilings and destroyed by the force of the storm. Hazel was the most severe hurricane in the memory of residents of the southern part of the North Carolina coast.

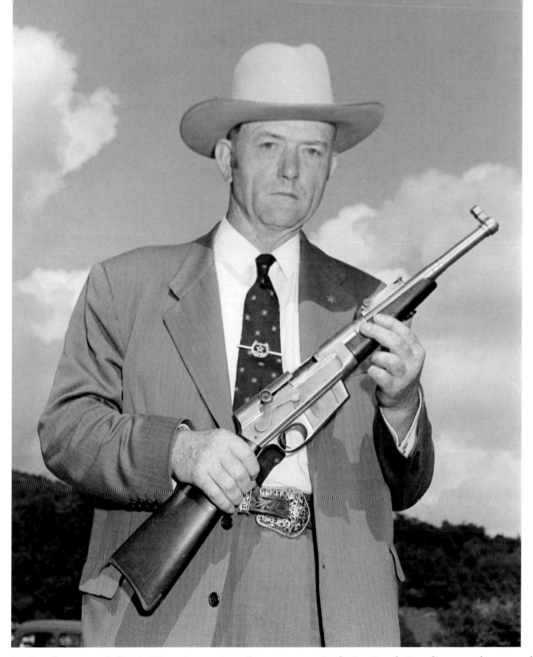

In October 1950 *Collier's Magazine* assigned me to go to Godwin, North Carolina, to photograph Marshall Williams, who invented guns. The assignment editor said to be sure to take pictures of Williams standing in the doorway of his workshop, test firing one of his guns into the cotton field out back. That is all I was told, and when Williams picked up a standard U.S. Army carbine to test fire, I said, "No, Mr. Williams, not that Army carbine; I want you with one of your guns." He gave me a withering stare and said, "I invented it." The story ran in the March 3, 1951, issue, and only then did I learn the full story of David Marshall "Carbine" Williams. He invented the carbine while serving a prison sentence after a revenue officer was killed in a raid on a whiskey still said to be owned by Williams. Williams was a firearms genius who held dozens of patents, and although hardened by prison, he was fiercely loyal to the United States government responsible for his confinement. The carbine was one of the main small arms weapons used by the United States in World War II. In this photo Williams is holding one of the many other guns he invented.

In 1954 Osley Bird Saunooke was the duly elected chief of the Eastern Band of Cherokees, while at the same time holding the title of heavyweight wrestling champion of the world. Though perhaps not entirely enthusiastic about it, Chief Saunooke was willing to don a non-Cherokee headdress while posing for press photographers at the Grandfather Mountain Camera Clinic.

The ancient UNC gymnasium known as the "Tin Can" was the site for a big student dance in the winter of 1942 that featured Tommy Dorsey, his trombone, and his orchestra. At the right are Jo Stafford and Frank Sinatra of the Pied Pipers, and in the left background is Dorsey's famous drummer, Buddy Rich.

It was an exciting day for me when Benny Goodman, "the King of Swing," was a featured guest performer with the Greensboro Symphony Orchestra in 1979. Family friends Allen and Penny Preyer invited me to join them in their up-front seats in Greensboro Coliseum, and I was amazed that Goodman was just as good as he had been in the late 1930s when I was a teenager and he had in his band stars like Harry James, Gene Krupa, Teddy Wilson, and Lionel Hampton.

Lionel Hampton was an outstanding vibraphonist and member of the Benny Goodman Quartet, which brought him international fame. In 1981 Hampton brought his own band to play a dance in the indoor tennis facility at Grandfather Country Club at Linville.

(*opposite*)

In 1967 legendary trumpeter Louis Armstrong filled Brogden Hall at Wilmington's New Hanover High School with music fans, including five-year-old John Ponos, proud owner of a tiny trumpet that he was determined to show Louis. Those of us who witnessed the meeting between the two trumpet players will not forget the excitement the skilled showman gave young John with the suggestion that maybe they should exchange horns.

From an early age, Doc Watson (seated) was determined to be self-supporting, in spite of being totally blind. He and Jack Williams, shown here with Watson in a photograph taken in 1953, were members of a band that played for small dances and family gatherings, while Doc's day job was tuning pianos. The big break that led to his fame and fortune came when Doc Watson was "discovered" in Boone by Ralph Rinzler of the Smithsonian Institution.

Lulabelle and Scotty Wiseman (right) were stars on the WLS Chicago Radio Barn Dance for twenty-five years before returning to Route 2, Spruce Pine, to semi-retirement. Along with Roy Acuff (left), the "King of Country Music," they were members of the Country Music Hall of Fame. Scotty Wiseman was an accomplished songwriter, his most successful hit being "Have I Told You Lately That I Love You." Lulabelle was so popular that she was the only Democrat from Avery County in modern memory to be elected to the North Carolina General Assembly. Scotty Wiseman and Bascom Lamar Lunsford wrote the country music tune "That Good Old Mountain Dew." This photo was taken when Acuff and the Wisemans visited Grandfather Mountain for the 1975 Singing on the Mountain.

At the peak of their television and public appearance popularity in the 1960s, this was the lineup of Arthur Smith and the Cracker-Jacks, left to right: Arthur Smith, brother Ralph Smith, Clyde "Cloudy" McLean, brother Sonny Smith, Tommy Faile, and Don Reno. McLean received his name "Cloudy" because he was WBTV's main weatherman, as well as the Cracker-Jacks' announcer. The Charlotte-based group was on early morning television in every major market from Texas to Baltimore.

Two of the world's great banjo pickers, Arthur Smith (left) and Raymond Fairchild, warm up with "Dueling Banjos," the best-selling banjo tune in history, which Arthur Smith wrote. They were in the Loonis McGlohon Theater in Charlotte in 2001 to record a program for the North Carolina Public Television Network.

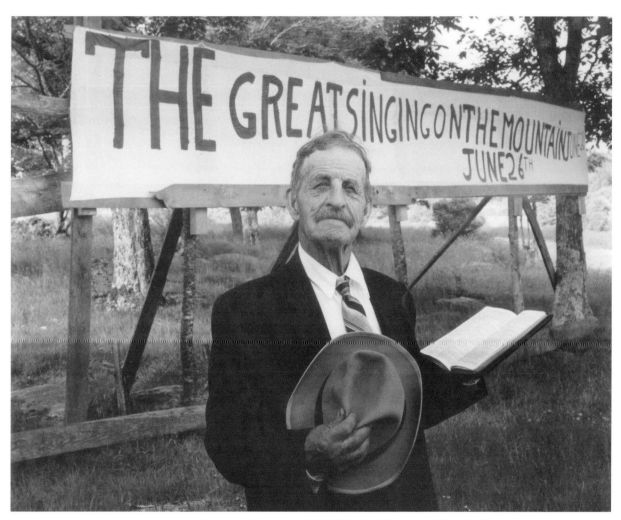

In the summer of 1960, Joe L. Hartley, with hat in one hand and Bible in the other, had just finished painting his "Singing on the Mountain" sign beside the highway at the base of Grandfather Mountain. Hartley, the founder of the all-day singing, preaching, Sunday school picnic, and family reunion, was convinced that his sign was the main reason that many thousands attended. It never seemed to dawn on him that Arthur Smith, who had a popular syndicated early morning TV show that was listened to all over the Southeast, was plugging the daylights out of Singing on the Mountain, inviting everyone to join Arthur's band there.

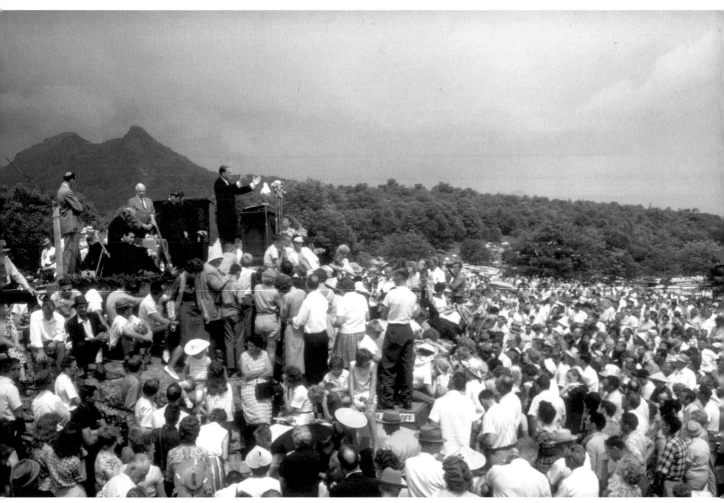

Singing on the Mountain is always the fourth Sunday in June, except the one time it was changed to August in 1963 to fit the schedule of Dr. Billy Graham, who drew tens of thousands of people, the largest audience ever assembled in the southern mountains. Thunderstorms were in progress in three different directions, but when Dr. Graham stood up to preach, the sun came out brightly. The Highway Patrol cautioned everyone not to try to rush home because U.S. 221 that passes the singing grounds was blocked from Marion to Blowing Rock, a distance of fifty-five miles.

(opposite, bottom)
Throughout his life Dr. Billy Graham has claimed North Carolina as his home, while for fifty years the Billy Graham Evangelistic Association has been headquartered in Minneapolis. When the downtown offices of the ever-expanding worldwide ministry became too cramped in 2002, a decision was made to construct a larger headquarters complex in Charlotte on Billy Graham Parkway, a few miles from the site of Dr. Graham's birth. The distinguished and excited group breaking ground for the new home in Charlotte included (front, left to right) Governor Michael Easley, Dr. Billy Graham, and the Reverend Franklin Graham and (back, left to right) the Reverend David Chadwick and Bishop George Battle.

The resemblance between Dr. Billy Graham and his son, the Reverend Franklin Graham, is remarkable. I made this picture on the day Franklin's Samaritan's Purse Headquarters in Boone was dedicated. Franklin still heads Samaritan's Purse in its missionary work in needy areas around the world, and he has taken on the duties of president of the Billy Graham organization to help lighten the tremendous responsibilities of his father.

It is hard to argue with the sentiments expressed in this sign, especially when the serpent that tempted Eve is there for added emphasis. But the truth is that the State Transportation Department says it is against the law, and therefore at least a misdemeanor if not a sin, to tack any other sign onto a state traffic sign. I don't know what a judge might say, but I feel there is charm in the message of Big Flats Baptist Church in Watauga County.

(opposite)
Julia Wolfe, mother of Thomas Wolfe, stands in the doorway of the Old Kentucky Home, the boarding house she maintained in Asheville. I was sent there in 1941 by the UNC student publication *Carolina Magazine* to photograph whatever I could that related to Thomas Wolfe, the famous author and Carolina alumnus. Wolfe was somewhat unkind to his mother in the book I told her I had studied, *Look Homeward, Angel*, so at first Mrs. Wolfe was not sure whether I was friend or foe. Eventually she received me as a friend, showed me pictures of Tom in her scrapbook, and rode with me to the cemetery to visit his grave.

I went to Luther Thomas's ninetieth birthday party near Burnsville, and found him with his six-year-old great-great-grandson sitting on his knee. That was remarkable enough, but more remarkable still is the fact that the wooden flower he had carved, with its long, narrow stem and open-ing petals, was carved from a single, unbroken and unglued piece of wood. My hat is off to someone who is that skilled, patient, and alert at age ninety.

It was January, and Glenn Causey, who played Daniel Boone in the outdoor drama *Horn in the West*, was back at his winter job teaching school in Arlington, Virginia. A woodsy picture of Causey and his muzzle-loader rifle was needed in the town of Boone for a special promotion, so I arranged to meet Causey at the edge of the Potomac at Theodore Roosevelt Park for the picture session. Causey opened the trunk of his car, picked up the rifle, and was immediately spotted by a by-the-book park ranger who was prepared to arrest us for having a firearm. Ultimately we convinced him that the rifle had not been fired for nearly 100 years, and he let us make the picture.

Richard Brown of Grandfather Mountain is holding wild mountain onions called ramps, believed to have the strongest aroma and taste of any onion. Brown says ramps, which are in season in springtime, are delicious when cooked with fried potatoes. In the old days, mischievous mountain boys knew that when they chewed raw ramps they would be sent home from school, and if they hid ramps behind warm radiators at school the whole class would be sent home.

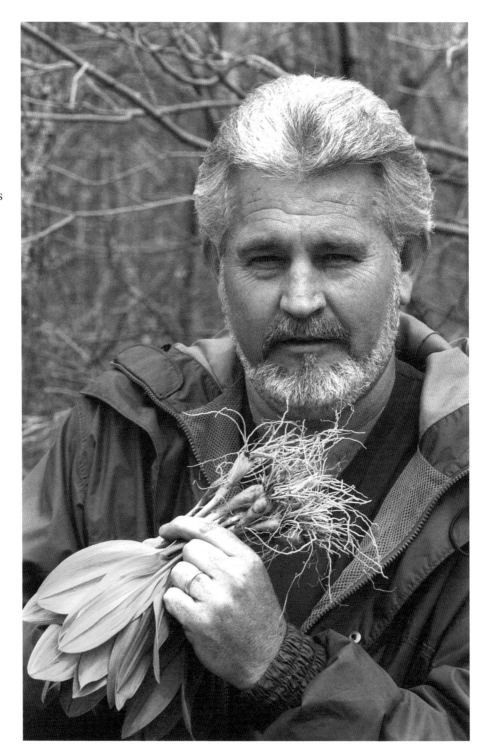

3. Sports

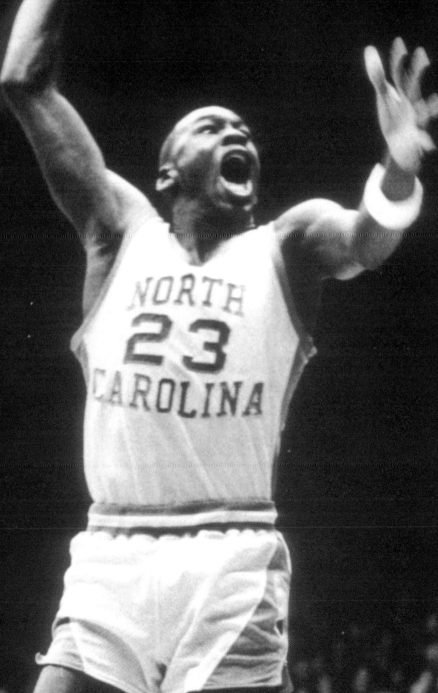

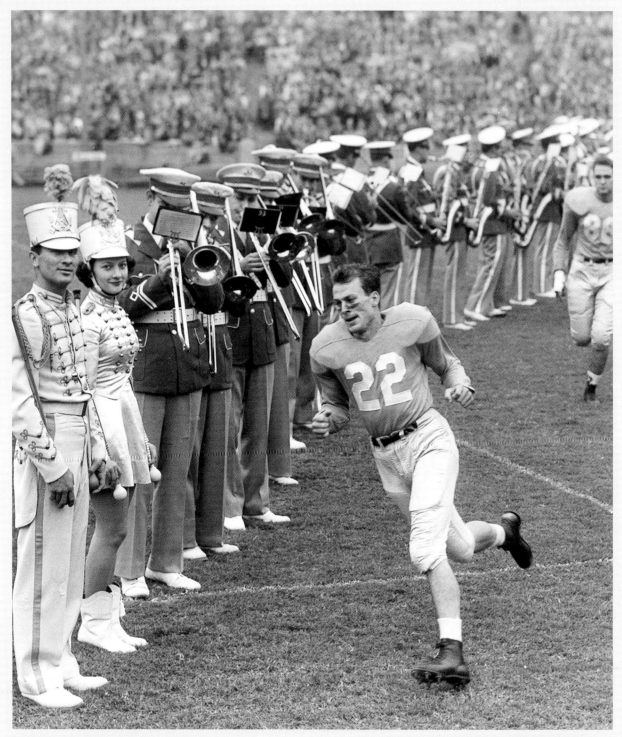

The last time that Charlie Justice ran onto the field in a Carolina uniform was at the 1950 Cotton Bowl in Dallas, where UNC faced Rice University. Charlie had been runner-up to SMU All-American Doak Walker for the Heisman Trophy, and Walker was in the Carolina stands rooting for UNC. But Rice won, 27 to 13.

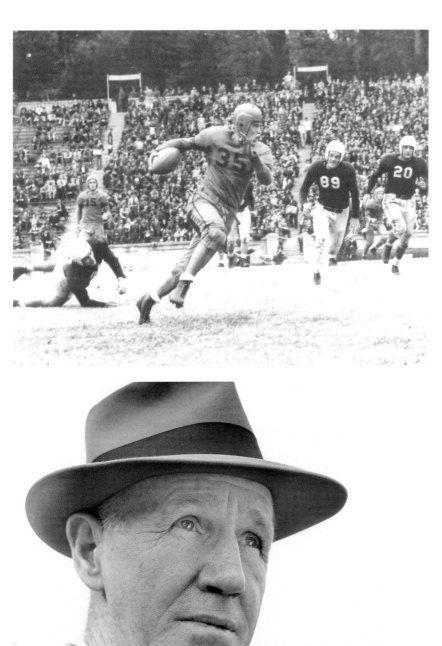

Bill Dudley (35), the University of Virginia's great running back, made possibly his most impressive college run by dashing eighty-nine yards for a touchdown in Kenan Stadium on November 20, 1941, less than three weeks before Pearl Harbor thrust the United States into World War II. Burke Davis, then sports editor of the *Charlotte News* and now a noted historian, ran this picture several columns wide under the headline "I'm Coming, Virginia," which was also the title of a popular swing band era tune. Fred Stallings (89) and Harry Dunkle (20) gave vain chase, and Carolina lost to Virginia, 28 to 7. Bill Dudley and Carolina's Charlie Justice were Washington Redskins teammates following their college careers.

Duke's head football coach, Wallace Wade, a stern disciplinarian with a somewhat brusque style, was feared by a substantial number of those with whom he came in contact (myself among them). When Coach Wade was in the first group to be inducted into the North Carolina Sports Hall of Fame, I mustered the courage to walk up and congratulate him. I was astounded at how warm and friendly he was. He said he knew who I was and even had known my mother in her younger years. He said she was a beautiful redhead.

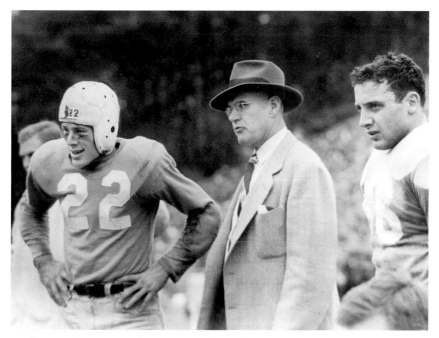

Carl Snavely (center), famous UNC head football coach in the late 1940s, is joined on the sidelines in this photo by Charlie "Choo-Choo" Justice (left) and Paul Rizzo (right), members of one of Carolina's greatest football teams. In 2002 the UNC Athletic Department used this photograph as the centerpiece of an award and tribute for the former blocking back Rizzo. After college Paul Rizzo rose to become vice-chairman of the board of IBM, and upon retirement from IBM, he was dean of the UNC business school from 1982 to 1992.

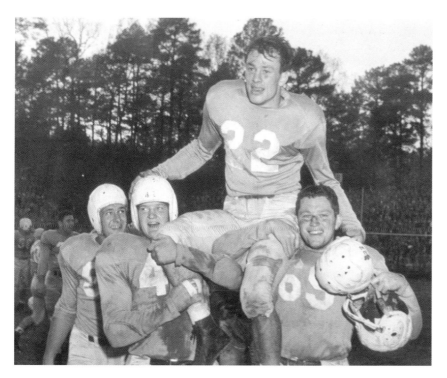

Charlie Justice being carried off the Kenan Stadium field after the 1948 Duke game by teammates (left to right) Joe Niekirk, Bob Mitten, and Bob Cox. Sadly, Bob Mitten died young from a heart attack, but Joe Niekirk went on to become vice-chairman of the board of the Norfolk and Southern Railroad, and Bob Cox was vice-president of the Pepsi-Cola Company, as well as president of the national organization of the Jaycees.

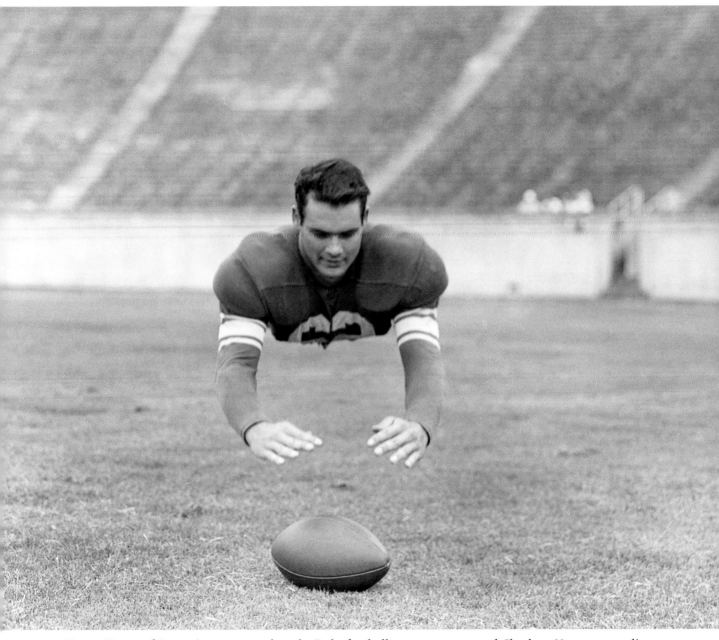

Jimmy Knotts of Gastonia was a guard on the Duke football team, 1947–49, and *Charlotte News* sports editor Burke Davis wanted a preseason picture of Knotts leaping for the ball. Burke and I were both surprised when the 1/500 of a second shutter speed caught Knotts's shoulders completely blocking his feet and body.

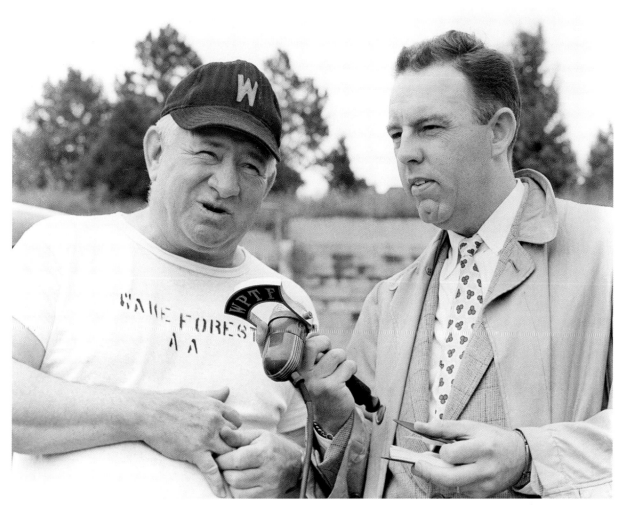

In the days when Wake Forest College was in Wake Forest, in Wake County, Douglas Clyde "Peahead" Walker (left) was its colorful head football coach. Walker was always a good interview for WPTF sports director Jim Reid. Reid was so admired and respected that he was elected Raleigh's mayor.

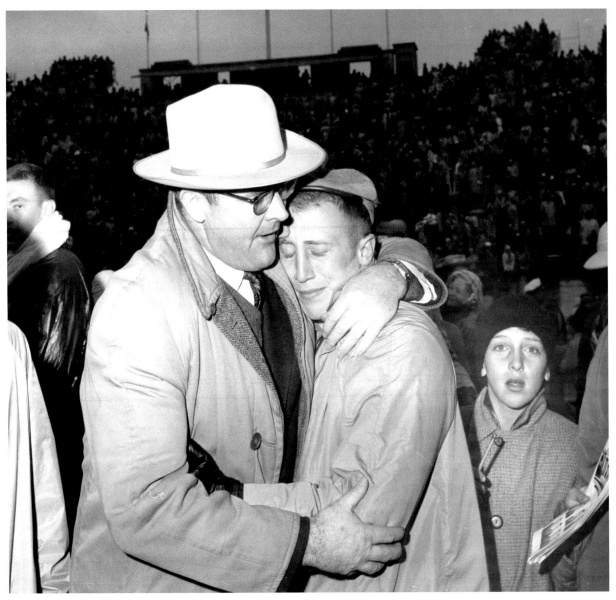

Carolina football coach Jim Tatum (left) suspended his co-captain and star running back Dave Reed the week before UNC's 1957 game with Duke for an infraction of team rules, and consequently Carolina was very much the underdog for the game with its traditional rival. When the Tar Heels upset the Blue Devils 21 to 13, a tearful Dave Reed embraced his disciplinarian coach in the center of the field at Wallace Wade Stadium.

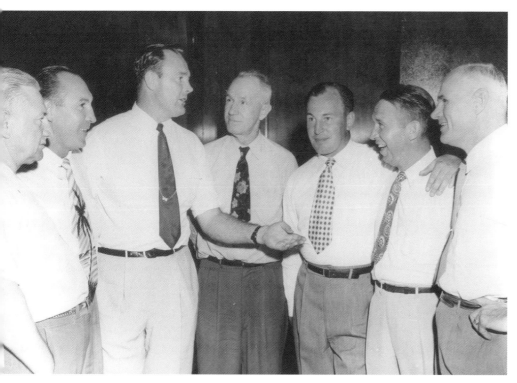

Shortly before the Atlantic Coast Conference was formed in 1953, an assembly of the conference's football coaches brought together some of the top names of the day in the sport of football. Left to right: D. C. "Peahead" Walker, Wake Forest; Beattie Feathers, N.C. State; Jim Tatum, Maryland; Wallace Wade, Duke; assistant coaches George Barclay and Crowell Little, UNC; and UNC head coach Carl Snavely.

N.C. State head football coach Earle Edwards (left) has reason to be proud of his quarterback Roman Gabriel, who was an All-American in 1960 and 1961. In high school Gabriel was All-State in both football and basketball in Wilmington for Coach Leon Brogden's New Hanover Wildcats. In the NFL, Gabriel played quarterback for the Los Angeles Rams from 1962 to 1972 and for the Philadelphia Eagles from 1973 to 1977. While in Los Angeles, Gabriel moonlighted as an actor and appeared in at least one Hollywood production in which John Wayne was the star. In 2001 Gabriel was a radio sportscaster in Charlotte with the NFL Carolina Panthers.

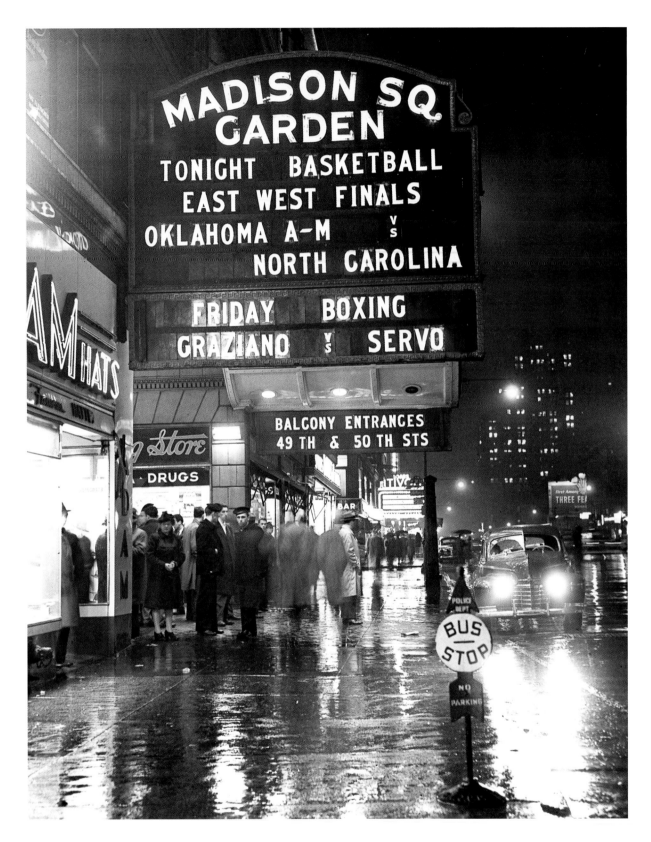

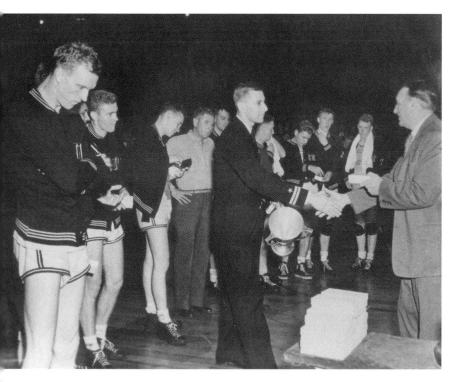

In 1946, before the NCAA national basketball championship became known as the Final Four, UNC lost in the championship game, 43 to 40, to Oklahoma A&M. The game was played in the old Madison Square Garden before 18,479 spectators. UNC head basketball coach and Navy lieutenant Ben Carnevale, who had responsibilities at the Navy Pre-Flight School at Chapel Hill as well, accepted the runner-up trophy. Carolina's Horace "Bones" McKinney (far left) was not pleased at being runner-up.

(bottom left)
Coach Everett Case of N.C. State is generally credited with bringing big-time college basketball to North Carolina. Domination in the sport rotated among N.C. State, UNC, and Duke while Case coached at State, compiling a win-loss record of 189-88.

(bottom right)
Frank McGuire (left) came down from New York to make UNC hoops competitive after Everett Case was successful at N.C. State. Former head coach Ben Carnevale recommended to McGuire that he hire as an assistant Dean Smith (right), who was on the basketball staff of the U.S. Air Force Academy in Colorado.

(opposite)
The famous original Madison Square Garden had sparkling wet sidewalks and streets out front when North Carolina and Oklahoma A&M met in the 1946 NCAA national basketball championship game.

Charlie Scott (33) was the first black basketball player in the Atlantic Coast Conference. Scott was an All-American in 1969 and 1970, and he was an Academic All-American as well. He later had a ten-year professional basketball career playing for the Virginia Squires, Phoenix Suns, Boston Celtics, Los Angeles Lakers, and Denver Nuggets.

(bottom)
Meadowlark Lemon took time off from the Harlem Globetrotters to come to his hometown of Wilmington to help the community deal with the aftermath of the death of Martin Luther King Jr. Meadowlark made appearances at every public school in New Hanover County, and racial tensions that had appeared hopeless to resolve were eased overnight. At the time, Meadowlark, who had starred with the Globetrotters before tremendous crowds in ninety countries, was beloved and respected worldwide.

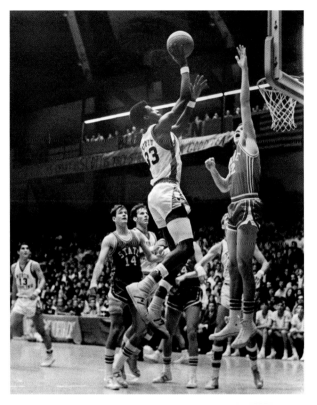

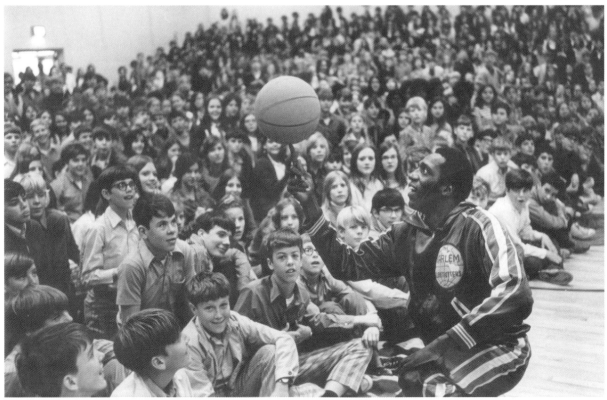

Harvie Ward of Tarboro, at age fourteen, startled a group of talented adult golfers by winning the prestigious Linville Men's Golf Tournament in 1940. It was the beginning of an illustrious amateur golfing career that ultimately saw Ward win the British Amateur in 1952, the Canadian Amateur in 1954, and the United States Amateur in 1955 and 1956. I made the 1940 photograph of Ward for Burke Davis, sports editor of the *Charlotte News*, which was the beginning of a career for me as well as for Harvie. It was my first photo assignment for a daily newspaper.

Arnold Palmer (left) was a student at Wake Forest when he received a sterling silver tray for winning the amateur division of the Azalea Open Golf Tournament at Wilmington in 1954. Hollywood actress Anita Colby presented Palmer with the trophy as Bob Toski, the winning professional for the tournament, looked on. In 1957, while still an amateur, Palmer won the whole tournament, beating the pros.

Agnes Morton Cocke (now Agnes Woodruff) could never beat Estelle Lawson Page (left) in any of their golf matches. Upon Estelle's retirement, Agnes won the Women's Carolinas Golf Championship four times between 1948 and 1958. They are shown here in a match at Cape Fear Country Club in Wilmington.

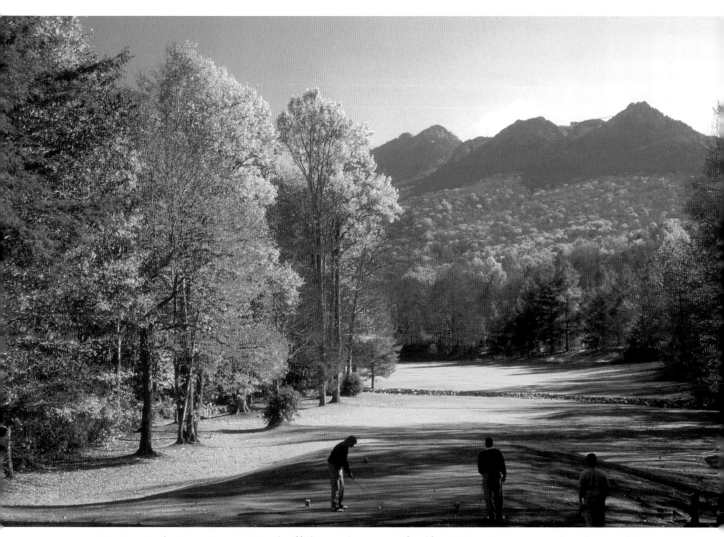

Agnes Morton Cocke (now Agnes Woodruff) knew the game of golf, so it is not surprising that she would opt to build a golf course on property she inherited in the Linville River Valley at the base of Grandfather Mountain. With architect Ellis Maples, she personally oversaw the chopping out of wilderness of the center lines of most of the eighteen holes of the championship course, making sure that each hole had picturesque exposure to surrounding peaks and water. Of the thousands of golf courses in the United States, Grandfather Golf and Country Club ranks in the top hundred.

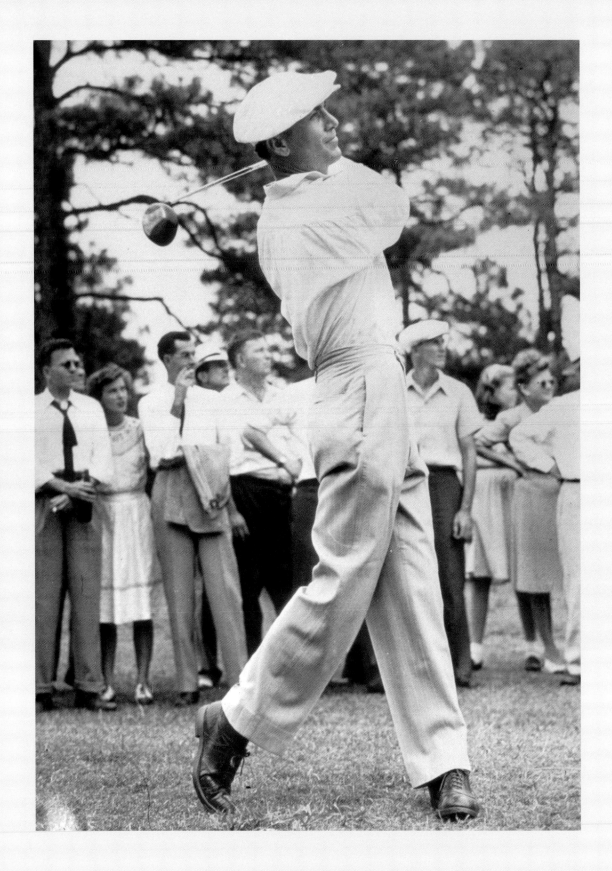

The United States has had some great Ryder Cup teams, and the 1951 team that assembled at Pinehurst for a group photograph included several players who are legends in the game of golf. Left to right: Jackie Burke, Lloyd Mangrum, Henry Ransom, Clayton Heafner, Sam Snead, Skip Alexander, Ben Hogan, Jimmy Demaret, and Porky Oliver. The Ryder Cup matches that year were in England.

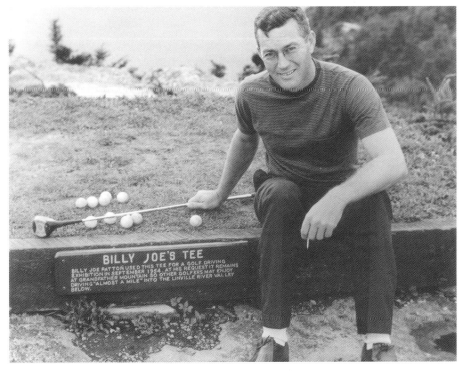

Playing as an amateur, Billy Joe Patton of Morganton had five top-ten finishes in major golf championships, including two at the U.S. Open and three at the Masters, for a record unmatched by an amateur golfer in modern times. Billy Joe drove from a special tee off the cliff at Grandfather Mountain during a sports photography lecture by Frank Jones of the *Winston-Salem Journal*.

(*opposite*)
One of America's all-time great golfers was Ben Hogan, who played an exhibition match at Cape Fear Country Club in Wilmington during a weekend off from his World War II military service at the U.S. Air Force Base at Goldsboro.

Ted Williams, one of the greatest hitters ever, enjoyed hitting several baseballs "almost a mile" from a golf tee at 5,300 feet in elevation on Grandfather Mountain. The tee was built for a driving exhibition by noted amateur golfer Billy Joe Patton. Mickey Mantle also had fun hitting baseballs from the tee, which was later removed when several extremely amateur golfers shanked drives into windshields of cars in the Swinging Bridge parking lot below.

(bottom)
Ted Williams will always be known for his exploits on the baseball field, but I will remember him as the best fisherman I have ever known. The guy thought like a fish. He knew when he cast whether he could get a strike or not, and he was rarely wrong. Williams developed a love for North Carolina when he was in the Navy Pre-Flight School at Chapel Hill in World War II.

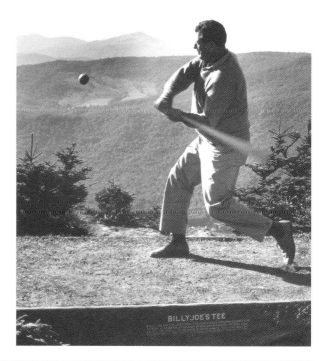

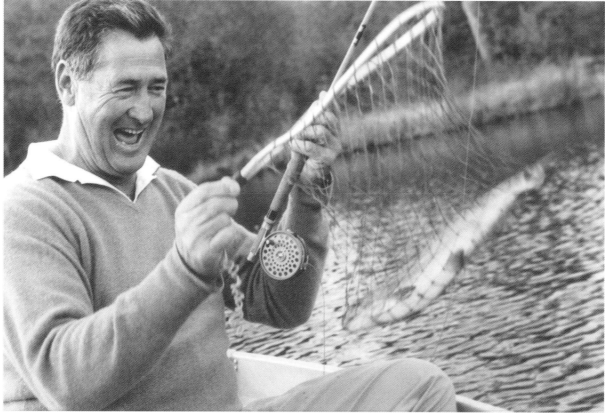

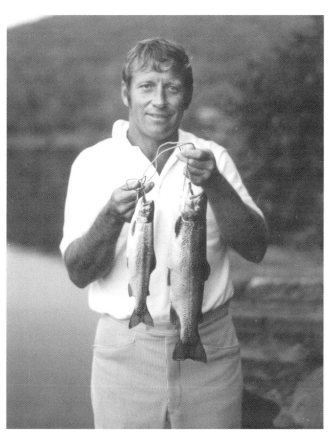

I had fun fishing with New York Yankees slugger Mickey Mantle, and he took great pleasure in telling anyone who would listen that he caught the larger trout pictured here and I, the smaller one.

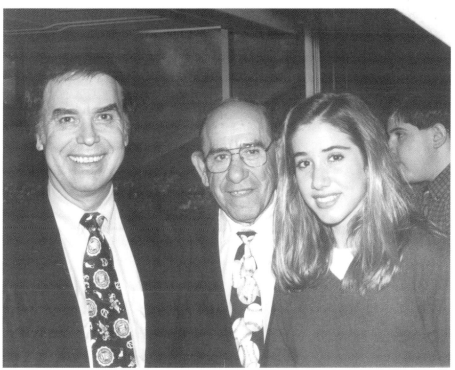

Richard Cole (left) is dean of the UNC School of Journalism and Mass Communications, one of the best journalism schools in the nation. Yogi Berra's granddaughter Lindsay Berra (right) graduated from the school in May 1999. I took this photo at a basketball game when Yogi was visiting Lindsay in Chapel Hill.

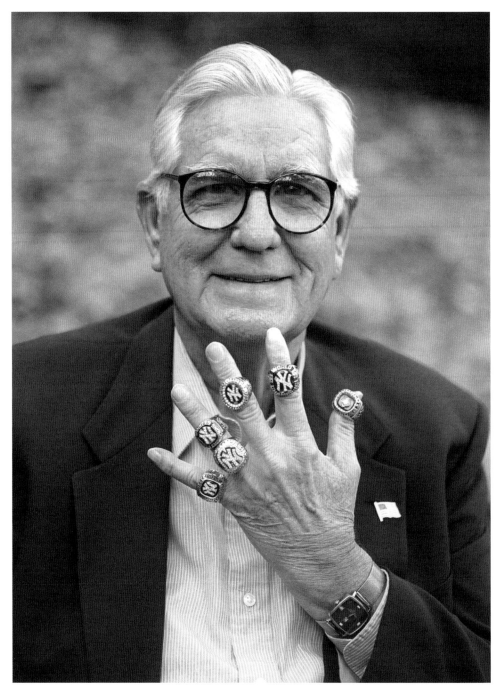

I kid my friend Clyde King of Goldsboro that he has more rings than Tammy Faye, but to be honest, Clyde usually wears his rings one at a time. He won the rings while employed by George Steinbrenner in various capacities, including general manager of the New York Yankees. King was also manager of the Atlanta Braves and the San Francisco Giants, and earlier he had been a pitcher for the UNC Tar Heels and the Brooklyn Dodgers.

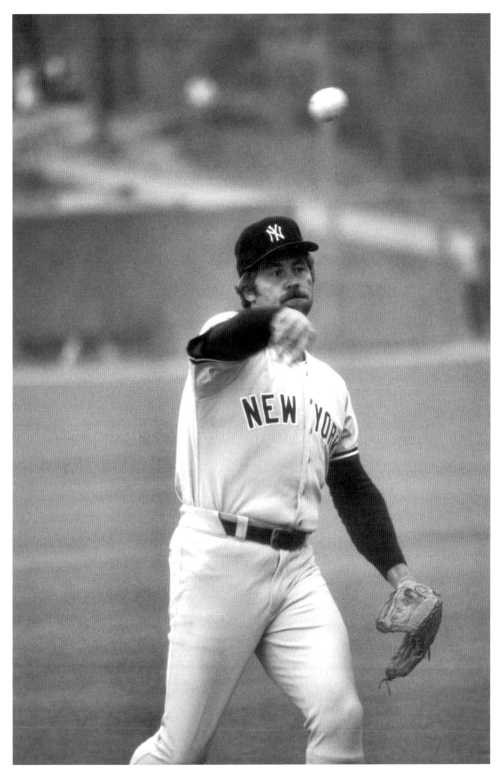

Hertford's Jim "Catfish" Hunter had no fear on the mound, and he was the pitcher the New York Yankees staff wanted when a big game was on the line. Clyde King, former Yankees general manager and himself once a pitcher for the Brooklyn Dodgers, described his fellow Tar Heel as "a gentle person with no ego in him." This picture of Hunter was made during warmups for an exhibition that the Yankees played in Chapel Hill. It was a sad stroke of fate that "Catfish" died before his time from the disease named for another great Yankee, Lou Gehrig.

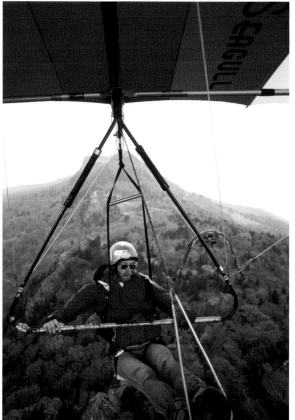

(top)

Francis Rogallo of Kitty Hawk worked for NASA on techniques to bring space vehicles back to earth safely, and his research resulted in the development of the Rogallo Wing, which made possible the sport of Hang Gliding. A spinoff from the flexible Rogallo Wing was the invention of the high performance canopy or square parachute that is now of great importance to America's military. It allows skilled parachutists "to land on a dime."

(bottom)

I joined with hang glider pilot John McNeely to produce a film entitled "The Hawk and John McNeely." The production won the CINE Golden Eagle award and first place in a festival for real-life adventure films in Italy. Woody Durham, "the Voice of the Tar Heels," narrated the production, and Arthur Smith wrote and recorded the original musical score. The hawk landed on McNeely's control bar several times during each of John's flights.

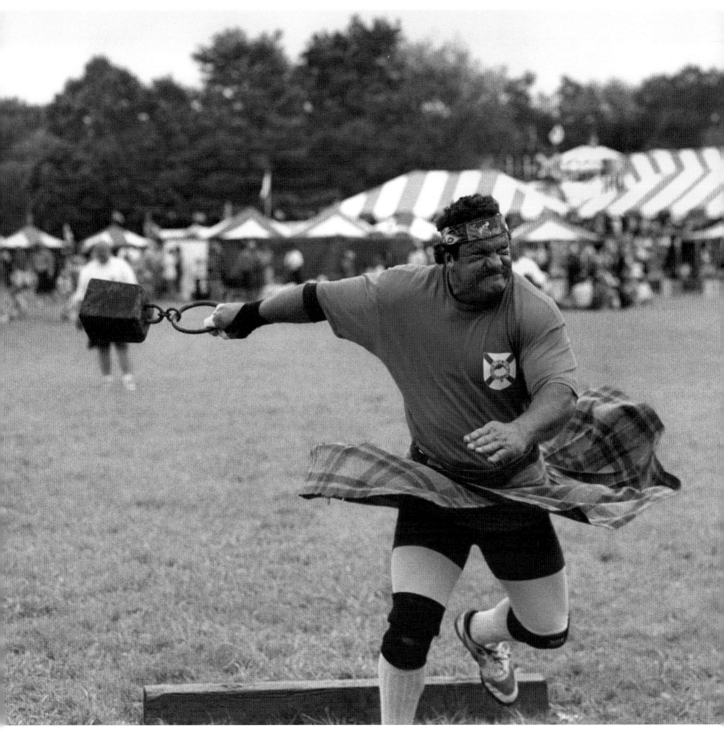

The question was "What does the Scotsman wear under his kilt?" and it was answered pretty emphatically by a professional Scottish athlete at the Grandfather Mountain Highland Games and Gathering of Scottish Clans.

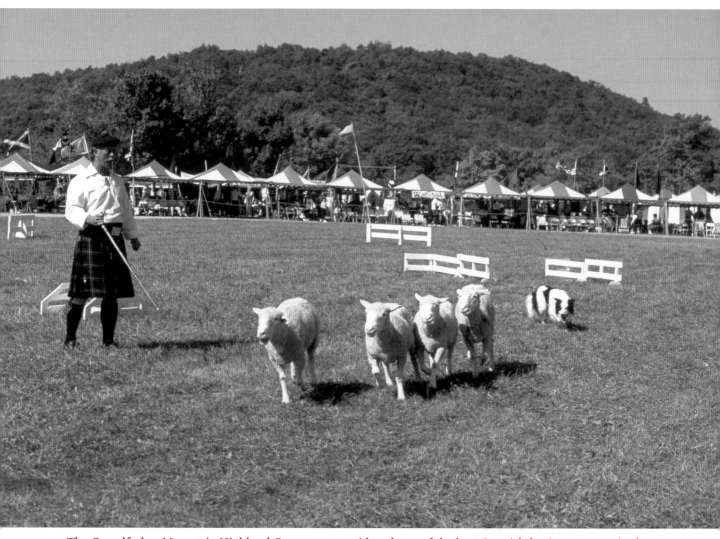

The Grandfather Mountain Highland Games are considered one of the best Scottish-heritage events in the world, and sheep-herding border collies put on one of the most popular parts of the program.

Legend has it that the popular sport of stock car racing had its beginnings when Junior Johnson was racing the back roads of Wilkes County with moonshine whiskey to be delivered to eager customers. The legend may simply be myth, but one thing is for sure: if you go to a race or a car show and are able to obtain Johnson's autograph in indelible ink on the lid of a quart fruit jar, you have a priceless souvenir.

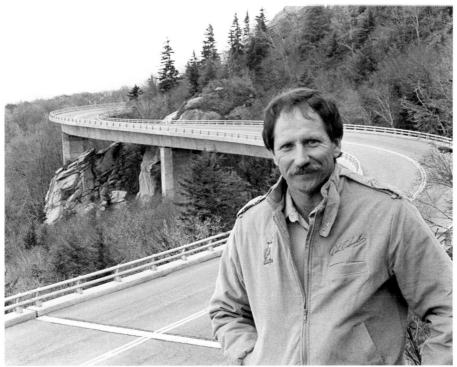

NASCAR champion Dale Earnhardt was brought to Grandfather Mountain by my photographer friend Don Hunter to be in a large "King of the Hill" poster of Dale standing atop Grandfather's Linville Peak. Afterward we took Earnhardt to see the Blue Ridge Parkway Viaduct, and his comment was, "Boy, would I like to take Number 3 around those banked curves!"

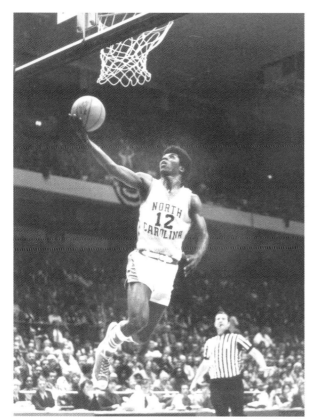

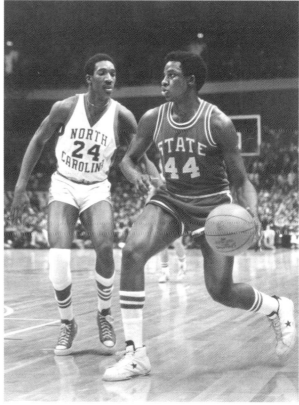

(left)

UNC's Phil Ford was an All-American in 1976, 1977, and 1978, and National Player of the Year in 1978. Carolina's all-time leading scorer, with 2,290 points, Ford will always be known in Chapel Hill as the player who ran Dean Smith's Four Corners the best. My son, Hugh Morton Jr., Phil's good friend, called me one day to say that Ford's fiancée, Traci, who was from Durham, wanted to be married in Duke Chapel but she and Phil had been turned down by the Chapel "because they had no Duke connection." Hugh Jr. asked if I would call my friend Terry Sanford, former Duke University president and then U.S. senator. When I told Senator Sanford the story, he said, "Hugh, you tell Phil Ford that I am his Duke connection." Traci chose twelve bridesmaids, and the twelve groomsmen that Phil selected rivaled the NBA All-Star Team, with Walter Davis as best man.

(right)

Most N.C. State Wolfpack fans think David Thompson (44) was their greatest basketball player, and sportscaster Dick Vitale says Thompson is one of the top five college basketball players of all time. Guarding Thompson on this occasion was North Carolina's Walter Davis (24), who earned the nickname "Sweet D" because of his heads-up defensive play. Thompson was an All-American in 1973, 1974, and 1975, as well as Associated Press National Player of the Year in both 1974 and 1975. Davis had an outstanding professional career in Phoenix and Denver and is now an advance scout for Michael Jordan's Washington Wizards.

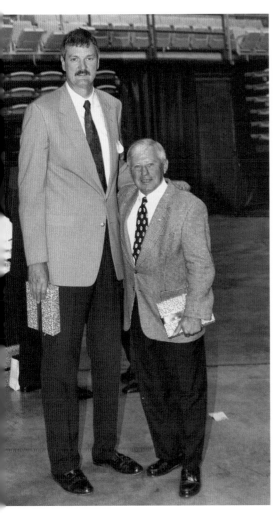

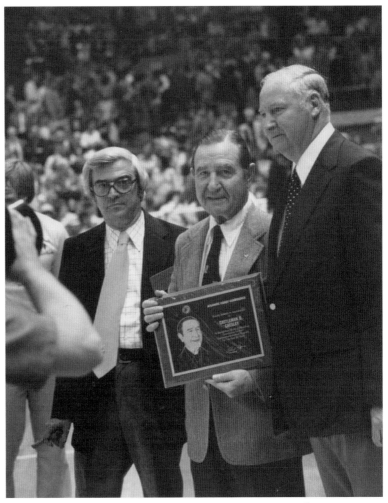

(left)
The North Carolina High School Athletic Association held a program in 2000 to honor some of its former athletes who had gone on to great accomplishments after high school. Two of my good friends who were honorees were Tommy Burleson (left) and Jim Beatty. Tommy was the All-American Center on the N.C. State University 1974 national champion basketball team, and Jim Beatty, of UNC, was the first person to run a mile indoors in less than four minutes.

(right)
Atlantic Coast Conference commissioner Bob James (right) and ACC information director Marvin "Skeeter" Francis (left) stand at midcourt at halftime at the 1977 ACC Tournament to honor Castleman D. Chesley for his masterful pioneering television coverage that helped lead to the ACC being recognized as the most prominent college basketball conference in the nation.

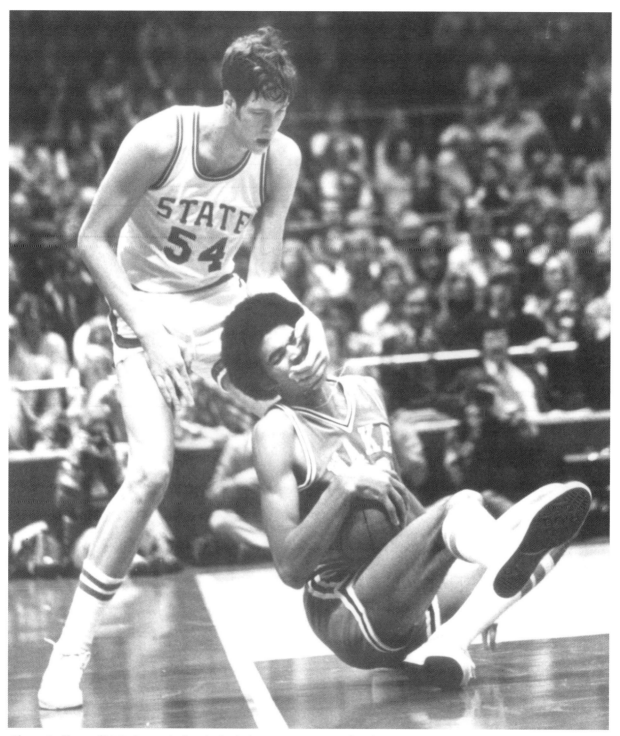

Glenn Sudhop of N.C. State obviously fouled Larry Harrison of Wake Forest. Smith Barrier, for many years the dean of Atlantic Coast Conference sportswriters, said this was the best basketball picture I ever made. I tried to explain that Sudhop was merely showing polite sportsmanship by lifting Harrison up from the floor, but Barrier wouldn't listen.

Of the many pictures that I have of Dean Smith (left), this one is my favorite. The group was completely exhausted, and if it were not for the net around James Worthy's neck one wouldn't know that Carolina had just won the 1982 NCAA national championship. Sports Information Director Rick Brewer is looking at his watch, fearful that the story will not make East Coast sports page deadlines, and Coach Smith and Jimmy Black are just plain tired. They are waiting to be interviewed by the media.

(bottom)
Dean Smith was head coach and John Thompson assistant coach of the 1976 U.S. gold medal Olympic basketball team in Montreal, and they became good friends. When Dean Smith's 1982 UNC team beat Thompson's Georgetown team for the NCAA national championship in New Orleans, the two friends embraced outside the press interview room following the game. Thompson's back was turned, so I did not at first get the picture I wanted. When I asked Coach Thompson to face me and continue to hug Dean, he did so with such enthusiasm that he lifted Coach Smith all the way off the floor.

Woody Durham (right) is bound to have known Carolina would win the 1982 national basketball championship when he picked Frank McGuire (center) and Jim Valvano to be his "color" commentators. McGuire had been there as winning coach with the 1957 UNC championship team, and Valvano's day was to come in 1983, when his N.C. State team would be national champions.

(opposite)
Michael Jordan was airborne in Carmichael Auditorium against Virginia, and this is my most published action shot of him at Carolina. I told him ahead of time that I hoped he would have a good game, and as he brushed by after making this basket he asked, "Was that good enough?"

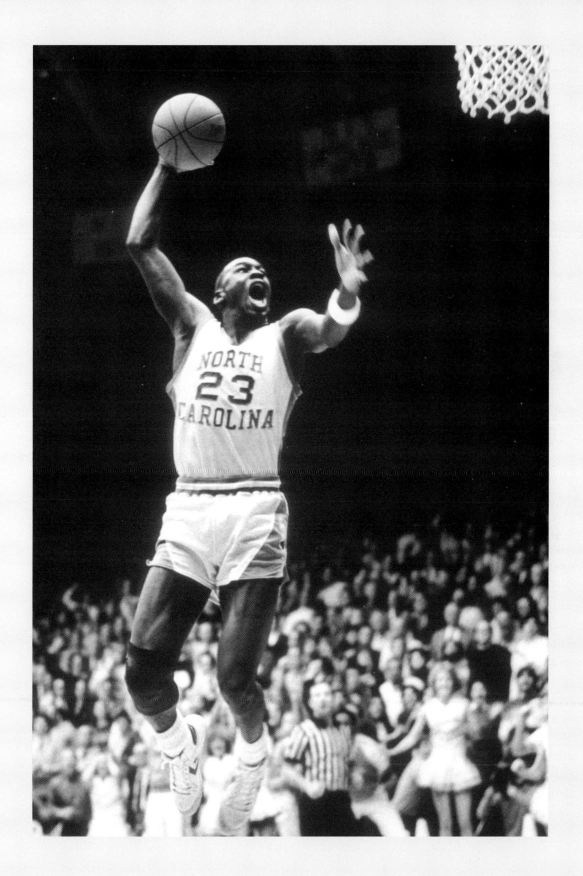

Michael Jordan (left) and Matt Doherty, members of UNC's 1982 national championship basketball team, wait at the scorer's table to be sent into a game in Carmichael Auditorium. Nearly twenty years later, when Doherty was offered the job as head coach of the Tar Heels, his good friend and ex-teammate Jordan urged him to take it.

Michael Jordan, with his proud father James Jordan seated beside him (right), was being interviewed in the locker room of the old Charlotte Coliseum following a UNC victory in the NCAA regional basketball tournament. Years later, when James Jordan was tragically murdered and his car stolen, a special license plate that Michael had given his father, with his jersey number, 23, was instrumental in the detection and conviction of the murderers.

When Dean Smith (right) was honored by the entire sixteen-unit University of North Carolina System with the University Award, basketball's winningest college coach chose two of his greatest stars to be featured speakers. Michael Jordan (seated) had eloquent praise for Coach Smith, and Charlie Scott brought tears to many eyes in the room. Making reference to the fact that each member of Dean Smith's family had been introduced at the banquet, Charlie Scott said: "When they introduce Coach Smith's family, why don't they mention my name? My father died when I was twelve years old, and Dean Smith is the only father I ever had."

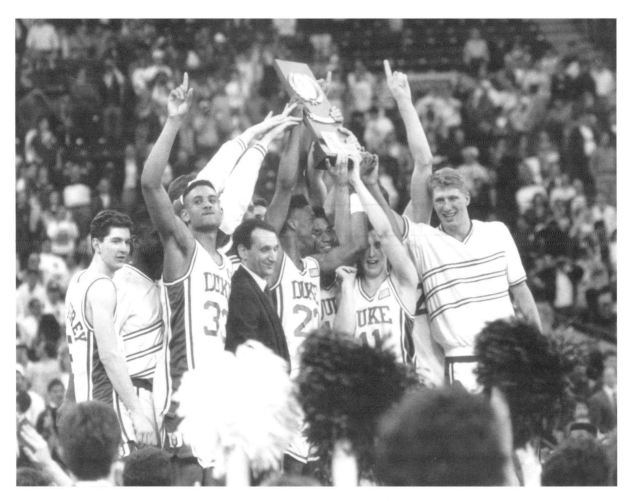

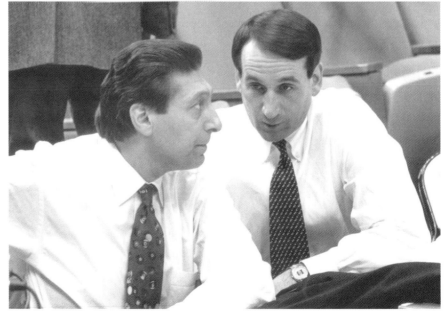

(top)
Duke Coach Mike Krzyzewski's first Final Four championship came in 1991 in Indianapolis, and there was great joy among the Blue Devils. Two of Coach K's main horses, Grant Hill (33) and Bobby Hurley (11), had a hand on the championship trophy, as well as a big hand in the victories it took to win it. The two other unobscured happy faces belong to Billy McCaffrey (left) and Clay Buckley (right).

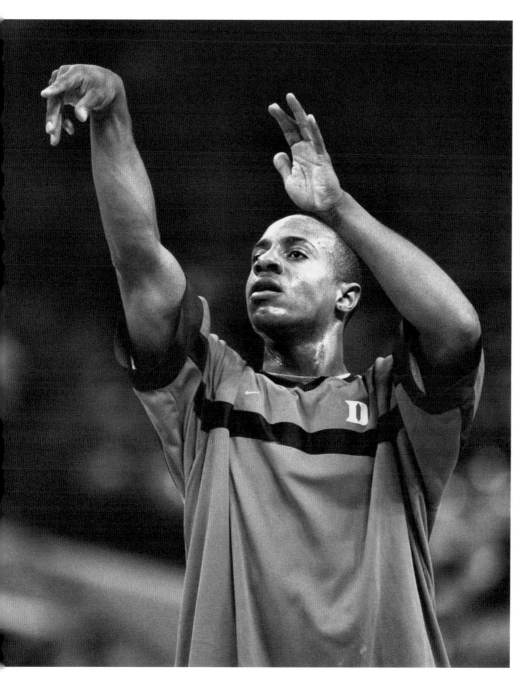

Jason Williams resembles a conductor leading the symphony a split second after he released a free throw during practice at the 2002 Atlantic Coast Conference Basketball Tournament, which his Duke University team won, in Charlotte. Days later the Associated Press announced that Williams was a unanimous selection for All-American. A fine student as well as an outstanding athlete, Jason Williams set for himself a remarkable scholastic schedule to graduate from Duke in only three years.

(opposite, bottom)
An hour before Carolina's March 7, 1993, basketball game with Duke in Chapel Hill, Duke coach Mike Krzyzewski (right) was in the stands engaged in intense conversation with former N.C. State coach Jim Valvano. According to my good friend Bob Harris, the radio voice of the Blue Devils, Coach K described the meeting as "a moment of reflection by two old friends before Jim Valvano's last ABC television broadcast." Valvano died of cancer seven weeks later on April 28.

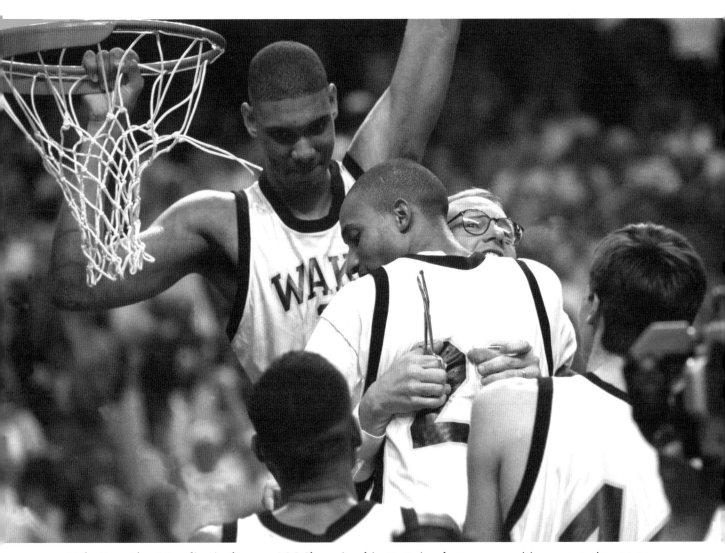

Wake Forest beat Carolina in the 1995 ACC Championship 82-80 in what was as exciting an overtime game as has ever been played in the Greensboro Coliseum. The great Tim Duncan is holding the net, while Wake Forest head coach Dave Odom is holding the scissors and Randolph Childress.

(opposite)
Clarence "Bighouse" Gaines, for thirty-eight years head basketball coach and athletic director at Winston-Salem State University, was inducted into the National Basketball Hall of Fame in 1982. Among the stars he developed was Earl "the Pearl" Monroe. Gaines was the second coach at a four-year college to win 800 games, after Adolph Rupp.

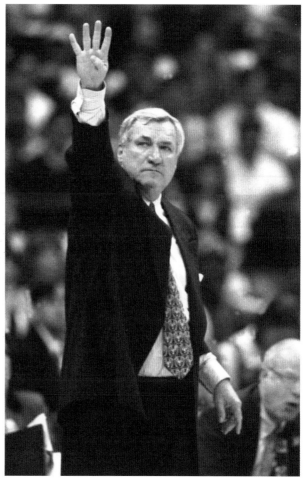

(left)

The large American flag that hangs from the rafters of UNC's Dean Smith Center is four times larger than the flag moved there from Carmichael Auditorium. The Carmichael flag was so dwarfed in the spacious Dean Dome that the audience had difficulty locating it when the Star Spangled Banner was played. I gave Athletic Director John Swofford a flag catalog and told him I would donate the largest American flag he could select that did not block vision from the top row seats, and this is the one he picked. I wanted it to be a statewide North Carolina American flag, so before turning it over to John Swofford, I had it flown at Grandfather Mountain, Mount Mitchell, the Biltmore House, the State Capitol, the USS *North Carolina* Battleship Memorial, Cape Hatteras Lighthouse, and the Wright Brothers National Monument.

(right)

Coach Dean Smith is signaling for the basketball offense he created known as the Four Corners. On the bench behind him at the left is Assistant Coach Phil Ford, who, as a player for UNC in the 1970s, ran the Four Corners offense more effectively than any player since. Bill Guthridge, who was Coach Smith's valuable and loyal assistant for thirty years, is at the right. The photograph was made during Carolina's victory over Louisville in an NCAA regional championship game in Syracuse that sent Coach Smith's team to the 1997 Final Four. It was the 879th and last win for Dean Smith at UNC.

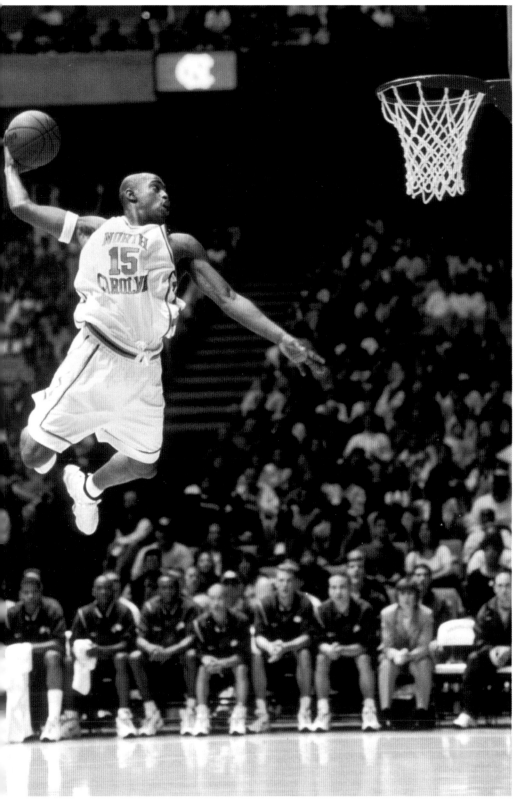

Fans in the ACC knew Carolina's Vince Carter was special, and this dunk in the Smith Center let the California bench behind him know how high he could get up off the floor. Upon seeing the photograph, Carter told Dean Smith's secretary, Linda Woods, in the UNC basketball office that he would love a copy for each of the members of his family for Christmas. NCAA rules forbid appreciative alumni from giving anything of value to current players. I therefore gave three color enlargements to Linda Woods, and I hope she helped Vince with his Christmas shopping.

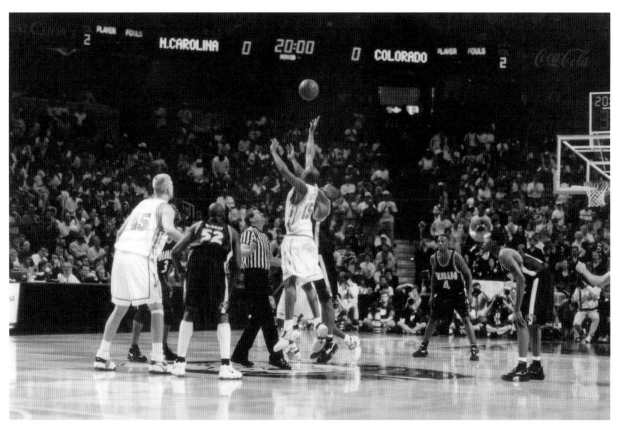

(top)
On March 15, 1997,
Vince Carter jumped
center in the tipoff of
the game with Colorado
that was win number
877 for UNC coach
Dean Smith, breaking
the record for most
wins that had been
held by Kentucky's
Adolph Rupp.

(left)
Better known for his football prowess, Julius Peppers (45), who led the nation in sacks in the 2000 football season, was simply having a good time playing for Coach Matt Doherty's UNC basketball team in the loss that ended the 2001 season, against Penn State in the NCAA Tournament in New Orleans. Brendan Haywood (00) went on to the NBA to play for Michael Jordan's Washington Wizards.

(right)
Julius Peppers was a first string All-American and the winner of the Vince Lombardi Trophy in recognition of his outstanding defensive play for the North Carolina Tar Heels of Coach John Bunting. The 2001 team played one of the toughest schedules in the nation, and it racked up enough wins to be invited to the Peach Bowl in Atlanta. Peppers became the top draft pick of the NFL Carolina Panthers, who play their home games in Charlotte.

(opposite, bottom)
At one time, Roy Williams, Dean Smith, Bill Guthridge, and Matt Doherty (pictured here, left to right) had all been part of the same UNC Team, but at the 1991 Final Four in Indianapolis they were opponents. Smith and Guthridge were there to coach Carolina, and Williams and Doherty were there to coach the University of Kansas. Kansas beat Carolina, Duke beat UNLV in the other semifinal game, and then Duke beat Kansas in the championship game.

I was in Kenan Stadium for the UNC-State game with the rest of the news photographers, taking pictures of what the N.C. State Wolfpack cheerleaders proudly said was a real wolf pup. News stories published a few days later, however, revealed that the wolf was really a young coyote. I have yet to decide if the Wolfpack cheerleaders were having fun playing tricks on the press photographers, or whether they themselves had been suckered into purchasing a small coyote that they thought was a juvenile wolf. Anyway, I now think I know a coyote when I see one.

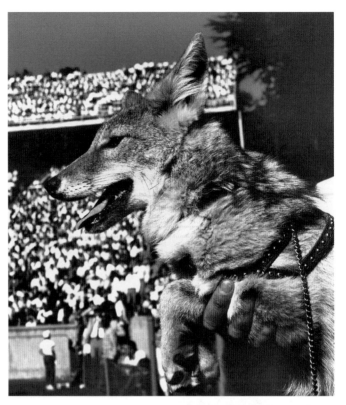

(bottom)
Mack Brown had tough sledding in the first years after he was named head football coach at UNC in 1988, but he did a beautiful job of building a winning football program again for Carolina.

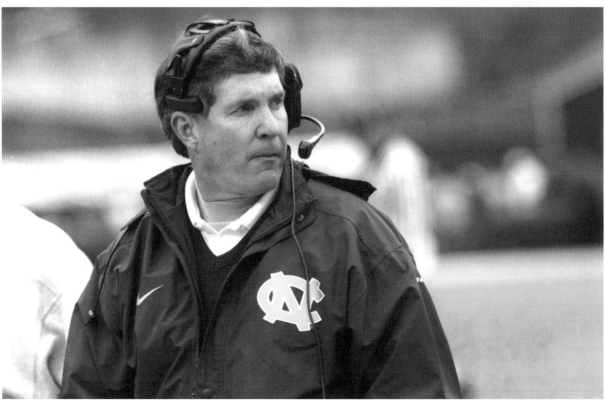

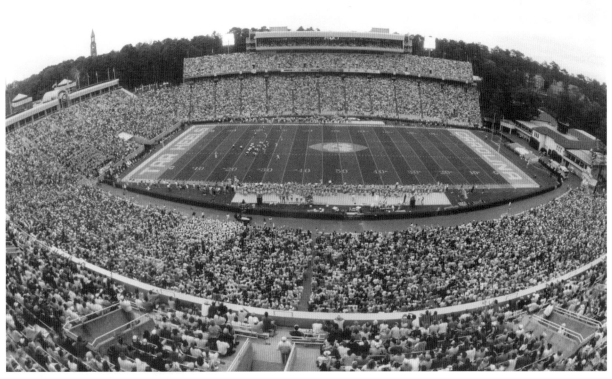

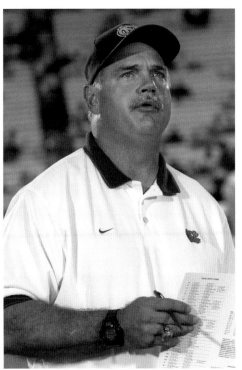

(top)
I am told that some Tar Heel fans have criticized Coach Mack Brown for leaving to coach at Texas for twice his UNC salary. Others with better memories give Brown much of the credit for reviving interest in football at Carolina and making possible the closing of the Bell Tower end of Kenan Stadium, giving the Tar Heel faithful a beautiful horseshoe stadium.

(bottom)
John Bunting, an alumnus of UNC with several years experience in pro football, became UNC head football coach in 2001. Already he has kindled much enthusiasm, both in players and alumni, who believe he will assure that Carolina will be heard from on the gridiron.

November 30, 1946, was a great day for Charlie Justice (left) and the Tar Heels, who outscored Virginia 49 to 14 in Charlottesville. It was also a fine day for young C. D. Spangler Jr., a high school student in Virginia at Woodberry Forest, who, with the help of a UNC cheerleader, retrieved a tattered grass-stained number 22 jersey that had been discarded behind the Carolina bench. Spangler, who later served with distinction for ten years as president of the University of North Carolina System, gave the UNC Athletic Department the keepsake he had guarded for more than fifty years. It is now the centerpiece of the Charlie Justice Hall of Honor, the football memorabilia room in Kenan Stadium.

Index